# THE
# SOCK PROJECT

For Dave, always,
and my two very best chickens,
Memphis and Sailor

Editors: Shawna Mullen and Meredith Clark
Designer: Jenice Kim
Managing Editor: Lisa Silverman
Production Manager: Kathleen Gaffney

Library of Congress Control Number: 2023936452

ISBN: 978-1-4197-6811-8
eISBN: 979-8-88707-027-8

Printed and bound in China
10 9 8 7 6 5

Abrams books are available at special discounts when purchased
in quantity for premiums and promotions as well as fundraising
or educational use. Special editions can also be created to
specification. For details, contact specialsales@abramsbooks.com
or the address below.

ABRAMS The Art of Books
195 Broadway, New York, NY 10007
abramsbooks.com

# THE
# SOCK PROJECT

colorful, cool socks to knit and show off

## Summer Lee

ABRAMS | NEW YORK

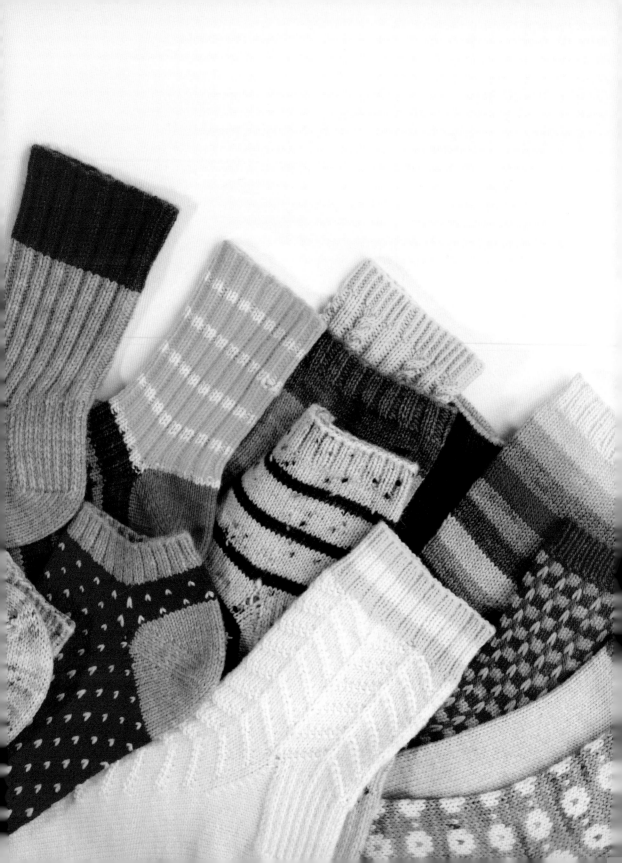

# CONTENTS

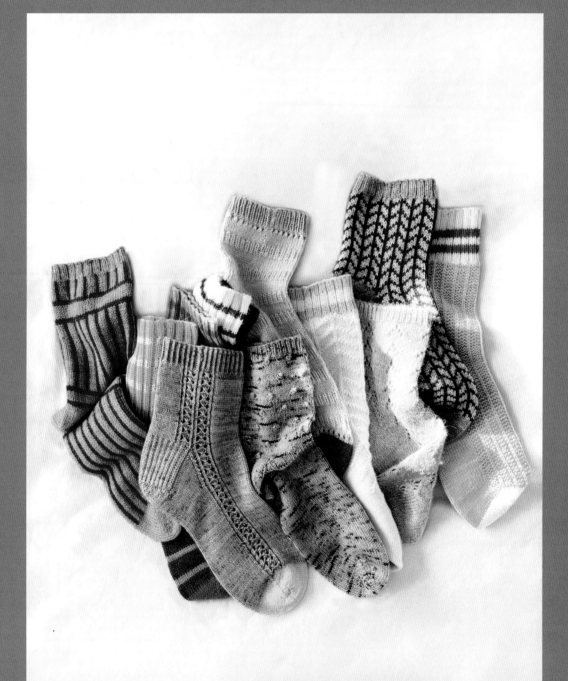

# INTRODUCTION

Perhaps you picked up this book because you are eager to learn how to knit socks. Maybe you're a seasoned sock knitter looking for fresh patterns to fill your sock drawer. Or it's entirely possible you were gifted this book by a well-meaning friend who saw you knitting a sweater and thought you might enjoy knitting socks as well.

However this book came to be in your hands, I'm delighted you're here (yes, even you, the sweater knitter who received this book as a gift and now you're leafing through it, trying to decide whether to give socks a go).

This book is organized to help build your skills, starting with the basics of sock knitting—the anatomy of a sock, how to construct the various parts, and how to work simple stripes and fades—then moving on to all the lovely knitting techniques that make your socks sing glorious songs for anyone lucky enough to see them peeping over the top of your boots. Texture, lace, cables, Fair Isle, and more will be presented in the chapters to come, along with helpful tips, tricks, and tutorials. Each chapter builds upon skills learned in the previous chapter so that by the end of the book, you will be a battle-hardened sock knitter with a drawer full of well-earned woolly treasures.

For those curious about how to knit better-fitting socks suited to your particular, unique feet, there's a chapter for that too! So grab your beverages of choice (hot vanilla chai for me!), gather some needles and yarn, sequester yourself in a comfy knitting nook, and begin. The sock knitting community is the best community, I always say. Sure, sweaters and shawls are great, and who doesn't love to knit up a hat or a pair of mittens once in a while. But sock knitting? Sock knitting is pure magic. May your feet ever be hugged by the stitches you make with your own two hands!

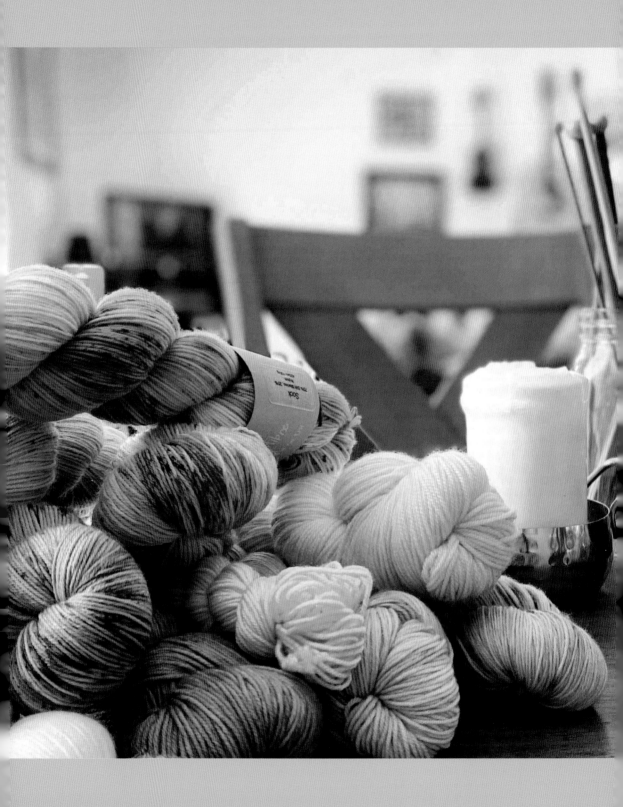

# MATERIALS, SIZING & FIT

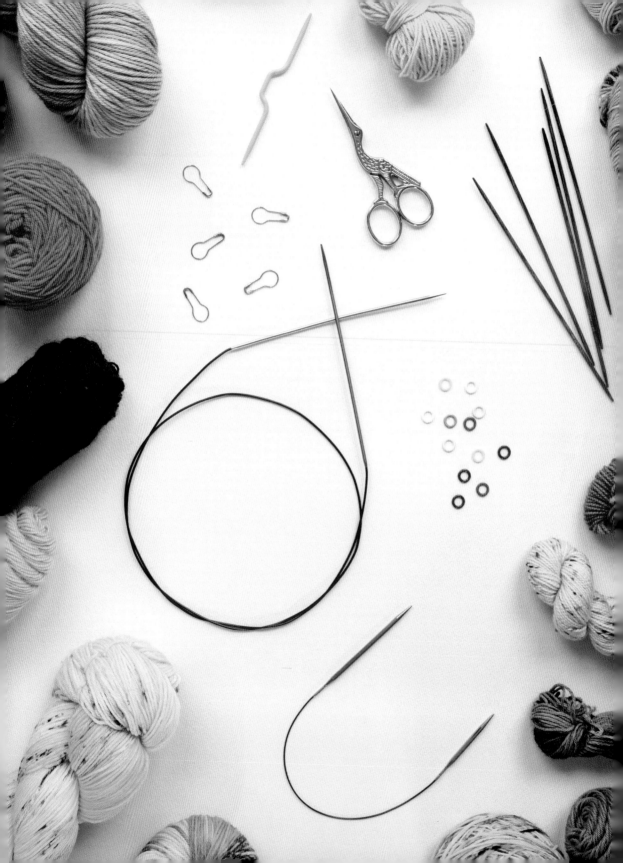

# Chapter 1
# YARN, NEEDLES & NOTIONS

**S**ock knitting fortunately requires very little in the way of materials. Some yarn and needles are all you really need to get started. But not all yarn is suitable for making socks, and the kind of needles you need depends entirely on which method of sock knitting you prefer. There are also notions that, while not strictly necessary, can certainly make your life a bit easier as you work to fill up your sock drawer.

## Yarn

Merino/Nylon blends are my absolute favorite sock yarns to knit with. Merino is one of the softer wools, and the addition of nylon adds strength to your socks while prolonging their lifespan. You'll notice different ratios on yarn labels: 80/20, 90/10, 85/15, or 75/25. This simply refers to the percentage of merino wool (the higher number) to the percentage of nylon (the lower number). If you plan on wearing your socks while cozied up in your favorite chair watching a British murder mystery series on Netflix, 90/10 ratios will suit you just fine. If, however, you are an actual British detective inspector, and you plan on wearing your socks while stomping about the muddy English countryside looking for murderers, you would be better off with higher nylon ratios, such as 75/25.

Merino/Cashmere/Nylon blends are exactly as described above, with one important distinction. These fancy sock-yarn blends incorporate a hint of cashmere, that inexplicably soft, luxurious fiber that comes from a goat, of all creatures! Having been herded into many a petting zoo when my children were small, I never touched a goat whose hair was anything but coarse, so it baffles me that one of the world's most sought-after fibers comes from such an animal.

BFL yarn comes from the wool of a Bluefaced Leicester sheep. A hardy little breed hailing from Great Britain, these sheep produce strong wool with a good twist. When blended with nylon, BFL makes a wonderfully durable sock. While it's not quite as soft as merino, for knitters who plan on taking their socks out into the world for daily adventures, BFL creates a sturdy sock that won't faint and fall apart under extreme duress.

100% Merino yarns are for the risk-takers, the purists, the devil-may-care knitters who keep a darning basket by the fireside and a box of strong wine in the fridge. Without nylon to reinforce it, pure merino may wear faster in the heels and toes. You spend hours lovingly knitting each stitch of your sock, yet in a few months' time, holes may develop at an alarming rate, growing ever bigger the longer they're ignored. Does this mean you shouldn't ever knit socks with pure merino? Of course not! Sometimes I develop an intense obsession with a particular color that only comes in merino fingering, and the absence of nylon simply will not deter me from possessing it. In that case, I either treat those socks delicately, only wearing them while ensconced in my spot on the couch, or I knit contrasting cuffs, toes, and heels in a yarn that does contain nylon.

Other Fibers: What about other, less common materials such as yak, silk, bamboo, cotton, or acrylic? You won't see these fibers present in sock yarns that often, and for good reason. They simply don't hold up as well as wool under constant friction. If you were to google a yak, you might be taken aback that this majestic Himalayan stock animal could produce anything other than the sturdiest of stuff to knit with. Alas, yaks produce a lovely but delicate yarn that, like silk and bamboo, is best reserved for shawls or hats.

Acrylic, while durable, isn't breathable. It traps moisture next to your skin, and, well, you can imagine what that does to your socks after a long day of wearing them.

For those who might be allergic to wool, your best bet is a blend of bamboo, cotton, silk, and nylon. While it won't be quite as durable as a wool blend, you'll still be able to knit lovely socks that you enjoy wearing.

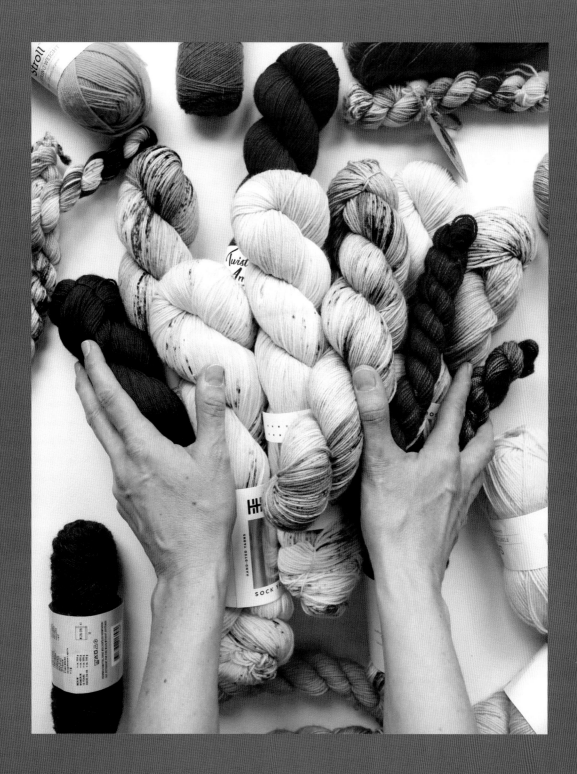

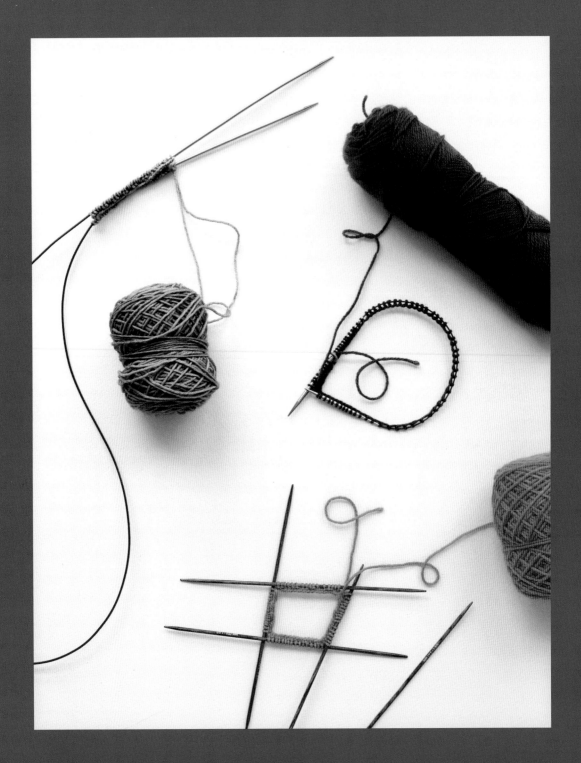

# Needles

I keep a variety of needles on hand so I always have what I need to fit whatever kind of sock knitting mood might strike me. There are three primary methods for knitting socks: magic loop (my personal fave), double-pointed needles, or tiny circular needles. Socks are typically knit on US size 1 (2.25 mm), 1.5 (2.5 mm), or 2 (2.75 mm) needles when using fingering weight yarn, while thicker socks are knit on US size 3 (3.25 mm) or 4 (3.5 mm). Needles are usually crafted from either wood or stainless steel. Many knitters take great comfort in the warmth that seems to radiate from wooden needles. Others prefer the quick glide and indestructible nature of stainless steel.

Circular Knitting Needles: For the magic loopers among you, a circular knitting needle at least 32" (80 cm) long is needed. I personally live and die for my beloved ChiaoGoo US size 1 (2.25 mm) 40" (100 cm) circulars. Almost every sock I've ever knit has come off those stainless steel marvels. If my house ever caught fire, I wouldn't even bother grabbing them because they'd likely survive the flames.

Double-Pointed Needles are best if you prefer your knitting to remain as close to the experience our ancestors enjoyed and want to knit the old-fashioned way (and believe me, I'm an analog girl at heart who loves anything deemed "old-fashioned"). They typically come in sets of five so you can keep your stitches on three needles and knit with a fourth, or keep your stitches on four needles and knit with the fifth (or knit with three and a half because you've broken one by sitting on it, and the other has disappeared in that crack between your car seats).

Tiny Circular Needles, which are usually 9–12" (23–30 cm) in length, are another option. Allowing you to knit freely in the round as you would a hat or sweater, these teeny little tools are not for the faint of hand. Beware of cramping, and intense feelings of discomfort in the knuckle area (in this knitter's laughably unscientific opinion). It must be noted that many knitters happily stitch away on them for hours with absolutely no complaints, so give them a try if they pique your interest. Hand ailments aside, tiny circulars are incredibly useful for knitting colorwork socks (more on that in chapter eleven), so they're good to have on hand. I like the ChiaoGoo Twist Shorties because one needle is slightly longer than the other, which helps me out with the aforementioned hand-cramping.

If you are a beginner knitter and would like to see these three methods of sock knitting in action, head to the internet. Knitters are a generous group, and you'll find tons of great instructional videos that show you the ins and outs of knitting socks on a variety of needles.

# Notions

Knitters are universally known for talking to others about the joy and fun involved in whiling away the hours with a project. However, we do privately acknowledge among ourselves that certain projects can be tedious—miles of 1×1 ribbing, panels of intricate cables, and the dreaded moss stitch just to name a few.

One or two hours into a less-than-relaxing stitch pattern and our hands start drifting toward our phone or laptop. Perhaps a little shopping is in order, as a reward for all those mind-numbing stitches?

Your wallet would burst into tears and lock itself in the bathroom if you bought yarn every time you took a break. Notions like stitch markers, tapestry needles, project bags, and embroidery snips are much easier on your budget, and, as it turns out, quite complementary to sock knitting.

Stitch Markers: Something as simple as a spare strand of waste yarn tied into a circle can serve as a stitch marker. However, if you prefer something a bit sturdier, I like the Cocoknits set of small stitch markers. They are the perfect size for sock needles, and they come in an array of bright colors so you can easily separate the beginning of a round from decreases or increases. I also frequently use simple bulb markers that can clasp on and off my knitting.

Small Embroidery Snips are my scissor preference. I keep two pair in my knitting cart because I have two children, both of whom are notorious and unrepentant thieves. If I happen to read online that a famous, priceless painting has gone missing, a small part of me wonders if they could have flown to Luxembourg or wherever and pulled off the crime caper of the year, all without my knowing.

Small Crochet Hook: This comes in handy for picking up dropped stitches (I use a size US C-2 [2.75 mm] one).

Cable Needle Supplies: A toothpick, spare US size 1 (2.25 mm) double-pointed needle, or cable needle is great for when you knit cables on your socks.

A project bag comes in handy to keep safe your half-knit socks, stitch markers, toothpicks, candy stash, scissors, measuring tape (both the cute one that doesn't work that well and the ugly plastic one you got from your insurance agent that works like a dream), antacid tablets, nicotine gum (good for you for quitting smoking!), loose change, etc.

Bear in mind that none of these notions and accessories are really necessary. A hank of yarn and some needles are all you need to knit up a pair of beautiful socks that you will love and wear and treasure until the end of your days. I list them all here because some people (myself included) love to throw themselves wholeheartedly into new obsessions, and much like shopping for school supplies every fall (oh, the SMELL of fresh crayons!), gathering up all the supplies is half the fun.

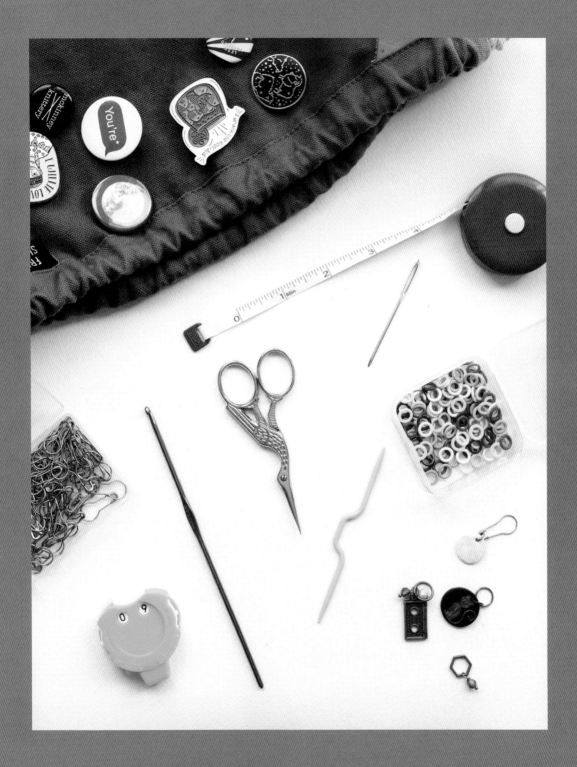

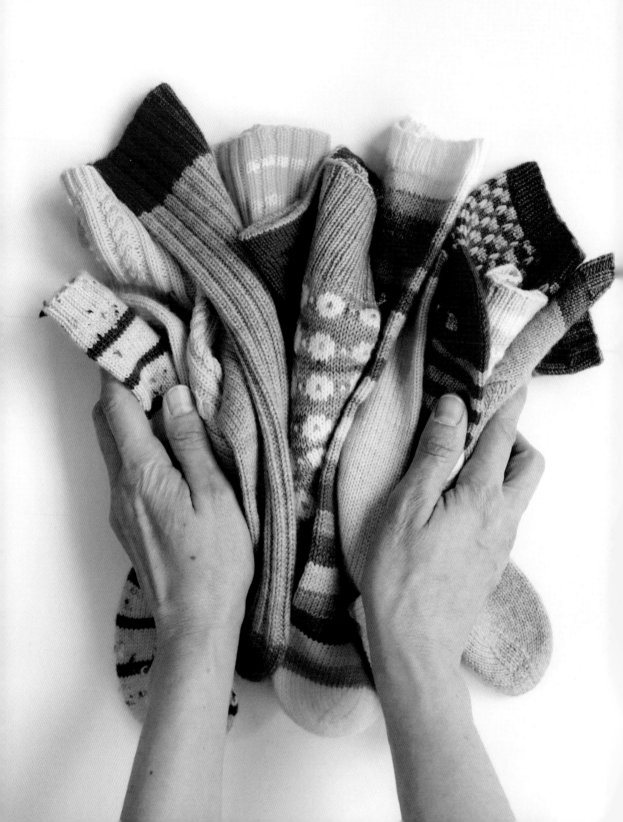

# Chapter 2
# SIZING & FIT

The first sock I ever knit was completely unwearable. I didn't knit the foot long enough, so the heel ended up in the middle of my arch. It was a lumpy, ugly little affront to the very idea of knitting, and I quickly buried it in the bottom of the trash can. I couldn't even bear to salvage the yarn—I just wanted the stupid thing out of my sight. So many evenings wasted on that woolly abomination now squished beneath banana peels and coffee grounds.

But a funny thing happened when (after several weeks) I picked up my little needles and a new ball of sock yarn and began slowly, carefully knitting another sock. As the first attempt had been too tight in the leg, in addition to being too short in the foot, I cast on more stitches. I also googled "Why is my stupid sock too tight across the top of my foot?" and learned I likely have a high arch and needed to knit a longer heel flap.

And I stumbled across a wonderful resource from the Craft Yarn Council that beautifully laid out foot lengths and their complementary shoe sizes. I also overcame my fear of shoving my big foot into the sock while it was still on the needles and discovered the thrill of just knitting the foot until it reached the tip of my pinky toe.

This was knitting in its purest form! Taking lessons learned from a previous attempt, gathering the

requisite courage, and trying again. And again and again. It took several basic socks coming off my needles before I really understood the construction, and how to knit them to best fit my own unique foot.

What does all this mean for you? Well, you may have a few ugly little socks that end up in the trash can. (Though I advise saving those charming first attempts—I'd give anything to frame my first ugly sock in a shadowbox and display it proudly on my bookshelf.) The only way to figure out what fit issues you have is to knit a basic sock so you can see what's what.

Most sock patterns are written in three or four sizes based on the circumference of the ball of your foot. Your first order of business is to wrap a tape measure around your foot, just below your toes, to see where you land.

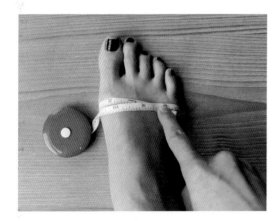

Use the table below to determine what size you are, based on the measurement you get.

| S | 7" (18 cm) |
|---|---|
| M | 8" (20 cm) |
| L | 9" (23 cm) |
| XL | 10" (25 cm) |

No doubt more than a few of you landed somewhere between whole numbers. I've gotten many emails over the years along the lines of, "I measured 7½" (19 cm). NOW what am I supposed to do??"

This is where the trial-and-error part of sock knitting comes into play. You won't truly know what your perfect size is until you knit a sock and can examine it for clues. Your own personal gauge plays a big part in the final fit of your sock. Gauge refers to how tightly or loosely you knit (how big or small your stitches are). As I am a chronically anxious person whose outlook on life could best be described as "we're all doomed," my gauge is TIGHT, and my stitches are so tiny they're practically invisible without a microscope. But maybe you're an optimist with a box full of special brownies and a Grateful Dead bumper sticker on your Subaru Outback. Your gauge is loose, like your limbs, and your stitches as big as your life-loving heart. The only way to know is to knit up a swatch and see what happens. I like to knit the cuff, and then about 3 inches of the leg. I put the stitches on waste yarn, block my little swatch, and then whip out my tape measure again to count how many stitches I get in a horizontal row of knitting.

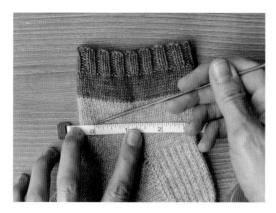

If you get somewhere between nine and ten stitches in a horizontal inch of knitting, congratulations! You are mired in existential dread, like me, and your knitting is tight; if the circumference of the ball of your foot measures between sizes, go with the larger.

If you fall between seven and eight stitches, you're loose, man—ready to have good times while you knit to Bob Seger and sip on some box wine. If you measure between sizes, choose the smaller.

You might be wondering how measuring your foot can possibly determine how well a sock will fit around your calf. Truthfully, it doesn't provide an accurate fit for everyone. Some people have narrow feet and thick calves. Others have wide feet and skinny legs. We're all built differently, with bodies that don't always conform to "standard measurements."

In my opinion, the foot measurement is a good jumping-off point: Once you've knit a sock and put it on, you can clearly see what's working and what isn't. Is it baggy on your calf, but fitted on your foot? Is it too tight all over, or just too tight on the leg? Does the calf fit like a dream, but the foot is loose (what I like to refer to as the Kevin Bacon conundrum)?

All of these problems can be fixed by adjusting our stitch count. For example, let's say you knit the size medium and the foot fits fine, but the calf is too tight. On the next sock, knit the leg in a size large and the foot in a size medium. On a standard heel flap and gusset sock (you'll get the recipe for that in the next chapter), you would simply decrease down to the stitch count for a size medium as you work the gusset.

This book is all about giving you different recipes for fun, basic socks, plus providing patterns that use a wide variety of techniques so you can improve your skills and fill your sock drawer. For a really deep dive into fit that involves detailed math equations and charts, I highly recommend the book *Custom Socks: Knit to Fit Your Feet* by Kate Atherley. It's pure gold in terms of learning how to customize every part of your sock to your unique body.

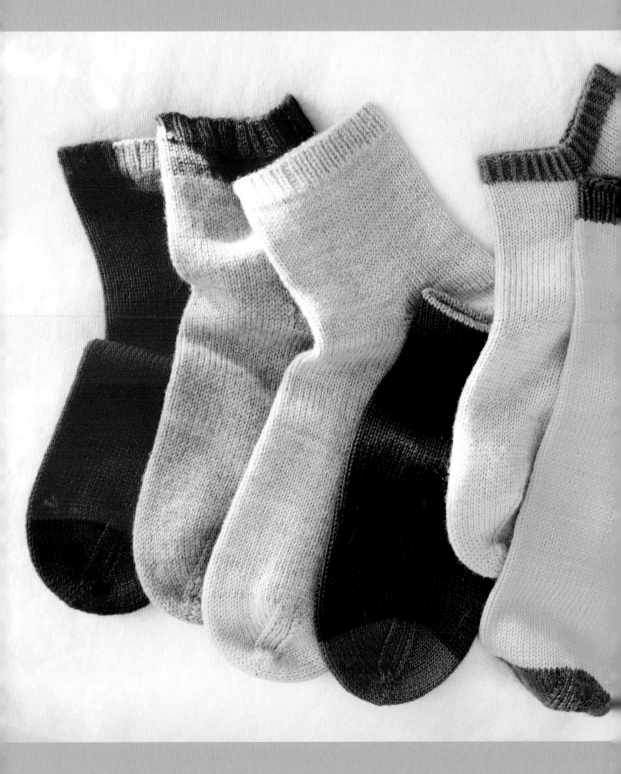

# BASICS

## Chapter 3

# THE BASIC SOCK

**A**s much as I love faffing around with lace and cables, and experimenting with different colorwork charts, there is something so pure and delightful about knitting a basic, vanilla sock. No frills, no frippery, just miles of smooth Stockinette, each naked stitch a blank canvas for showcasing a special colorway of yarn.

The first basic sock I learned to knit was a standard cuff-down with a heel flap and gusset and 2×2 ribbed cuff. (This would be the very sock that ended up in my trash.) I thought this was the only way to knit a sock, and I faithfully knit about a dozen before I learned that basic socks come in a variety of heel styles and cuff options, and that they can even be knit from the toe up, of all things!

In this chapter, I'll give you recipes for five different basic socks so you can experiment and find the recipe that fits well and is enjoyable to knit. If you are new to sock knitting, consider this a choose-your-own-adventure foray into this gloriously addictive craft. I'll give you different cuff and heel options that you can mix and match until you

happen upon the one you like best. (My personal favorite? A 2×1 ribbed cuff with a heel flap and gusset.)

If you're experienced, but limited to just one or two heels and cuffs, consider this your opportunity to try something new! Given that I've been ordering the same thing at Olive Garden for the past twenty-two years (fettucine alfredo—I'm basic, okay?), it's laughable that I'd advise you to branch out when I live in fear of Trying New Things. But I've learned that in sock knitting, you are almost always rewarded for taking that leap!

We all have our personal knitting preferences (magic loop or DIE), but ultimately, I want you to find the methods and recipes that make sock knitting a pure joy for YOU!

# Basic Sock No. 1:
# The Heel Flap and Gusset

I love this particular heel so much that I'm giving you two different options for this beloved little sock. Option A (the red sock with a cinnamon toe in the picture) is my absolute favorite basic sock to knit: the heel flap and gusset with a 2×1 ribbed cuff. The second option (the pink and orange) is a heel flap and gusset with a 2×2 ribbed color-block cuff.

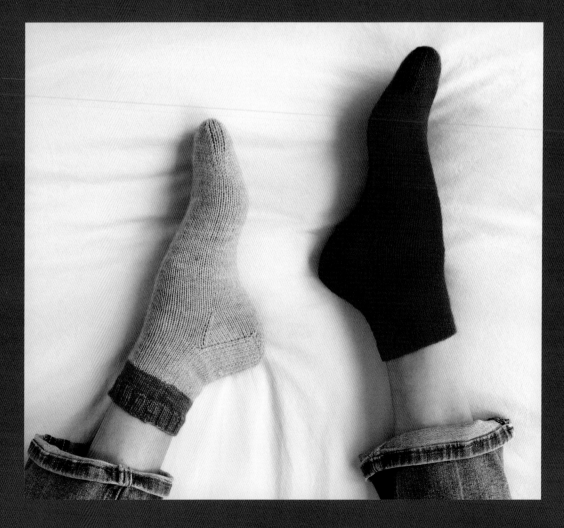

## MATERIALS

**Yarn (Option A):** Knit Picks Stroll [75% fine superwash merino/25% nylon; 231 yards (211 m)/1¾ ounces (50 g)]: 99 (123) 149 (176, 194, 224) yards [91 (112) 136 (161, 177, 205) m] in Buoy (MC)

Filcolana Arwetta [80% superwash merino/20% nylon; 230 yards (210 m)/1¾ ounces (50 g)]: 10 (12,) 14 (16, 18, 20) yards [9 (11) 13 (15, 16, 18) m] in 352 Red Squirrel (CC)

**Yarn (Option B):** Knit Picks Stroll [75% fine superwash merino/25% nylon; 231 yards (211 m)/1¾ ounces (50 g)]: 91 (117) 136 (168, 199, 235) yards [83 (107) 124 (154, 182, 215) m] in Dogwood Heather (MC)

The orange for the color-block cuff (CC) is a leftover ball from deep in my stash with no label. Who knows what it is or where it came from! But Lang Jawoll in 275–Yam is a very close approximation. [75% superwash wool/25% nylon; 230 yards (210 m)/1¾ ounces (50 g)]: 12 (16) 20 (24, 28, 32) yards [11 (15) 18 (22, 26, 29) m]

*Note: You can use any fingering weight sock yarn!*

**Needles:** US size 1 (2.25 mm)

**Notions:** Tapestry needle, stitch markers, snips, measuring tape

**Gauge:** 38 sts = 4" (10 cm), knit in Stockinette in the rnd and blocked

**Sizes**
Toddler (Kid) S (M, L, XL)

**Measurements**
The numbers below refer to the circumference of the ball of the foot, not the measurements of the finished sock.

3–4 (5–6) 7 (8, 9, 10)" [8–10 (13–15) 18 (20, 23, 25) cm]

## INSTRUCTIONS

### Cuff Option A: 2×1 Ribbing
*Note: While most sock patterns have you casting on an even number of sts, to work 2×1 ribbing, we cast on a number that is divisible by 3.*

With MC, CO **39 (48) 57 (63, 72, 81)** sts and join for working in the rnd, being careful not to twist your sts. Est 2×1 ribbing: [k2, p1] to end.

Cont working the ribbing until your Cuff measures ¾" (2 cm), or your desired length. On the last rnd of the ribbing, we need to get our stitch count back to an even number! If you are working the Kid or L sizes, you already have an even number and can move on to the Leg instructions. The rest of you, make the following increase or decrease according to your size:

**Toddler:** Work in rib pattern to the last 3 sts, kfb, k1, p1. **40 sts.**

**M:** Work in rib pattern to the last 3 sts, kfb, k1, p1. **64 sts.**

**S:** Work in rib pattern to the last 3 sts, k2tog, p1. **56 sts.**

**XL:** Work in rib pattern to the last 3 sts, k2tog, p1. **80 sts.**

## Cuff Option B:
## 2×2 Color-Block Ribbing

With CC, CO **40 (48) 56 (64, 72, 80)** sts and join for working in the rnd, being careful not to twist your sts. Est 2×2 ribbing: [k2, p2] to end.

Cont working the ribbing until your Cuff measures ¾" (2 cm), or your desired length.

## Leg

You've finished your Cuff and now it's time to set the cruise control and zone out with some soothing Stockinette knitting! Simply knit every st, round after round, until the Leg of your sock (including the Cuff!) reaches your desired length. If you are knitting Option B, knit 9 rnds in CC, then break the yarn. Join in MC and use that yarn for the rest of your sock!

Not sure how long to knit the Leg? I knit both Option A and B on the shorter side (3" [8 cm]). But if you would like to knit yours longer or shorter, use the table below to determine a good measurement for various sizes.

**Shorty Socks:** Typically 1–2" (2.5–5 cm)
**Toddler Socks:** 3–4" (8–10 cm)
**Kid Socks:** 4–6" (10–15 cm)
**Adult Mid-calf:** 4–6" (10–15 cm)
**Adult Tall:** 7" (18 cm and up)

Once you are satisfied with the length of your Leg, it's time to move on to the Heel. If you are new to sock knitting, chin up! I promise it's not as hard as it looks!

## The Heel Flap

I adore this heel, for a number of reasons. Notably it was the first heel I tried, and as I've already illustrated with my sad Olive Garden ordering history, I'm a creature of habit. But it's also my favorite because it fits so well and can be easily customized to a variety of different foot shapes. Got a shallow instep? Knit the heel flap a little shorter. High instep? Knit it longer. This marvel of knitting engineering truly deserves its reputation as the Old Faithful of sock knitting—it shows up every time, ready to wow you with its incomparable fit and function.

Created using simple slip stitches, this heel is also durable—a must when thinking about the utility of our hand-knit socks! And while it looks complicated to knit, when broken down into parts, it's actually quite easy to get the hang of.

You will be working back and forth across the last half of your sts. The first half of your sts will be hanging out on your needles. If you are using tiny circulars, you'll need to bring in two double-pointed needles to work your Heel Flap. The first half of your sts can stay on your circulars, however.

Knit across the first **20 (24) 28 (32, 36, 40)** sts, then begin working your Heel Flap back and forth across the remaining **20 (24) 28 (32, 36, 40)** sts as follows:

**Row 1 (RS):** K2, [slip 1, k1] to end. Turn work.
**Row 2 (WS):** Slip 1 wyif, p to end. Turn work.
**Row 3:** [Slip 1, k1] to end. Turn work.

Repeat rows 2 and 3 until Heel Flap measures **1½ (1¾,) 2 (2, 2¼ , 2½)" [4 (4.5) 5 (5, 6, 6.5) cm]**. End *after* you have worked row 3.

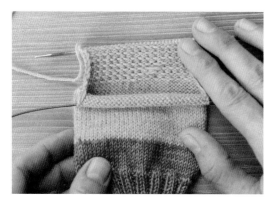

This is what your Heel Flap will look like as you work it. Notice how the first half of my sts are just resting on my needles while I work the Heel Flap back and forth on the last half of my sts.

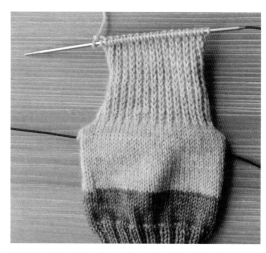

A finished Heel Flap from the right side of the fabric.

*Note: Do you remember earlier when I talked about how heel flaps can be customized to provide a better fit for your socks? The most common complaint I hear about hand-knit socks is that they are too tight across the top of the foot at the ankle. The solution to fix this is wonderfully straightforward! Simply work a few extra rows on your Heel Flap (still making sure to end after having worked row 3 of the instructions!). This will give you more stitches to pick up when you work the Gusset, thus giving you more fabric across the top of your foot.*

*If you know you have a high instep and would like to preemptively make your Heel Flap a bit longer, go for it! If you are unsure, however, stick to the measurements I gave you, and once you've finished your sock, try it on and see how it feels. If it's too tight across the top of your foot near the ankle, you'll know for the next sock to knit that Heel Flap a little longer.*

*Similarly, if you have a shallow instep, you can shorten your Heel Flap a bit so you don't have too much fabric around your ankle. Start by knitting it two rows shorter. You can always decrease more on the next sock if that still doesn't fit perfectly!*

## The Heel Turn

Now it's time to create a 3D shape with our knitting. Be prepared to marvel as a curvy little heel appears magically before your eyes! Heels are created by working simple short rows. You should be looking at the wrong side of your work. (You'll see purl bumps.)

**Row 1 (WS):** Slip 1 wyif, p**10 (12) 14 (16, 18, 20)**, p2tog, p1, turn.
**Row 2 (RS):** Slip 1, k3, ssk, k1, turn.
**Row 3:** Slip 1 wyif, p4, p2tog, p1, turn.
**Row 4:** Slip 1, k5, ssk, k1, turn.

You have now established the following pattern for your Heel Turn: slip 1, knit or purl to 1 st *before* the gap created by turning on the previous row, ssk or p2tog, k1 or p1, turn. Cont in this pattern until all your Heel sts have been worked, ending on a RS row. You should now have **12 (14) 16 (18, 20, 22)** Heel sts.

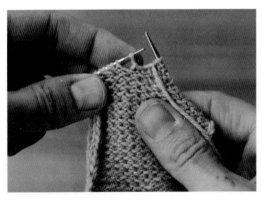

See that gap between the first and second stitches on my left needle? That is your visual clue to purl those two stitches together, thus closing that gap!

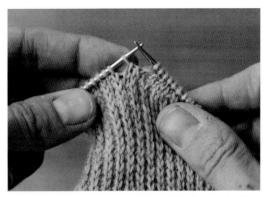

Here's the gap from the right side of the fabric. You'll work a SSK to close it.

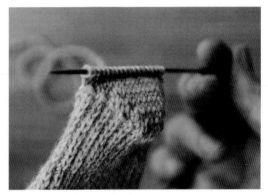

A finished, 3D Heel, created from simple short rows!

Once you finish the Heel Turn, you should have the world's most adorable heel popping out. Turning a Heel always feels like magic to me. Flat fabric becomes a knitted bowl to cradle our heels! So take a moment to admire your work, then let's move on to shaping the Gusset.

## Gusset

A gusset is simply a section of extra fabric on either side of your ankle designed to give your foot the room it needs in that area of your sock.

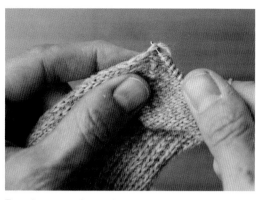

To pick up a stitch, simply insert your right needle under the V of the stitch you want to pick up.

See that line of diagonal stitches next to your Heel? That triangle of fabric between the stitch line and the Heel is your Gusset.

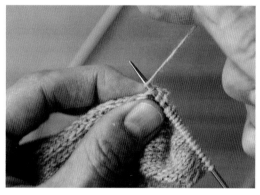

Wrap your yarn around the needle as if to knit, then use your needle to pull that yarn under and out of that V.

You'll be picking up sts on both sides of your newly fashioned Heel Flap, and then doing simple decreases of those sts to create neat little triangles at your ankles. When you worked the Heel Flap, you slipped the first st of each row. This gives you a nice big st on both sides, making it easy to pick up each st!

With the *right side of your work facing*, pick up and knit **8 (10) 12 (14, 16, 18)** sts along the left side of your Heel Flap.

Next, knit across the **20 (24) 28 (32, 36, 40)** sts that we've left undisturbed on our needles while working our Heel Flap. Pm, and pick up **8 (10) 12 (14, 16, 18)** sts on the right side of your Heel Flap. K across the Heel sts, then k down the first set of new sts you picked up on the left side. You've reached the end of the rnd, and all your sts have now been picked up. You should now have **48 (58) 68 (78, 88, 98)** sts total on your needles. You will be working in the round again, and will start shaping your Gusset next.

## Gusset Decreases

Remember all those stitches you just picked up on both sides of your Heel Flap? Well, it's time to get rid of most of them, lolz.

**Rnd 1:** K20 **(24) 28 (32, 36, 40)** sts, sl marker, k1, ssk, k around to 3 sts before the end of rnd, k2tog, k1.

**Rnd 2:** Work even with no decreases.

Repeat these two rnds until you have **40 (48) 56 (64, 72, 80)** sts on your needles.

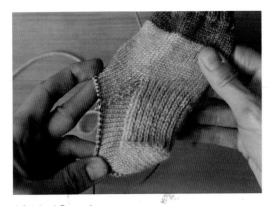

A finished Gusset!

And that's all there is to it! You've worked a Heel Flap and Gusset and you survived (hopefully). Proceed to the Foot knowing you have conquered the Everest of sock knitting, and no other knitting skill will ever confuse, elude, or break you again.

## Knitting the Foot

Friends, it's calm waters and easy sailing from here on out. Knitting the Foot is relatively straightforward: You just knit Stockinette in the round until your work reaches the tip of your pinky toe.

If you can't easily try your socks on as you knit (working on double-pointed needles or tiny circulars can make this challenging), or you are knitting gift socks for some lucky recipient, the Craft Yarn Council has issued the following length guidelines for the Foot of a sock, measured from the back of the Heel to the end of the Toe.

(All sizes are US.)
**Toddler:** 4½–6" (11–15 cm)
**Kid:** 6–7½" (15–19 cm)
**Women's shoe sizes 4–6.5:** 8–9" (20.5–23 cm)
**Women's shoe sizes 7–9.5:** 9¼–10" (23–25.5 cm)
**Women's shoe sizes 10–12.5:** 10¼–11" (26–28 cm)
**Men's shoe sizes 6–8.5:** 9¼–10" (23.5–25.5 cm)
**Men's shoe sizes 9–11.5:** 10¼–11" (26–28 cm)
**Men's shoe sizes 12–14:** 11¼–12" (28.5–30.5 cm)

When working a Heel Flap and Gusset, you also need to take into account your Toe length:

| | |
|---|---|
| **Toddler:** 1" (2.5 cm) | **M:** 1½" (4 cm) |
| **Kid:** 1¼" (3 cm) | **L:** 1½" (4 cm) |
| **S:** 1½" (4 cm) | **XL:** 1¾" (4.5 cm) |

Now, take your desired Foot length, from back of Heel to end of Toe, and subtract your Toe measurements. For example, my desired Foot length is 9" (23 cm). I subtract my Toe length (1½" [4 cm]), and that leaves me with 7½" (19 cm) I need to knit before starting my Toe decreases. Measure starting at the back of the Heel.

Once your Foot reaches the desired length, only an easy little Toe stands between you and finished sock glory. (Cue rousing Bruce Springsteen music, or perhaps some early Courtney Love.)

## Knitting the Toe

After everything you've been through, the Toe is relatively painless to knit. Just some simple decreases every other rnd, and then we close the whole thing up with a modified Kitchener Stitch.

If you are going to knit the Toe in a different color (as I did for Option A), cut your main yarn, join in your new yarn, and knit 1 rnd even. Otherwise, simply cont to the instructions below.

**Rnd 1:** K1, ssk, k**14 (18) 22 (26, 30, 34)** sts, k2tog, k1, pm, k1, ssk, k**14 (18) 22 (26, 30, 34)** sts, k2tog, k1.
**Rnd 2:** Knit.
**Rnd 3:** K1, ssk, knit to 3 sts before next marker, k2tog, k1, sl m, k1, ssk, knit around to 3 sts before end of rnd, k2tog, k1.

Repeat rnds 2 and 3 until **16 (20) 24 (28, 32, 36)** sts remain.

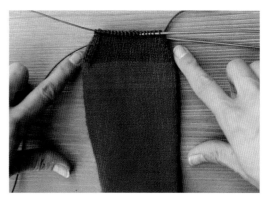

As you work the decreases on your Toe, you'll see a wedge shape starting to form.

Now we're going to use a brilliant technique called "Kitchener Stitch" to graft that Toe closed! Kitchener Stitch normally involves a few setup steps, but we're going to skip those on our socks to avoid having points on either end of our Toe.

First, evenly divide your sts on two needles. (If you are doing magic loop, you're already there!) Scooch your sts up so the first st on both needles is right at the very tip.

Cut your yarn, leaving a fairly long tail (at least 12" [30 cm], though I often do more because I'm anxious and paranoid). Thread your yarn tail through a tapestry needle.

Hold your work so that the needles are parallel to each other and squished together, with one needle in front, and the other in back.

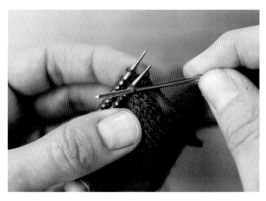

Next, insert the tapestry needle *purlwise* into the next st on the front needle. Bring the yarn through, but *leave that st on the needle.*

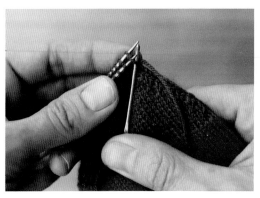

Insert your tapestry needle *knitwise* into the first st on the *front* needle. Lift that st off the needle and pull the yarn through.

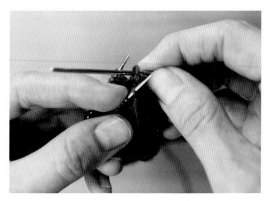

Next, insert your tapestry needle *purlwise* into the first st on the *back* needle. Pull the yarn through and lift that st off the needle.

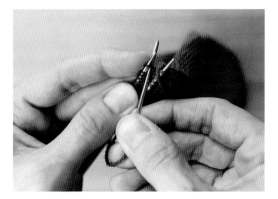

Finally, insert your tapestry needle *knitwise* into the next st on the *back* needle. Pull the yarn through, but *leave that st on the needle.*

And that's it! You'll keep repeating those four steps until only two sts remain on each needle. Just remember:

The front needle is *knitwise off, purlwise on.* The back needle is *purlwise off, knitwise on.*

Once you've reached the end and you have two sts left on each needle, do the following:

Insert your needle *knitwise* into the first st on the front needle, pull the yarn through, and lift that st off the needle. Insert your needle *purlwise* through the last st on the front needle, pull the yarn through, and lift that st off the needle as well. No more sts on the front needle!

Insert your needle *purlwise* through the first st on the back needle, pull the yarn through, and lift that st off the needle. Insert your needle *knitwise* into the last st on the back needle, pull the yarn through, and lift that last st off the needle.

Poke your tapestry needle into the side of your sock, close to that last st you just pulled off the needle, and thread the yarn through to the wrong side of the sock.

YOU ARE (almost) DONE! YOU KNIT A SOCK! Now you just need to weave in your ends and block it. (See chapter 4 for all the info you need on weaving in ends and blocking socks.)

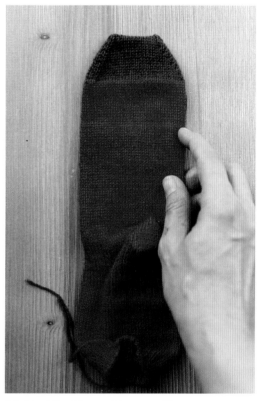

A finished Heel Flap and Gusset sock!

# Basic Sock No. 2:
# The Afterthought Heel

This is my second-favorite heel. (Notice how I'm subtly trying to persuade you to knit all *my* personal preferences by giving them top billing in this book? I'm biased, what can I say?) I love this heel because it's so quick and easy to knit, it looks adorable, and it makes colorwork socks a breeze! Like the heel flap, it can be customized to give you more or less room in the ankle area. In terms of durability, you don't have all that extra fabric created by the slip stitches like with the heel flap, but it's super easy to pop an afterthought heel out and knit in a new one if it gets absolutely shredded with use and a lazy approach to mending. (Hi, it's me! I'm the lazy mender!)

## MATERIALS

**Yarn:** Filcolana Arwetta [80% superwash merino/20% nylon; 230 yards (210 m)/1¾ ounces (50 g)]: 86 (112) 133 (160, 188, 216) yards [79 (102) 122 (146, 172, 198) m] in 978 Oatmeal (MC)

Hedgehog Fibres Sock [90% superwash merino/10% nylon; 437 yards (400 m)/3½ ounces (100 g)]: 20 (24) 28 (32, 36, 40) yards [18 (22) 26 (29, 33, 37) m] in UFO (CC)

*Note: You can use any fingering weight sock yarn!*

**Needles:** US size 1 (2.25 mm)

**Notions:** Tapestry needle, stitch markers (including a clasp marker), snips, measuring tape

**Gauge:** 38 sts = 4" (10 cm), knit in Stockinette in the rnd and blocked

**Sizes**
Toddler (Kid) S (M, L, XL)

**Measurements**
The numbers below refer to the circumference of the ball of the foot, not the measurements of the finished sock.

3–4 (5–6) 7 (8, 9, 10)" [8–10 (13–15) 18 (20, 23, 25) cm]

## INSTRUCTIONS

### Cuff

With MC, CO **40 (48) 56 (64, 72, 80)** sts and join for working in the rnd, being careful not to twist your sts. Est 1×1 ribbing: [k1, p1] to end.

Cont working the ribbing until your Cuff measures ½" (2 cm), or your desired length.

### Leg

Work Stockinette in the round (simply knit every st) until your Leg, including the Cuff, reaches the desired length. Not sure how long to knit the Leg? Use the table below to determine a good measurement for various sizes. I knit my sample Leg 4" (10 cm).

**Shorty Socks:** Typically 1–2" (2.5–5 cm)
**Toddler Socks:** 3–4" (8–10 cm)
**Kid Socks:** 4–6" (10–15 cm)
**Adult Mid-calf:** 4–6" (10–15 cm)
**Adult Tall:** 7" (18 cm and up)

### Placing the Marker for the Afterthought Heel

Once you've decided your Leg is long enough, on the next rnd, simply knit **30 (36) 42 (48, 54, 60)** sts, and clip a clasp marker onto that last st you just knit. Then just keep knitting! You've placed a marker in the center of the last half of your sts, which is where your Afterthought Heel will eventually go. Now move on to the Foot and come back once you've finished the Toe. You've got to admit, it's pretty fun clamping that little marker on and then forgetting about the Heel for a while as you continue to bliss out on easy Stockinette knitting while binging the seminal nineties TV show *Buffy the Vampire Slayer*.

## Knitting the Foot

Cont knitting Stockinette in the round until your Foot reaches the desired length. The Craft Yarn Council has issued the following length guidelines for the Foot of a sock, measured from the back of the Heel to the end of the Toe.

(All sizes are US.)
**Toddler:** 4½–6" (11–15 cm)
**Kid:** 6–7½" (15–19 cm)
**Women's shoe sizes 4–6.5:** 8–9" (20.5–23 cm)
**Women's shoe sizes 7–9.5:** 9¼–10" (23–25.5 cm)
**Women's shoe sizes 10–12.5:** 10¼–11" (26–28 cm)
**Men's shoe sizes 6–8.5:** 9¼–10" (23.5–25.5 cm)
**Men's shoe sizes 9–11.5:** 10¼–11" (26–28 cm)
**Men's shoe sizes 12–14:** 11¼–12" (28.5–30.5 cm)

When working an Afterthought Heel, you need to take into account both your Heel length and your Toe length (they will be the same).

| | |
|---|---|
| **Toddler:** 1" (2.5 cm) | **M:** 1½" (4 cm) |
| **Kid:** 1¼" (3 cm) | **L:** 1½" (4 cm) |
| **S:** 1½" (4 cm) | **XL:** 1¾" (4 cm) |

Now, take your desired Foot length, from back of Heel to end of Toe, and subtract both your Heel and Toe measurements. For example, my desired Foot length is 9" (23 cm). I subtract my Toe length (1½" [4 cm]) and my Heel length (1½" [4 cm]), and that leaves me with 6" (15 cm) I need to knit before starting my Toe decreases.

### Toe

Cut MC yarn and join in CC. Knit 1 rnd even in Stockinette before beginning the following decrease pattern to shape your Toe:

**Rnd 1:** K1, ssk, k**14 (18) 22 (26, 30, 34)** sts, k2tog, k1, pm, k1, ssk, k**14 (18) 22 (26, 30, 34)** sts, k2tog, k1.
**Rnd 2:** Knit.
**Rnd 3:** K1, ssk, k to 3 sts before next marker, k2tog, k1, sl m, k1, ssk, k around to 3 sts before end of rnd, k2tog, k1.

Repeat rnds 2 and 3 until **16 (20) 24 (28, 32, 36)** sts remain.

Use Kitchener Stitch to close up your Toe (see page 33).

### Knitting the Afterthought Heel

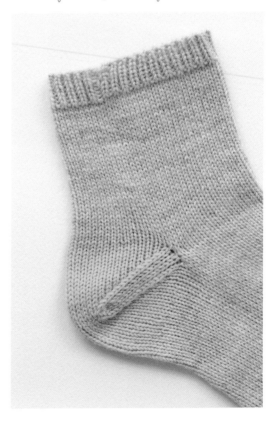

Toe done? Put Buffy on pause and let's knit the Afterthought Heel. Since you just finished knitting your cute little Toe, you'll find this Heel exceptionally easy because you'll be doing the EXACT SAME THING you just did! First, we need to get live stitches on our needles.

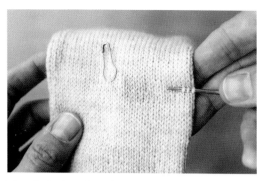

Identify the line of sts directly below the st you've marked. Select the first st at the edge of your tube on that line of sts and, with US size 1 (2.25 mm) needles, insert the tip of your needle into the right leg of that first st. Next insert the needle into the right leg of the second st, and then into the right leg of the third st.

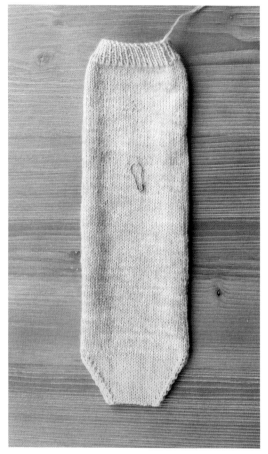

You should have a long tube with a Cuff at one end and a Toe at the other end. Go to the point in your tube where you placed your marker. Make sure your tube is pressed flat. You should have half your sts facing up at you, and the other half facing down. Your Toe should look like a wedge, with the decrease lines on the sides of the wedge.

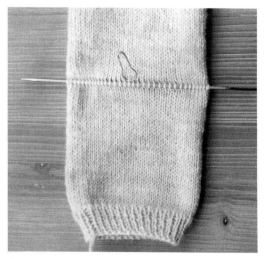

Cont inserting your needle into the right leg of every st until you have picked up **20 (24) 28 (32, 36, 40)** sts.

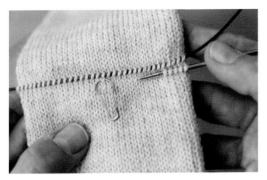

Now, repeat the same process for the line of sts on the other side of your marked st.

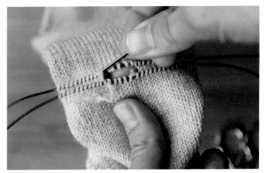

Using your tapestry needle, tease out the yarn you've snipped from the sts. Start in the middle where you snipped and go to the end. Then go back to the middle and tease out the sts to the other end.

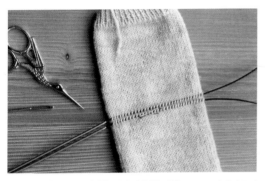

You should have **40 (48) 56 (64, 72, 80)** sts total divided evenly on your needles. If you are working magic loop, slide all your sts down to the cables.

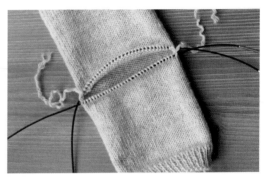

You now have a gaping hole in your sock tube, and live sts on your needles, ready to knit your Heel! You also have a strand of yarn dangling on each side of the hole you've made. Those will come in handy later when you weave in your ends—I use them to close any gaps I get at the corner of the Heel.

You will work your Afterthought Heel the same as you did your Toe. Join in your yarn and knit 3 rnds even. Then begin the following decrease pattern:

**Rnd 1:** K1, ssk, k**14 (18) 22 (26, 30, 34)** sts, k2tog, k1, pm, k1, ssk, k**14 (18) 22 (26, 30, 34)** sts, k2tog, k1.
**Rnd 2:** Knit.
**Rnd 3:** K1, ssk, knit to 3 sts before next marker, k2tog, k1, sl m, k1, ssk, knit around to 3 sts before end of rnd, k2tog, k1.

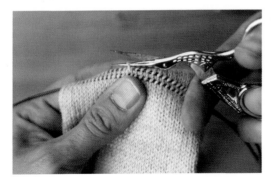

Now for the fun (but also kinda scary!) part. Remove the marker and tease that st up with your tapestry needle. Now hold your breath and snip that st with your scissors, being very careful not to snip anything else.

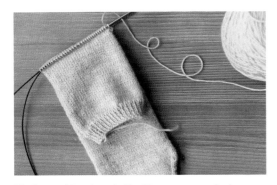

Work your Afterthought Heel just as you worked your Toe, creating a wedge shape.

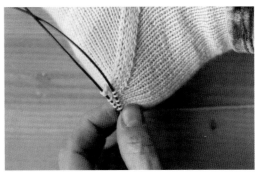

If you can easily pinch the fabric closed, your Heel is done!

Repeat rnds 2 and 3 until **16 (20) 24 (28, 32, 36)** sts remain. Use Kitchener Stitch to close that Heel up (see page 33).

*Note: You can adjust the depth and fit of your Heel by working more or fewer decrease rnds. Try the sock on occasionally as you work your decreases to see how it's fitting. Stop your decreases when you can easily pinch the fabric closed. If you have to pull the fabric to get it to close over your heel, then you need to work more decrease rnds to give your Heel more depth so it doesn't feel tight across the top of your foot. On your next sock, work more knit rnds before beginning your decreases.*

You've now completed your sock and can move on to chapter 4, which tells you all about how to finish a sock. (Imagine me handing you a Major Award for this awesome accomplishment! YOU KNIT A SOCK!)

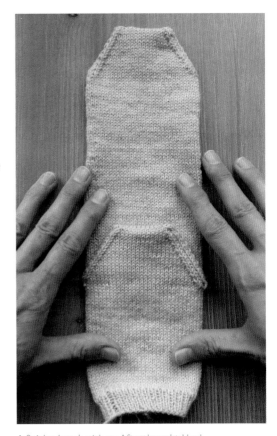

A finished sock with an Afterthought Heel.

# Basic Sock No. 3:
# The Forethought Heel

You might see this heel called a "peasant heel" in some patterns (including a few of my own). It's identical to an Afterthought Heel in terms of how you knit it, but instead of snipping yarn (which honestly is a tough thing to survive—I'll never get used to CUTTING MY ACTUAL KNITTING), you'll be knitting in a line of waste yarn where your heel will go.

I'll also introduce a new kind of cuff for you! Not feeling the look of ribbing, or maybe you just hate knitting it? Luckily there are many other options, from mock cables, to folded cuffs, to just plain Stockinette. I'll show you how to do a folded cuff below.

## MATERIALS

**Yarn:** Filcolana Arwetta [80% superwash merino/20% nylon; 230 yards (210 m)/1¾ ounces (50 g)]: 47 (63) 86 (104, 128, 147) yards [43 (58) 79 (95, 117, 134) m] in 202 Teal (MC)

Knit Picks Stroll [75% fine superwash merino/25% nylon; 231 yards (211 m)/1¾ ounces (50 g)]: 20 (24) 28 (32, 36, 40) yards [18 (22) 26 (29, 33, 37) m] in Pucker (CC1)

Knit Picks Stroll [75% fine superwash merino/25% nylon; 231 yards (211 m)/1¾ ounces (50 g)]: 4 (5) 6 (7, 8, 9) yards [4 (5) 5 (6, 7, 8) m] in Dogwood Heather (CC2)

*Note: You can use any fingering weight sock yarn!*

**Needles:** US size 1 (2.25 mm)

**Notions:** Tapestry needle, stitch markers, snips, measuring tape

**Gauge:** 38 sts = 4" (10 cm), knit in Stockinette stitch in the rnd and blocked

### Sizes
Toddler (Kid) S (M, L, XL)

### Measurements
The numbers below refer to the circumference of the ball of the foot, not the measurements of the finished sock.

3–4 (5–6) 7 (8, 9, 10)" [8–10 (13–15) 18 (20, 23, 25) cm]

## INSTRUCTIONS

### Folded Cuff

The first part is simple. You just cast on and knit in plain Stockinette. When I do a folded cuff, I like a little surprise peek of a different color on the inside.

With CC2, CO **40 (48) 56 (64, 72, 80)** sts and join for working in the rnd, being careful not to twist your sts. Knit 9 rnds in Stockinette (knit every st). Break CC2 and join in MC. Knit 9 more rnds in Stockinette.

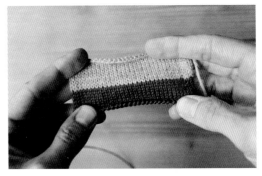

The surprise color (the light pink) will be folded to the inside of the Cuff.

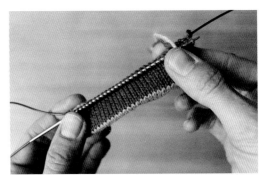

Next, it's time to fold that Cuff and knit it together. Fold so that the surprise color is on the inside of your sock, and the main color is on the outside. The wrong sides of the fabric should be together. Hold your Cuff so that the cast on edge lines up with the live sts on your needles.

Now get ready to knit! To create the Folded Cuff, you will be knitting the cast on stitches together with your live stitches.

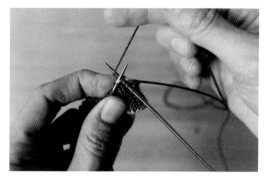

Simply insert your right needle into the first st of the cast on edge of your Cuff and lift it on to your left needle. Then knit the first st on your needle together with that cast on edge st. Pick up the second cast on edge st and place it on your left needle. Knit that together with your second st. Cont doing this to the end of the round.

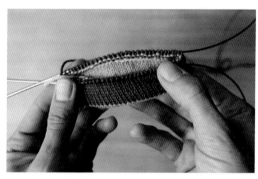

You've now knit your Cuff together, and can cont on to the Leg!

## Leg

Cont working Stockinette until your Leg reaches the desired length. I knit shorty socks for this pair and worked until my Leg, including Cuff, measured 1" (2.5 cm). If you'd like to adjust the length, use the following chart for length guidelines:

**Shorty Socks:** Typically 1–2" (2.5–5 cm)
**Toddler Socks:** 3–4" (8–10 cm)
**Kid Socks:** 4–6" (10–15 cm)
**Adult Mid-calf:** 4–6" (10–15 cm)
**Adult Tall:** 7" (18 cm and up)

## Placing the Waste Yarn for the Heel

Once you've decided your Leg is long enough, on the next round, knit across **20 (24) 28 (32, 36, 40)** sts. Next, cut the yarn you've been working with, leaving yourself a tail, then pick up some waste yarn and knit the remaining **20 (24) 28 (32, 36, 40)** sts with the waste yarn. Cut the waste yarn, join in your main yarn again, and keep knitting. Move on to the Foot section and come back when you've finished the Toe.

Women's shoe sizes 4–6.5: 8–9" (20.5–23 cm)
Women's shoe sizes 7–9.5: 9¼–10" (23–25.5 cm)
Women's shoe sizes 10–12.5: 10¼–11" (26–28 cm)
Men's shoe sizes 6–8.5: 9¼–10" (23.5–25.5 cm)
Men's shoe sizes 9–11.5: 10¼–11" (26–28 cm)
Men's shoe sizes 12–14: 11¼–12" (28.5–30.5 cm)

When working a Forethought Heel, you need to take into account both your Heel length and your Toe length (they will be the same):

| | |
|---|---|
| **Toddler:** 1" (2.5 cm) | **M:** 1½" (4 cm) |
| **Kid:** 1¼" (3 cm) | **L:** 1½" (4 cm) |
| **S:** 1½" (4 cm) | **XL:** 1¾" (4 cm) |

Now, take your desired Foot length, from back of Heel to end of Toe, and subtract both your Heel and Toe measurements. For example, my desired Foot length is 9" (23 cm). I subtract my Toe (1½" [4 cm]), and my Heel (1½" [4 cm]) and that leaves me with 6" (15 cm) I need to knit before starting my Toe decreases.

### Toe

Cut MC yarn and join in CC1. Knit 1 rnd even in Stockinette before beginning the following decrease pattern to shape your Toe:

**Rnd 1:** K1, ssk, k**14 (18) 22 (26, 30, 34)** sts, k2tog, k1, pm, k1, ssk, k**14 (18) 22 (26, 30, 34)** sts, k2tog, k1.
**Rnd 2:** Knit.
**Rnd 3:** K1, ssk, k to 3 sts before next marker, k2tog, k1, sl m, k1, ssk, knit around to 3 sts before end of rnd, k2tog, k1.

Repeat rnds 2 and 3 until **16 (20) 24 (28, 32, 36)** sts remain.

Use Kitchener Stitch to close up your Toe (see page 33).

This is what your finished sock should look like prior to knitting the Heel. Notice the line of waste yarn knit into the back half of your sock? That's where the Heel will go!

## Knitting the Foot

Cont knitting Stockinette in the rnd until your Foot reaches the desired length. The Craft Yarn Council has issued the following length guidelines for the Foot of a sock, measured from the back of the Heel to the end of the Toe.

(All sizes are US.)
**Toddler:** 4½–6" (11–15 cm)
**Kid:** 6–7½" (15–19 cm)

# Knitting the Forethought Heel

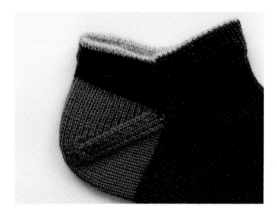

The forethought heel

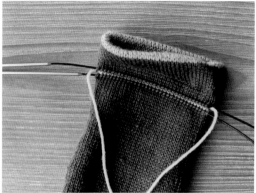

Identify the line of sts directly below the waste yarn. Select the first st at the edge of your tube on that line of sts, and with US size 1 (2.25 mm) needles, insert the tip of your needle into the right leg of that first st. Next, insert the needle into the right leg of the second st, and then into the right leg of the third st. Cont inserting your needle into the right leg of every st until you have picked up **20 (24) 28 (32, 36, 40)** sts.

Ready to knit your Heel? Excellent! First we need to get live sts back on the needles. (Sound eerily similar to the afterthought heel? I told you they are almost identical!)

You should have a long tube with a Cuff at one end and a Toe at the other end. Go to the point in your tube where you knit in that line of waste yarn. Make sure your tube is pressed flat. You should have half your sts facing up at you, and the other half facing down. Your Toe should look like a wedge, with the decrease lines on the sides of the wedge.

Now, repeat the same process for the line of sts on the other side of your waste yarn. You should have **40 (48) 56 (64, 72, 80)** sts total divided evenly on your needles. If you are working magic loop, slide all your sts down to the cables.

Tease out the waste yarn with your tapestry needle and remove it completely.

You should have a gaping hole in your sock, with all your Heel sts on your needles, ready to go!

Next, it's time to knit the Heel, which is done exactly the same as how you knit your Toe.

Join in CC1 and knit 3 rnds even. Then begin the following decrease pattern:

**Rnd 1:** K1, ssk, k**14 (18) 22 (26, 30, 34)** sts, k2tog, k1, pm, k1, ssk, k**14 (18) 22 (26, 30, 34)** sts, k2tog, k1.
**Rnd 2:** Knit.
**Rnd 3:** K1, ssk, knit to 3 sts before next marker, k2tog, k1, sl m, k1, ssk, knit around to 3 sts before end of rnd, k2tog, k1.

Repeat rnds 2 and 3 until **16 (20) 24 (28, 32, 36)** sts remain. Use Kitchener Stitch to close that heel up (see page 33)!

*Note: You can adjust the depth and fit of your Heel by working more or fewer decrease rnds. Try the sock on occasionally as you work your decreases to see how it's fitting! Stop your decreases when you can easily pinch the fabric closed. If you have to pull the fabric to get it to close over your heel, then you need to work more decrease rnds to give your Heel more depth so it doesn't feel tight across the top of your foot! On your next sock, work more knit rnds before beginning your decreases!*

You've now completed your sock and can move on to chapter 4, which tells you all about how to finish your socks. (Imagine me placing a giant wreath of flowers around your neck, like at the Kentucky Derby. YOU KNIT A SOCK!)

# Basic Sock No. 4:
# The German Short-Row Heel

This is not my favorite heel. I'm showing you how to do it in case it's the perfect heel for *you*. But me? I don't like it, and I've got no good reason! You know how there's that one person at your job that you just don't like, and you don't know why? That's the German short-row heel for me. It hasn't done anything to me, it looks perfectly pleasant, and it fits alright. But I rarely knit it; I'm only putting it in the book because my dislike is no reason to deprive you of potential joy.

Some knitters complain that this heel is ill-fitting if you have a high instep. (Agreed!) It isn't as customizable as other heels. But you'll find loads of knitters who swear by it. They love knitting it and they love the way it feels. So, as it often goes in life, we need to try it and see for ourselves.

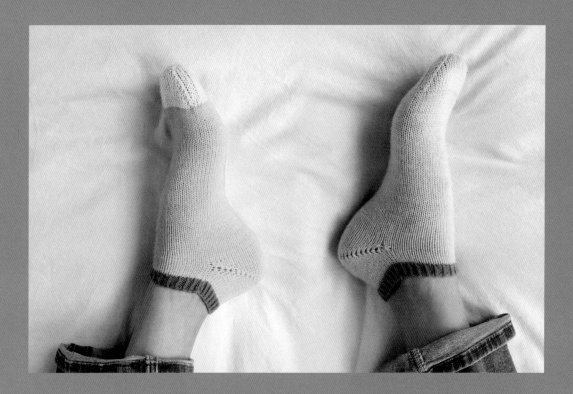

## MATERIALS

**Yarn:** Knit Picks Stroll [75% fine superwash merino/25% nylon; 231 yards (211 m)/1¾ ounces (50 g)]: 67 (89) 109 (128, 149, 162) yards [61 (81) 100 (117, 136, 148) m] in Wonderland Heather (MC).

Knit Picks Stroll [75% fine superwash merino/25% nylon; 231 yards (211 m)/1¾ ounces (50 g)]: 8 (10) 12 (14, 16, 18) yards [7 (9) 11 (13, 15, 16) m] in Treasure (CC1)

Knit Picks Stroll [75% fine superwash merino/25% nylon; 231 yards (211 m)/1¾ ounces (50 g)] : 10 (12) 14 (16, 18, 20) yards [9 (11) 13 (15, 16, 18) m] in Dandelion (CC2)

**Needles:** US size 1 (2.25 mm)

**Notions:** Tapestry needle, stitch markers, snips, measuring tape

**Gauge:** 38 sts = 4" (10 cm), knit in Stockinette in the rnd and blocked

### Sizes
Toddler (Kid) S (M, L, XL)

### Measurements
The numbers below refer to the circumference of the ball of the foot, not the measurements of the finished sock.

3–4 (5–6) 7 (8, 9, 10)" [8–10 (13–15) 18 (20, 23, 25) cm]

## INSTRUCTIONS

### Cuff
I used a 1×1 *twisted* rib for this Cuff! It tends to look quite a bit neater than regular 1×1 rib (which, let's face facts, can come out looking wobbly sometimes). To work this ribbing, you simply knit through the back loop, and purl through the back loop.

With CC1, CO **40 (48) 56 (64, 72, 80)** sts and join for working in the rnd, being careful not to twist your sts. Est 1×1 twisted rib: [k1tbl, p1tbl] to end.

Cont working the 1×1 twisted rib until your Cuff measures ¾" (2 cm), or your desired length.

### Leg
Break CC1 and join in MC. Work Stockinette in the rnd (knit every st) until your Leg reaches your desired length. I knit shorties for my pair, and worked until my Leg (including Cuff) measured 1" (2.5 cm). If you'd like to adjust the length, use the following chart for length guidelines:

**Shorty Socks:** Typically 1–2" (2.5–5 cm)
**Toddler Socks:** 3–4" (8–10 cm)
**Kid Socks:** 4–6" (10–15 cm)
**Adult Mid-calf:** 4–6" (10–15 cm)
**Adult Tall:** 7" (18 cm and up)

## Working the German Short-Row Heel

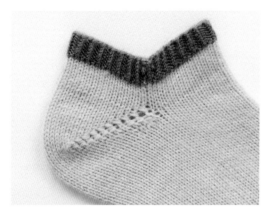

Once you've decided your Leg is long enough, on the next round, knit across **20 (24) 28 (32, 36, 40)** sts. Now we need to place markers before beginning our Heel, which will be worked across the remaining **20 (24) 28 (32, 36, 40)** sts. Follow the instructions according to your size below:

**Toddler:** K6, pm, k8, pm, k6. Turn work.
**Kid:** K8, pm, k8, pm, k8. Turn work.
**S:** K9, pm, k10, pm, k9. Turn work.
**M:** K10, pm, k12, pm, k10. Turn work.
**L:** K12, pm, k12, pm, k12. Turn work.
**XL:** K13, pm, k14, pm, k13. Turn work.

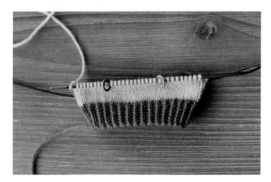

The last half of your sts should be divided with markers prior to starting the Heel shaping.

The math-minded among you may have noticed that we've essentially divided our Heel sts into thirds. The sts in between the two markers (right in the middle) will cover the heel of your foot. The sts at either end of the needle will form the gussets that rest under your ankle bones. All of our shaping will happen on those sts at either end of the needle.

Now that the markers are in place, and you've turned your work, you should be looking at the purl bumps on the wrong side of your work.

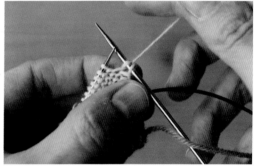

With your yarn in front, slip the first st and *make a double stitch (mds)*. How do you do that? Simply pull your yarn up and over the needle. You can see how it creates what looks like two sts on the needle.

**Purl to the end and turn your work.**

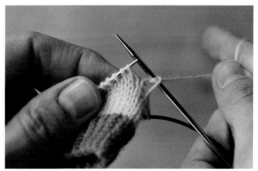

Now you are looking at the knit side of your fabric. With yarn in front (you will always be slipping with the yarn in front!), slip the first st and mds.

Knit all the way back to the first mds you made on the previous row. But don't knit it! We'll get to that later. Turn your work, slip the first st, mds, then purl all the way back to the mds on the other end of the needle.

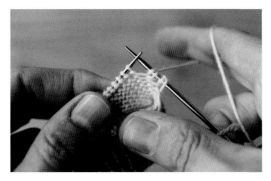

Our goal is to continue creating double sts on either end of our needle.

Turn your work, slip the first st, mds, and knit your way back until you reach the mds you just made on the previous rnd. Turn your work, and cont repeating these instructions until you've worked all the sts on either side of the markers. When finished, you should have a line of double sts on either side of the markers, and plain old single-knit sts in between the markers.

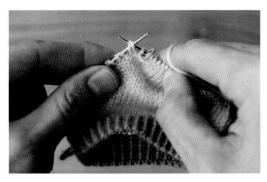

You will be in the middle of your needle, ready to knit those middle sts. Go ahead and knit them, and when you come to the double sts on the other end of the needle, knit each double st together, just as you would a k2tog.

The first half of your German Short-Row Heel is almost done! And it was maybe a little fun? I shudder to admit that I sort of enjoy that part of the Heel after trash-talking it so violently, but even I can grudgingly respect that making those cute little double stitches is satisfying.

You should now be in a position where you can knit across the first **20 (24) 28 (32, 36, 40)** sts that make up the front of the sock. We've been ignoring them while working our Heel. Knit across those sts, then once you've arrived at your Heel sts again, you'll be faced with more double sts. Knit each double st together, then work across the remainder of your heel sts.

Work across the first **20 (24) 28 (32, 36, 40)** sts again. Now we're done with those front sts again for a while and will only be working the Heel sts again. Knit across to the 2nd st marker on your needle, remove it, k1, then turn your work. Mds, then purl across to the other st marker. Remove it, p1, mds, turn your work. Knit to the first mds you made on the previous rnd, knit the double st together, k1, then turn your work. Mds, then purl to the mds you made on the previous rnd, purl that double st together, p1, turn your work, mds.

Cont in this pattern until you've used all the sts on either end of the needle. Resume knitting all your sock sts in the rnd, knitting the remaining double st together as you come to it.

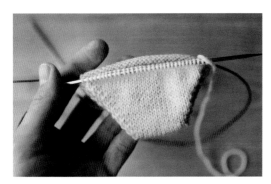

You've now completed the German Short-Row Heel and are ready to move on to the Foot!

If you loved knitting it, and more importantly, if you love the fit once your sock is complete, then I am truly happy for you. I hope it's clear that we all have our personal knitting preferences, and while I might not love something, as long as you do, that's all that matters! But if you hated it, please send me an email or a DM on Instagram so we can form a club and spend all our time trash-talking the German short-row heel.

## Knitting the Foot

Cont working in Stockinette until your Foot reaches just to the end of your pinky toe. If you can't easily try your socks on as you knit, or if you are knitting gift socks, the Craft Yarn Council has issued the following length guidelines for the Foot of a sock, measured from the back of the Heel to the end of the Toe.

(All sizes are US.)
**Toddler:** 4½–6" (11–15 cm)
**Kid:** 6–7½" (15–19 cm)
**Women's shoe sizes 4–6.5:** 8–9" (20.5–23 cm)
**Women's shoe sizes 7–9.5:** 9¼–10" (23–25.5 cm)
**Women's shoe sizes 10–12.5:** 10¼–11" (26–28 cm)

**Men's shoe sizes 6–8.5:** 9¼–10" (23.5–25.5 cm)
**Men's shoe sizes 9–11.5:** 10¼–11" (26–28 cm)
**Men's shoe sizes 12–14:** 11¼–12" (28.5–30.5 cm)

When working a German Short-Row Heel, you also need to take into account your Toe length:

**Toddler:** 1" (2.5 cm)      **M:** 1½" (4 cm)
**Kid:** 1¼" (3 cm)      **L:** 1½" (4 cm)
**S:** 1½" (4 cm)      **XL:** 1¾" (4 cm)

Now, take your desired Foot length, from back of Heel to end of Toe, and subtract your Toe measurements. For example, my desired Foot length is 9" (23 cm). I subtract my Toe (1½" [4 cm]) and that leaves me with 7½" [19 cm] I need to knit before starting my Toe decreases. Measure starting at the back of the Heel.

## Toe

Break MC and join in CC2. Knit 1 rnd even, then begin the following decrease pattern for your Toe:

**Rnd 1:** K1, ssk, k**14 (18) 22 (26, 30, 34)** sts, k2tog, k1, pm, k1, ssk, k**14 (18) 22 (26, 30, 34)** sts, k2tog, k1.
**Rnd 2:** Knit.
**Rnd 3:** K1, ssk, k to 3 sts before next marker, k2tog, k1, sl m, k1, ssk, knit around to 3 sts before end of rnd, k2tog, k1.

Repeat rnds 2 and 3 until **16 (20) 24 (28, 32, 36)** sts remain.

Close the Toe up with Kitchener Stitch (see page 3). You can now move on to chapter 4, which tells you all about how to finish your socks.

You've KNIT A SOCK! Visualize me showering you with confetti and handing you a flute of champagne or sparkling apple cider!

# Basic Sock No. 5:
# The Toe-Up Recipe with a Fleegle Heel

You will recall I put my favorite socks first and saved my least favorite socks for near the end. Given that this is my *last* basic sock recipe, I think we can quickly deduce how I feel about toe-up socks. Knitters all over the world love working socks using this method, however, so it clearly has its merits (and die-hard enthusiasts). I'm a malcontent who hates change, as you've no doubt learned, so I encourage you to ignore my grumblings and give it a try!

## MATERIALS

Yarn: Kindred Red Rad Sock [75% superwash merino/25% nylon; 463 yards (423 m)/3½ ounces (100 g)]: 117 (131) 152 (176, 198, 228) [107 (120) 139 (161, 181, 208) m] in Jaderade (MC)

Knit Picks Stroll [75% fine superwash merino/25% nylon; 231 yards (211 m)/1¾ ounces (50 g: 20 (24) 28 (32, 36, 40) yards [18 (22) 26 (29, 33, 37) m] )] in Rainforest Heather (CC)

*Note: You can use any fingering weight sock yarn!*

Needles: US size 1 (2.25 mm)

Notions: Tapestry needle, stitch markers, snips, measuring tape

Gauge: 38 sts = 4" (10 cm), knit in Stockinette stitch in the rnd and blocked

### Sizes
Toddler (Kid) S (M, L, XL)

### Measurements
The numbers below refer to the circumference of the ball of the foot, not the measurements of the finished sock.

3–4 (5–6) 7 (8, 9, 10)" [8–10 (13–15) 18 (20, 23, 25) cm]

## INSTRUCTIONS

### Toe

With CC, and using Judy's Magic Cast-On (google a video if unfamiliar), CO **16 (20) 24 (28, 32, 36)** total sts.

Using Judy's Magic Cast-On, you should have your sts divided evenly between two needles. Flip your needles so they are pointing to the right.

Knit all the sts on your first needle. You should be knitting the first **8 (10) 12 (14, 16, 18)** sts. When you come to the sts on the second needle, knit those sts *through the back loop*. They aren't oriented properly on your needle, and knitting them through the back loop orients them the right way. You only need to knit through the back loop this first rnd. Every other rnd, you'll be knitting them as you normally would.

Now it's time to begin increasing our stitch count.

**Rnd 1:** K1, kfb, k to the last 2 sts on the needle, kfb, k1. Repeat for second needle.
**Rnd 2:** Knit.

Repeat these two rnds until you have **40 (48) 56 (64, 72, 80)** sts divided evenly between your two needles—so, **20 (24) 28 (32, 36, 40)** per needle.

Your Toe is complete, and looking pretty adorable. Now it's time to knit the Foot!

## Foot

Break CC and join in MC. Compared with the Toe, the Foot is wildly simple. Just knit every rnd until your work reaches the bend of your ankle.

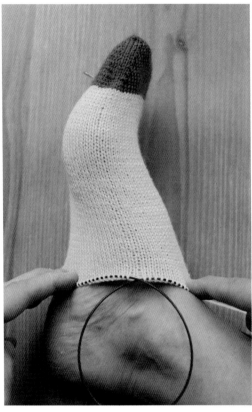

Stop knitting the Foot once your work reaches the bend of your ankle.

If you can't easily try your socks on as you knit, or if you are knitting gift socks, the Craft Yarn Council has issued the following length guidelines for the Foot of a sock, measured from the back of the Heel to the end of the Toe.

(All sizes are US.)
**Toddler:** 4½–6" (11–15 cm)
**Kid:** 6–7½" (15–19 cm)
**Women's shoe sizes 4–6.5:** 8–9" (20.5–23 cm)
**Women's shoe sizes 7–9.5:** 9¼–10" (23–25.5 cm)
**Women's shoe sizes 10–12.5:** 10¼–11" (26–28 cm)
**Men's shoe sizes 6–8.5:** 9¼–10" (23.5–25.5 cm)
**Men's shoe sizes 9–11.5:** 10¼–11" (26–28 cm)
**Men's shoe sizes 12–14:** 11¼–12" (28.5–30.5 cm)

You will also need to take into account the depth of your Heel.

| | |
|---|---|
| **Toddler:** 1¼" (2.5 cm) | **M:** 2" (5 cm) |
| **Kid:** 1¾" (4 cm) | **L:** 2" (5 cm) |
| **S:** 2" (5 cm) | **XL:** 2½" (6 cm) |

Now, take your desired Foot length, from back of Heel to end of Toe, and subtract your Heel measurements. For example, my desired Foot length is 9" (23 cm). I subtract my Heel (2" [5 cm]) and that leaves me with 7" (18 cm) I need to knit before starting my Fleegle Heel. Measure from the tip of the Toe.

## Knitting a Fleegle Heel

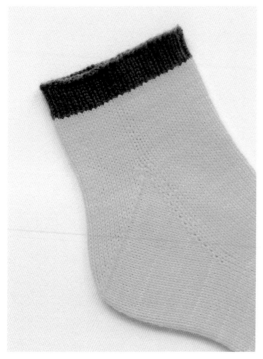

The stitch count on your Heel needle will grow, but the stitch count on your front needle will remain the same.

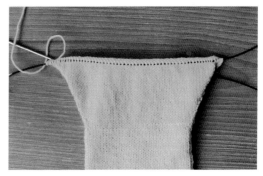

You can see how, as we increase 2 sts every other rnd, the stitch count on the Heel needle continues to grow.

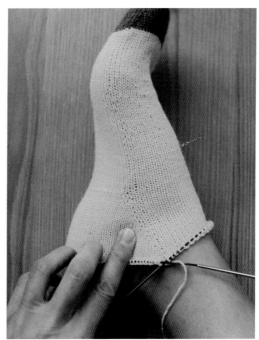

Those stitch increases are creating a gusset on either side of our ankle!

Working a Fleegle Heel is similar to a heel flap and gusset, or a German short-row heel—all the magic happens on the back half of your stitches. We will be knitting in the round, across *all* of our sts for the majority of this Heel, however, instead of just working back and forth across half the sts.

To start, we're going to work a simple 2 rnd repeat.

**Rnd 1:** Knit across the first **20 (24) 28 (32, 36, 80)** sts of your sock (these sts are on your front needle). On the remaining **20 (24) 28 (32, 36, 80)** sts (the ones resting on the Heel needle), K1, m1r, knit until 1 st remains, m1l, k1. You've increased your stitch count by 2.
**Rnd 2:** Knit.

Now all you have to do is repeat those two rnds until you have **38 (46) 54 (62, 70, 78)** sts on your Heel needle. You should still have only **20 (24) 28 (32, 36, 40)** sts on your front needle.

It's time for the Heel turn: Knit across the **20 (24) 28 (32, 36, 40)** sts on the front needle, and then leave those sts alone for a while. We will be working flat, back and forth, across the sts on the Heel needle only.

**Row 1:** K**20 (24) 28 (32, 36, 40)** sts, k2tog, k1, turn work.
**Row 2:** Slip 1, p 3, p2tog, p1, turn.
**Row 3:** Slip 1, k 4, k2tog, k1, turn.
**Row 4:** Slip 1, p 5, p2tog, p1, turn.

You have now established the following pattern for your Heel turn: slip 1, knit or purl to 1 st *before* the gap created by turning on the previous row, k2tog or p2tog, k1 or p1, turn.

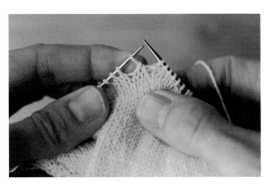

See that gap between the first and second sts on my left needle? That is your visual clue to knit those two sts together, thus closing that gap!

Cont in this pattern until you have one decrease left to work. Knit around the front needle sts, then on the Heel needle, work that very last decrease.

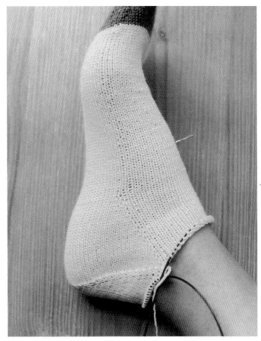

A finished Fleegle Heel!

And that's it! You've created your Fleegle Heel and you are ready to knit the Leg. You should have **40 (48) 56 (64, 72, 80)** sts on your needles.

## Leg

Much like the Foot, working the Leg only requires that you knit every rnd until your Leg reaches your desired length. I wanted the Leg on my sock to be 3" (8 cm), including the Cuff, so I worked the Leg for 2¼" (6 cm). If you'd like to adjust the length, use the following chart for length guidelines:

**Shorty Socks:** Typically 1–2" (3–5 cm)
**Toddler Socks:** 3–4" (8–10 cm)
**Kid Socks:** 4–6" (10–15 cm)
**Adult Mid-calf:** 4–6" (10–15 cm)
**Adult Tall:** 7" (18 cm and up)

Break MC.

## Cuff

Join in CC and work 1 rnd in Stockinette (knit every st). On the next rnd, est 2×2 rib pattern: [k2, p2] to end. Cont working the rib pattern until Cuff measures ¾" (2 cm), or desired length. Use Jeny's Stretchy Bind-Off to finish up your sock. (Google a video if you are unfamiliar with this bind-off.) You can now move on to chapter 4, which tells you all about how to finish up a sock!

You've completed a toe-up sock! Imagine me applauding you with gusto, because toe-up socks aren't my favorite to knit, and I'm really proud of you for doing it! Head to the next chapter for all the details on weaving in your ends and blocking.

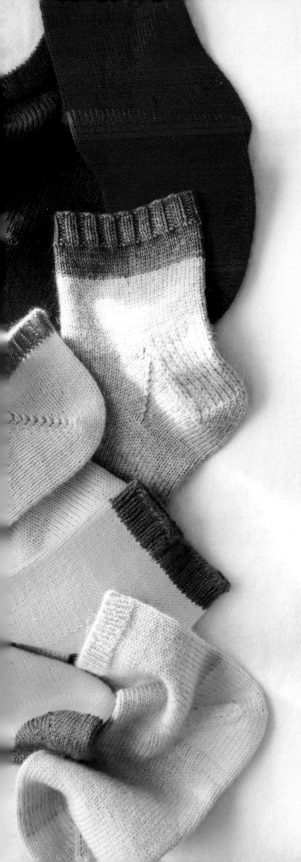

# Conclusion

WELL. That was a wild ride! Five heels, five cuffs, and six different basic socks. I hope you were able to find that magic sock recipe that feels great on your feet and suits your personal knitting preferences.

One of my best pieces of advice for newer sock knitters is to knit lots of basic socks at first. This allows you to become intimately familiar with the construction techniques, which makes it easier to incorporate stitch patterns and colorwork later on. You'll also get a feel for what kind of yarn you like working with, and what colors make you the happiest to knit with. Before you know it, you'll have a drawer full of colorful socks you can wear everyday (or if you're like me and live in a swampy, hot climate, a drawer full of colorful socks you can look at and admire).

When you're ready, dive into the fun patterns I've included in the rest of the book!

Chapter 4

# FINISHING & CARING FOR YOUR SOCKS

**W**hile I understand the desire to immediately put the socks on once you've knit that last stitch, allow me to persuade you to engage in a few small tasks that will make your knit socks even more enjoyable to wear for years to come.

## Finishing

First, weave in any ends that might be dangling about on the inside. I simply create a sideways U when I weave, leaving about ½" (2 cm) of a tail. Any shorter and it might poke its way through to the right side of the fabric.

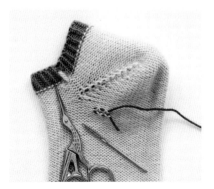

Once your ends are nice and tidy, it's time to block. Is this strictly necessary? I'd love to lie and insist that it very much IS. But that would dash my credibility as the Patron Saint of Sock Knitting (a title bequeathed to me on Instagram by a fellow sock knitter, and you better believe I immediately set about embroidering it on my pillowcases and towels).

So no, blocking isn't totally necessary, but you should still do it. It makes your socks so much softer, and more importantly, you'll get a more accurate look at your own knitting.

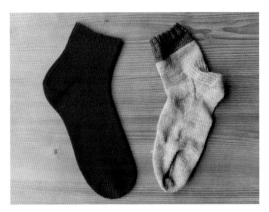

A blocked sock on the left compared with a non-blocked sock on the right

Put a dollop of the wool wash in your sink or bowl, fill it with lukewarm water, and then press your sock into the water until it's covered. Let it soak for about thirty minutes (though nothing will happen if you forget about it and leave it in there all night, which I do all the time).

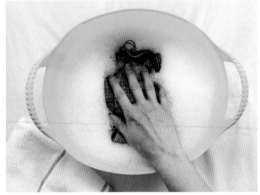

Once it's done soaking, squeeze (DON'T WRING!) the excess water out, then roll your wet sock up in a dry towel.

When you soak wool knitting in warm water with a mild detergent, a miraculous thing happens. All those little wobbly stitches you spent hours coaxing into existence begin to relax. They snuggle up to their neighbors, their little legs stretching into neat lines.

In short, the considerably rumpled and lumpy (but no less endearing) sock that came off your needles transforms into a perfect, silky soft, idealized version of a sock once it's had a nice long bath. Look at this way: You're still wonderful and amazing when you wake up with bedhead and a pillow crease on your face. But you have to admit, after you've had a shower and put on a fresh outfit, you're a different kind of amazing.

To block a sock you need a sink (or small tub, large bowl, etc.) of warm water, some wool wash (I like the brands Soak and Eucalan), and a sock blocker. (I use the ugly blue plastic kind from Knitter's Pride.)

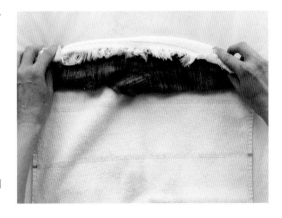

Place the towel on the floor and stomp on it for a few minutes to get even more excess water out, and also to release any pent-up anger or aggression you might be harboring.

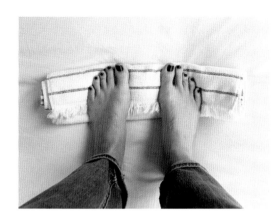

Now take your damp sock and put it on the sock blocker. I put mine in the center of my bed under the ceiling fan, and within twelve hours it's dry and ready to wear.

## Caring for Handknit Socks

Most sock yarn is "superwash," meaning that it's been specially treated to withstand being tumbled about in a washing machine. In theory you can toss your socks in with a load of laundry and treat them as you would any other garment.

Have I ever done that? NO. My general fear and paranoia make me approach my beloved knit socks with extreme caution. I like to soak mine in warm water and wool wash, then lay them flat to dry. I've seen other knitters do a "sock day" where they soak all their socks, then drape them prettily on a drying rack outdoors in the shade. You never want to dry them in the sun, because the dye might fade.

With regular wool (that is not designated superwash), you definitely don't want to pop them in the washer and dryer. They'll felt up and shrink, your heart will break, and then you'll have to mourn for at least six months while you work up the courage to knit another pair.

In terms of wear and tear, it's true that hand-knit wool socks require a little more care than machine-knit commercial socks you buy in a store. Holes are most likely to develop at the heels and the pads of your foot, the areas with the most friction. You can purchase a darning mushroom to mend them, which makes the job quite a bit easier. There are loads of tutorial videos online that show you all kinds of methods for keeping your socks going for years to come with some simple sewing techniques.

Numbers can also work on your side in terms of longevity. The more knit socks you have, the less you wear each pair. So if you really want to make your socks last without frequent mending, just follow my example and knit about a hundred pairs. That way each one gets worn only about three times a year. (Kidding! But not really.)

Do I have a giant plastic tub full of knit socks? YES.

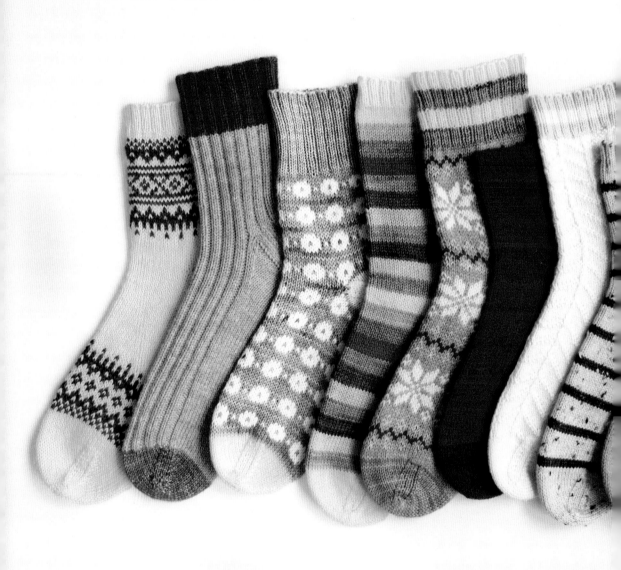

# 25
# SOCKS

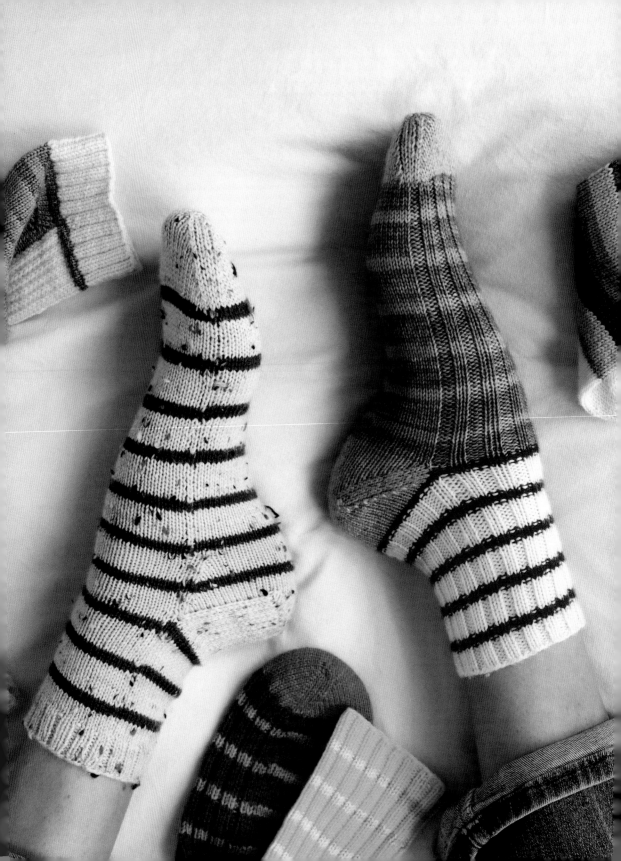

# Chapter 5
# STRIPED SOCKS

There is nothing I love better than knitting miles and miles of stripes. This simple pattern has completely invaded my life. I have striped curtains, striped cushions, striped walls, striped sweaters, striped scarves, and of course dozens of striped SOCKS. What better way to summon cheer than pulling on a colorful, stripey pair of hand-knit socks?

It's also a wonderful way to use up your scrap yarn stash. Scrappy socks are the BEST socks, in my opinion, because they are a perfect, nostalgic, visual map of your unique knitting journey. There's the yarn you bought in Santa Fe, New Mexico. And on that stripe, you used leftover yarn from the first pair of socks you knit. And the yarn on this stripe was used in that sweater you love, the one that the coffee shop barista couldn't stop complimenting. And so it goes.

Stripes, then, are almost always the answer to "What should I knit next?"

But many knitters shy away from them in fear. "The dreaded ends," they whisper. "I can't possibly weave in all those ends."

Fear not! It's entirely possible to finish a scrappy, colorful, stripey pair of socks with only a few ends to weave in. You can simply knit them in as you go, and I'll show you how.

# Multicolor Stripes

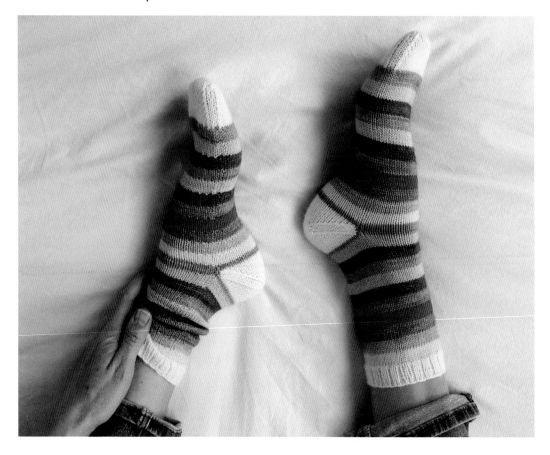

First, gather up all the yarn you want to use. Scraps are great for stripey socks, but you can also use the adorable mini skeins you've been collecting, or perhaps you bought a bunch of solid yarn because you liked how all the colors flowed together. (I've done all three.)

Next, decide on your stripe width. I'm partial to five rows for each color, and I think for the method I'm about to show you, it creates a nice fabric as well.

Knit your cuff. (I like to do a cream yarn for my cuff, heel, and toe, but you do you!) Then knit the first stripe of your first color.

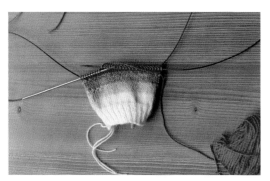

On the last row of that first color, stop when you have 9 sts left to go in the rnd.

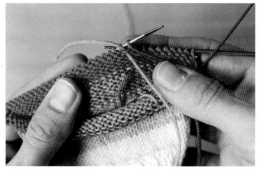

You've now caught the new yarn behind your current yarn.

Take your second color and lay the yarn over your working yarn. Knit the next st.

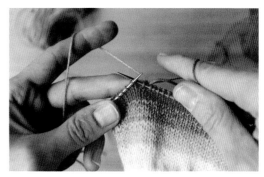

Next, hold the new yarn in your left hand, and tension it on your index finger. Hold your old color, the working yarn, in your right hand.

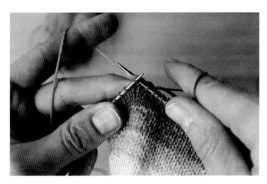

Insert your right needle into the next st as if to knit it, but before you do, use your left finger to flick the new yarn so that it lays over the right needle.

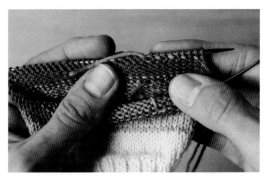

You can see the new color caught behind the sts on the wrong side of the fabric.

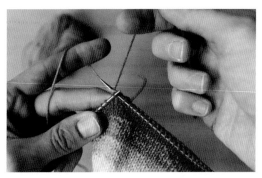

Then knit the st with your working yarn. The new yarn will now be caught behind the st you just knit on the wrong side of the fabric.

Knit the next st like normal. Then on the third st, do your new yarn flicking trick. Cont catching the new yarn tail behind one st, then knitting the next st like normal, until you reach the end of the rnd. You've now knit in your new color!

But we need to knit in the old color as well. You are now ready to start knitting the next stripe in your new color. So switch your new color to your right hand. It is now your working yarn. Hold the old color in your left hand and tension it on your index finger. Repeat the same steps as above, catching your old color behind the sts you are making with your new color. Once you've worked 8 sts, snip the old color, leaving about a **2" (5 cm)** tail. (We'll need that later.)

Once you've finished your sock, we've still got a few steps to go.

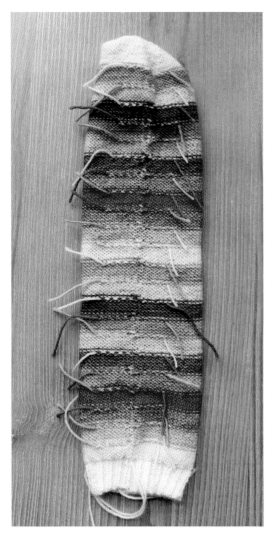

Turn it wrong side out and lay it flat so you can see all the colorful tails.

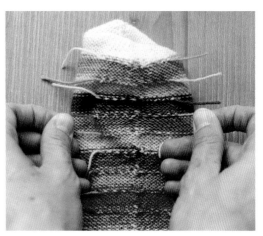

Starting at the top, grab the first pair of tails and gently tug them away from each other. Don't pull too tight or you will pucker the fabric.

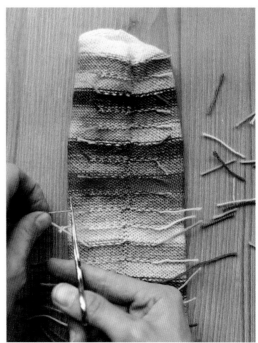

Once you've finished giving all your tails a tug, snip them down to 1" (3 cm).

We need to pull on each tail to tighten up the seam where your old color and new color meet on each stripe.

And that's the simple secret to avoiding endless end-weaving with colorful stripey socks.

# Two-Color Stripes

For our next knitting trick, let's focus on two-color stripes. There's no need to cut the yarn each time you change colors. Instead, you can just carry the yarn you aren't using up the inside of your sock until you need it again.

For this particular pair, I did a Breton stripe pattern: 8-row stripes in my light blue, then 3-row stripes in the dark blue. Do you remember our flicking trick we used earlier? You'll be doing that again to "catch" the yarn you aren't using as you work your stripes. This keeps that yarn secured to the inside of your sock so you don't have long floats. At the beginning of a round, simply catch your non-working yarn behind the first stitch.

How often you catch is up to you. Some people like to catch the nonworking yarn every other round. Some people (like me) often forget and don't catch it all. So far nothing bad has happened to my stripey socks with insanely long threads on the inside where I didn't catch my nonworking yarn. But to be on the safe side, try to remember to catch your nonworking yarn at least every third or fourth round.

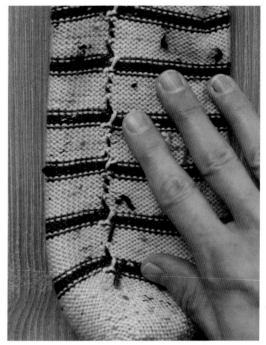

You can see where I caught my nonworking yarn behind the first stitch in a new round.

## Avoiding the Jog

I was a knitter for years before I learned that I was actually knitting a spiral, not a circle, when knitting in the round. (I only learned last year that a pickle is really just a cucumber. I still haven't gotten over the fact that for forty years I thought there was such a thing as a pickle plant.)

This can make changing colors a bit of a challenge, because the first stitch in a new round sits up higher than the last stitch you knit in the previous round. You'll see a hitch in the fabric where your new and old colors meet.

But of course way back when, some brilliant knitting ancestor of ours figured out how to mitigate this little color-changing jog and it's marvelously simple to execute. Here's what you do:

Knit your first round in your new color.

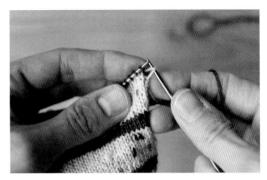

On the first st of the second round, take your right needle, and lift up the right leg of the stitch just below that first stitch. Place that leg on your left needle, then knit it together with that first stitch.

And that's it! Continue knitting the rest of your stripe like normal, then repeat that little trick when you change colors for the next stripe.

Then go forth and knit stripes on EVERYTHING, like the stripe-obsessed knitter I know you'll become once you die of happiness over your first pair of stripey, colorful socks.

# Stripes Recipe No. 1:
# Happy and Scrappy

## MATERIALS

**Yarn:** Knit Picks Stroll [75% fine superwash merino/25% nylon; 231 yards (211 m)/1¾ ounces (50 g)]: 28 (32) 36 (40, 44, 48) yards [26 (29) 33 (37, 40, 44) m] in Bare (MC)

Stripes (CC colors): You need the following total approximate amounts, divided evenly between the colors you are using. (I used various speckled yarn leftovers.)

139 (161) 186 (208, 236, 277) yards [127 (147) 170 (190, 216, 253) m]

*Note: As always, any fingering weight sock yarn will do.*

**Needles:** US size 1 (2.25 mm)

**Notions:** Tapestry needle, stitch markers (including a clasp marker), snips, measuring tape

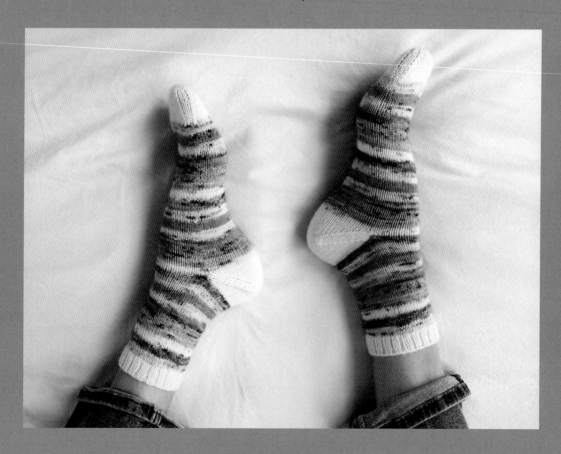

Gauge: 38 sts = 4" (10 cm), knit in Stockinette in the rnd and blocked

Sizes
Toddler (Kid) S (M, L, XL)

Measurements
The numbers below refer to the circumference of the ball of the foot, not the measurements of the finished sock.

3–4 (5–6) 7 (8, 9, 10)" [8–10 (13–15) 18 (20, 23, 25) cm]

## INSTRUCTIONS

### Cuff
With MC, CO **39 (48) 57 (63, 72, 81)** sts and join for working in the rnd, being careful not to twist your sts. Est 2×1 ribbing: [k2, p1] to end.

Cont working the ribbing until your Cuff measures ¾" (2 cm), or your desired length. On the last rnd of the ribbing, we need to get our stitch count back to an even number. If you are working the Kid or L sizes, you already have an even number and can move on to the Leg instructions. Otherwise, make the following increase or decrease according to your size:

**Toddler:** Work in rib pattern to the last 3 sts, kfb, k1, p1. **40** sts.

**M:** Work in rib pattern to the last 3 sts, kfb, k1, p1. **64** sts.

**S:** Work in rib pattern to the last 3 sts, k2tog, p1. **56** sts.

**XL:** Work in rib pattern to the last 3 sts, k2tog, p1. **80** sts.

### Leg
You will be working the rest of your sock in Stockinette (knit every st).

Break MC and join in CC1. Work 5 rnds, then break CC1 and join in CC2. Cont working 5 rnds of each color until your Leg, including the Cuff, reaches the desired length. Not sure how long to knit the Leg? Use the table below to determine a good measurement for various sizes. I knit my sample Leg to 4" (10 cm).

**Shorty Socks:** Typically 1–2" (2.5–5 cm)
**Toddler Socks:** 3–4" (8–10 cm)
**Kid Socks:** 4–6" (10–15 cm)
**Adult Mid-calf:** 4–6" (10–15 cm)
**Adult Tall:** 7" (18 cm and up)

Once you've decided your Leg is long enough, on the next rnd, simply knit **30 (36) 42 (48, 54, 60)** sts, and clip a clasp marker onto that last st you just knit. Then just keep knitting! You've placed a marker in the center of the last half of your sts, which is where your Afterthought Heel will eventually go.

### Knitting the Foot
Cont knitting Stockinette in the round until your Foot reaches the desired length. The Craft Yarn Council has issued the following length guidelines for the Foot of a sock,

measured from the back of the Heel to the end of the Toe.

(All sizes are US.)

**Toddler:** 4½–6" (11–15 cm)
**Kid:** 6–7½" (15–19 cm)
**Women's shoe sizes 4–6.5:** 8–9" (20.5–23 cm)
**Women's shoe sizes 7–9.5:** 9¼–10" (23–25.5 cm)
**Women's shoe sizes 10–12.5:** 10¼–11" (26–28 cm)
**Men's shoe sizes 6–8.5:** 9¼–10" (23.5–25.5 cm)
**Men's shoe sizes 9–11.5:** 10¼–11" (26–28 cm)
**Men's shoe sizes 12–14:** 11¼–12" (28.5–30.5 cm)

When working an Afterthought Heel, you need to take both your Heel length and your Toe length into account (they will be the same).

**Toddler:** 1" (2.5 cm)        **M:** 1½" (4 cm)
**Kid:** 1¼" (3 cm)             **L:** 1½" (4 cm)
**S:** 1½" (4 cm)               **XL:** 1¾" (4 cm)

Now, take your desired Foot length, from back of Heel to end of Toe, and subtract both your Heel and Toe measurements. For example, my desired Foot length is 9" (23 cm). I subtract my Toe (1½" [4 cm]), and my Heel (1½" [4 cm]) and that leaves me with 6" (15 cm) I need to knit before starting my Toe decreases.

## Toe

Break CC yarn and join in MC. Knit 1 rnd even in Stockinette before beginning the following decrease pattern to shape your Toe:

**Rnd 1:** K1, ssk, k**14 (18) 22 (26, 30, 34)** sts, k2tog, k1, pm, k1, ssk, k**14 (18) 22 (26, 30, 34)** sts, k2tog, k1.
**Rnd 2:** Knit.

**Rnd 3:** K1, ssk, k to 3 sts before next marker, k2tog, k1, sl m, k1, ssk, knit around to 3 sts before end of rnd, k2tog, k1.

Repeat rnds 2 and 3 until **16 (20) 24 (28, 32, 36)** sts remain.

Use Kitchener Stitch to close up your Toe (see page 33).

## Knitting the Afterthought Heel

First, get your needles on the rows of sts on either side of your clasped-on stitch marker. (See page 40 for a detailed tutorial on working an Afterthought Heel.)

You will work your Afterthought Heel the same as you did your Toe. Join in MC and knit 3 rnds even. Then begin the following decrease pattern:

**Rnd 1:** K1, ssk, k**14 (18) 22 (26, 30, 34)** sts, k2tog, k1, pm, k1, ssk, k**14 (18) 22 (26, 30, 34)** sts, k2tog, k1.
**Rnd 2:** Knit.
**Rnd 3:** K1, ssk, knit to 3 sts before next marker, k2tog, k1, sl m, k1, ssk, knit around to 3 sts before end of rnd, k2tog, k1.

Repeat rnds 2 and 3 until **16 (20) 24 (28, 32, 36)** sts remain. Use Kitchener Stitch to close that Heel up (see page 33).

*Note: You can adjust the depth and fit of your Heel by working more or fewer decrease rnds. Try the sock on occasionally as you work your decreases to see how it's fitting. Stop your decreases when you can easily pinch the fabric closed.*

## Finishing

Weave in your ends (hopefully you don't have that many since you knit them in as you worked), and block your socks (see chapter 4).

# Stripes Recipe No. 2:
# The French Connection

## MATERIALS

Yarn: Knit Picks Stroll Tweed [65% fine superwash merino/25% nylon/10% Donegal tweed; 231 yards (211 m)/1¾ ounces (50 g)]: 41 (64) 96 (128, 151, 183) yards [37 (58) 88 (117, 138, 167) m] in North Pole Heather (MC)

Knit Picks Stroll Tweed [65% fine superwash merino/25% nylon/10% Donegal tweed; 231 yards (211 m)/1¾ ounces (50 g)]: 55 (63) 72 (80, 89, 97) yards [50 (58) 66 (73, 81, 89) m] in Lapis (CC)

*Note: As always, any fingering weight sock yarn will do.*

Needles: US size 1 (2.25 mm)

Notions: Tapestry needle, stitch markers, snips, measuring tape

Gauge: 38 sts = 4" (10 cm), knit in Stockinette in the rnd and blocked

Sizes
Toddler (Kid) S (M, L, XL)

Measurements
The numbers below refer to the circumference of the ball of the foot, not the measurements of the finished sock.

3–4 (5–6) 7 (8, 9, 10)" [8–10 (13–15) 18 (20, 23, 25) cm]

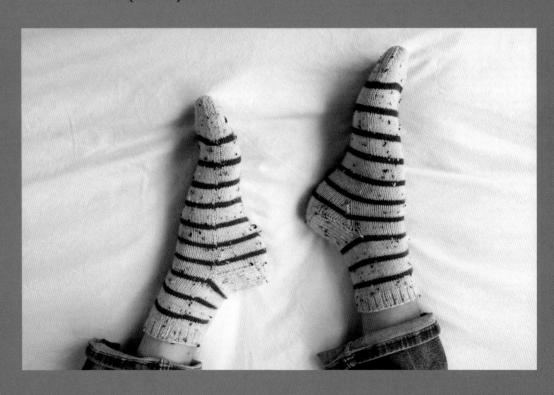

## Cuff

With MC, CO **39 (48) 57 (63, 72, 81)** sts and join for working in the rnd, being careful not to twist your sts. Est 2×1 ribbing: [k2, p1] to end.

Cont working the ribbing until your Cuff measures ¾" (2 cm), or your desired length. On the last rnd of the ribbing, we need to get our stitch count back to an even number. If you are working the Kid or L sizes, you already have an even number and can move on to the Leg instructions. Otherwise, make the following increase or decrease according to your size:

**Toddler:** Work in rib pattern to the last 3 sts, kfb, k1, p1. **40** sts.

**M:** Work in rib pattern to the last 3 sts, kfb, k1, p1. **64** sts.

**S:** Work in rib pattern to the last 3 sts, k2tog, p1. **56** sts.

**XL:** Work in rib pattern to the last 3 sts, k2tog, p1. **80** sts.

## Leg

You will be working the rest of your sock in Stockinette (knit every st).

Work 5 rnds in MC, then join in CC. (Remember: don't break your MC yarn. You'll be carrying the nonworking yarn on the inside of your sock.)

Est Breton stripe pattern: Work 3 rnds of CC, then 9 rnds of MC. Cont repeating this stripe pattern (3 rnds CC, 9 rnds MC) until your Leg (including Cuff) measures 3½" (9 cm), or your desired length. Not sure how long to knit the Leg? Use the table below to determine a good measurement for various sizes.

**Shorty Socks:** Typically 1–2" (2.5–5 cm)
**Toddler Socks:** 3–4" (8–10 cm)
**Kid Socks:** 4–6" (10–15 cm)
**Adult Mid-Calf:** 4–6" (10–15 cm)
**Adult Tall:** 7" (18 cm) and up

Once you are satisfied with the length of your Leg, begin working the Heel flap. I stopped for the Heel after working 3 rnds in MC.

## Heel Flap

The Heel Flap is worked in MC. Knit across the first **20 (24) 28 (32, 36, 40)** sts, then begin working your Heel Flap back and forth across the remaining **20 (24) 28 (32, 36, 40)** sts as follows:

**Row 1 (RS):** K2, [slip 1, k1] to end. Turn work.
**Row 2 (WS):** Slip 1 wyif, p to end. Turn work.
**Row 3:** [Slip 1, k1] to end. Turn work.

Repeat rows 2 and 3 until Heel Flap measures **1.5 (1.75) 2 (2, 2.25, 2.5)" [4 (4.5) 5 (5, 6, 6.5) cm]**. End after you have worked row 3.

## Heel Turn

**Row 1 (WS):** Slip 1 wyif, p**10 (12) 14 (16, 18, 20)**, p2tog, p1, turn.
**Row 2 (RS):** Slip 1, k3, ssk, k1, turn.
**Row 3:** Slip 1 wyif, p4, p2tog, p1, turn.
**Row 4:** Slip 1, k5, ssk, k1, turn.

You have now established the following pattern for your Heel Turn: slip 1, knit or purl to 1 st before the gap created by turning on the previous row, ssk or p2tog, k1 or p1, turn. Cont in this pattern until all your Heel sts have been worked, ending on a RS row. You should now have **12 (14) 16 (18, 20, 22)** Heel sts.

## Gusset

With the right side of your work facing, pick up and knit **8 (10) 12 (14, 16, 18)** sts along the left side of your Heel Flap.

Next, knit across the **20 (24) 28 (32, 36, 40)** sts that we've left undisturbed on our needles while working our Heel Flap. Pm, and pick up **8 (10) 12 (14, 16, 18)** sts on the right side of your Heel Flap. Knit across the Heel sts, then knit down the first set of new sts you picked up on the left side. You've reached the end of the rnd, and all your sts have now been picked up. You should now have **48 (58) 68 (78, 88, 98)** sts total on your needles.

## Gusset Decreases

**Rnd 1:** K20 (24) 28 (32, 36, 40) sts, sl marker, k1, ssk, knit around to 3 sts before the end of rnd, k2tog, k1.
**Rnd 2:** Work even with no decreases.

Repeat these two rnds until you have **40 (48) 56 (64, 72, 80)** sts on your needles, while at the same time maintaining the Breton stripe pattern.

## Foot

Cont working the Breton stripe pattern until your work reaches just to the tip of your pinky toe. If you can't easily try the sock on, or if you are knitting gift socks, the Craft Yarn Council has issued the following length guidelines for the Foot of a sock, measured from the back of the Heel to the end of the Toe.

(All sizes are US.)
**Toddler:** 4½–6" (11–15 cm)
**Kid:** 6–7½" (15–19 cm)
**Women's shoe sizes 4–6.5:** 8–9" (20.5–23 cm)
**Women's shoe sizes 7–9.5:** 9¼–10" (23–25.5 cm)
**Women's shoe sizes 10–12.5:** 10¼–11" (26–28 cm)
**Men's shoe sizes 6–8.5:** 9¼–10" (23.5–25.5 cm)
**Men's shoe sizes 9–11.5:** 10¼–11" (26–28 cm)
**Men's shoe sizes 12–14:** 11¼–12" (28.5–30.5 cm)

When working a Heel Flap and Gusset, you also need to take into account your Toe length:

**Toddler:** 1" (2.5 cm)    **M:** 1½" (4 cm)
**Kid:** 1¼" (3 cm)    **L:** 1½" (4 cm)
**S:** 1½" (4 cm)    **XL:** 1¾" (4 cm)

Now, take your desired Foot length, from back of Heel to end of Toe, and subtract your Toe measurements. For example, my desired Foot length is 9" (23 cm). I subtract my Toe (1½" [4 cm]) and that leaves me with 7½" (19 cm) I need to knit before starting my Toe decreases. Measure starting at the back of the Heel.

## Toe

The Toe is worked in MC.

**Rnd 1:** K1, ssk, k14 (18) 22 (26, 30, 34) sts, k2tog, k1, pm, k1, ssk, k14 (18) 22 (26, 30, 34) sts, k2tog, k1.
**Rnd 2:** Knit.
**Rnd 3:** K1, ssk, knit to 3 sts before next marker, k2tog, k1, sl m, k1, ssk, knit around to 3 sts before end of rnd, k2tog, k1.

Repeat rnds 2 and 3 until **16 (20) 24 (28, 32, 36)** sts remain.

Use Kitchener Stitch to close the Toe (see page 33).

## Finishing

Weave in all ends and block your socks (see chapter 4).

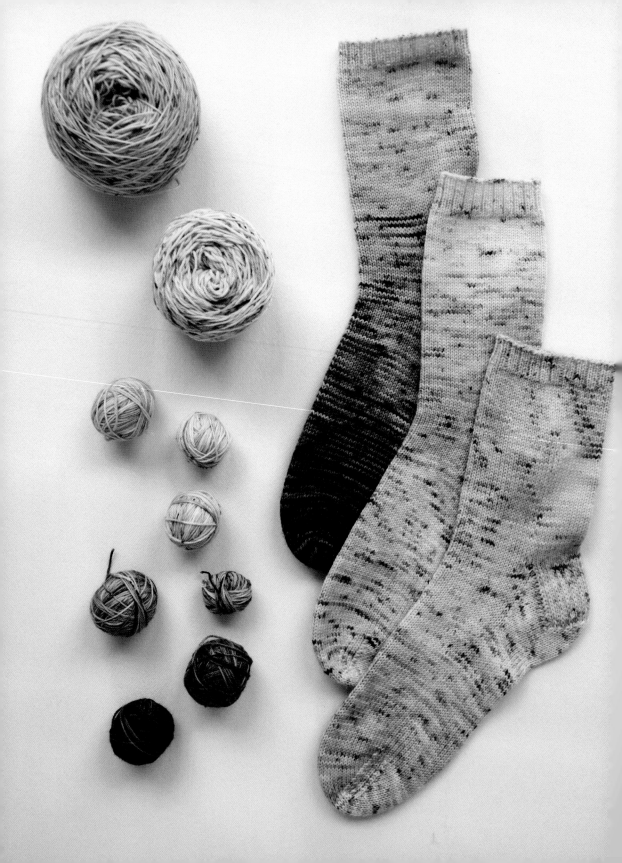

## Chapter 6
# SOCKS WITH FADES

There's no doubt that fading is a trend. It might be considered ugly in twenty years, but I don't care. I'll always love it, and I'll always moon over my faded socks because they look so magical!

As a technique, this is one of the simplest things you can do to create an outcome that looks highly technical and, frankly, quite show-stopping. The trick is all in choosing the right yarn. In my experience, fading looks best with lightly speckled yarns that are very similar in color. Many indie dyers even craft fade kits to make our lives a little easier, but it's still possible to choose yarn from your own stash.

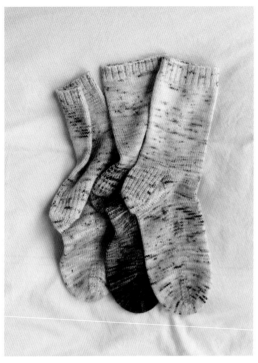

Speckled yarns work best for fading, but variegated yarns can work too.

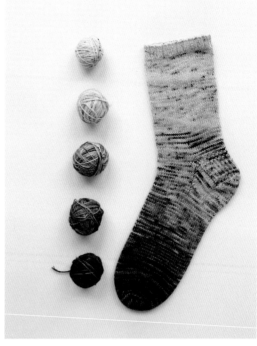

Arrange your yarn from lightest to darkest, or from darkest to lightest.

The red pair you see in the pictures was from a fade kit created by Hedgehog Fibres, but the other two pairs I put together myself using speckled scrap yarn from my stash. I typically go from lightest yarn to darkest yarn, but you could do the opposite as well. The key to a good fade is going in one direction or the other. You don't want to have dark yarn in the middle of two shades of light yarn, for example.

Fading is achieved by working simple stripes with your old color and your new color. I like to knit my faded socks a little taller so I can work in more colors, but you can knit them any length you like. I've done shorties with just three colors. All the socks you see pictured have either five or six colors worked in.

I start by arranging my colors in the order I would like them to go, from lightest to darkest.

Then I cast on and knit my cuff and about two inches of the leg in my first color. Next, I start bringing in my next color by working simple stripes.

Many knitters have their own way of blending from one yarn to the next. I like to avoid discernible patterns. (Our brains are wired to look for patterns, so the key to achieving a good fade is outsmarting our brain.) I'll knit a few rounds in the new color, then one round in the old, one in the new, then two rounds in the old, one round in the new, one in the old, two rounds in the new, two rounds in the old, one round in the new, and then finally one round in the old. Then I cut the old yarn and carry on in my new color until it's time to start blending in the third color.

Other knitters will knit one row in the old, one row in the new, and keep repeating that for an inch or two to blend. Or they might do two in each color. But again, I like to avoid discernible patterns. Our brains can see 1/1 and 2/2, and discern the stripes more easily than if we mix it up.

# The Ultimate Faded Socks Recipe

## MATERIALS

Yarn: Fingering weight yarn in the following approximate amounts, divided evenly between the number of colors you want to use. (I used Hedgehog Fibres leftovers from my stash, and a Hedgehog Fibres fade kit): 198 (221) 242 (264, 289, 318) yards [181 (202) 221 (241, 264, 291) m]

Note: As always, any fingering weight sock yarn will do.

Needles: US size 1 (2.25 mm)

Notions: Tapestry needle, stitch markers, snips, measuring tape

Gauge: 38 sts = 4" (10 cm), knit in Stockinette in the rnd and blocked

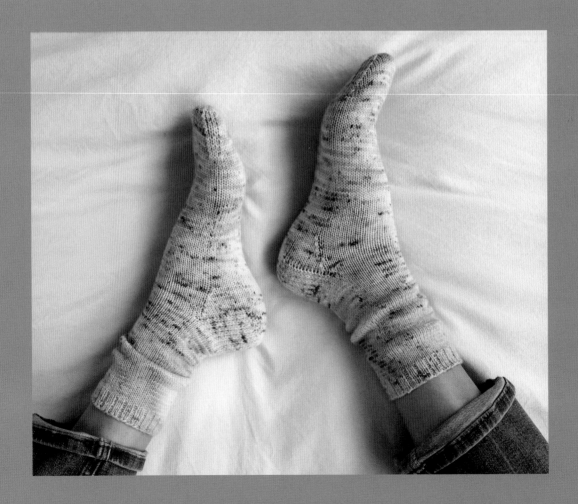

Toddler (Kid) S (M, L, XL)

## Measurements

The numbers below refer to the circumference of the ball of the foot, not the measurements of the finished sock.

3–4 (5–6) 7 (8, 9, 10)" [8–10 (13–15) 18 (20, 23, 25) cm]

# INSTRUCTIONS

## Cuff

With Color A, CO **39 (48) 57 (63, 72, 81)** sts and join for working in the rnd, being careful not to twist your sts. Est 2×1 ribbing: [k2, p1] to end.

Cont working the ribbing until your Cuff measures ¾" (2 cm), or your desired length. On the last rnd of the ribbing, we need to get our stitch count back to an even number. If you are working the Kid or L sizes, you already have an even number and can move on to the Leg instructions. Otherwise, make the following increase or decrease according to your size:

**Toddler:** Work in rib pattern to the last 3 sts, kfb, k1, p1. **40** sts.

**M:** Work in rib pattern to the last 3 sts, kfb, k1, p1. **64** sts.

**S:** Work in rib pattern to the last 3 sts, k2tog, p1. **56** sts.

**XL:** Work in rib pattern to the last 3 sts, k2tog, p1. **80** sts.

## Leg

With Color A, work **.5 (.5) 1 (1, 1, 1)" [1 (1) 3 (3, 3, 3) cm]** in Stockinette (knit every st), then blend in Color B.

Work **.5 (.5) 1 (1, 1, 1)" [1 (1) 3 (3, 3, 3) cm]** in Stockinette, then blend in Color C. Work 3 rnds of color C before starting the Heel Flap.

## Heel Flap

Knit across the first **20 (24) 28 (32, 36, 40)** sts, then begin working your Heel Flap back and forth across the remaining **20 (24) 28 (32, 36, 40)** sts as follows:

**Row 1 (RS):** K2, [slip 1, k1] to end. Turn work.
**Row 2 (WS):** Slip 1 wyif, purl to end. Turn work.
**Row 3:** [Slip 1, k1] to end. Turn work.

Repeat rows 2 and 3 until Heel Flap measures **1.5 (1.75) 2 (2, 2.25, 2.5)" [4 (4.5) 5 (5, 6, 6.5) cm]**. End after you have worked row 3.

## Heel Turn

**Row 1 (WS):** Slip 1 wyif, p10 (12) 14 (16, 18, 20), p2tog, p1, turn.
**Row 2 (RS):** Slip 1, k3, ssk, k1, turn.
**Row 3:** Slip 1 wyif, p4, p2tog, p1, turn.
**Row 4:** Slip 1, k5, ssk, k1, turn.

You have now established the following pattern for your Heel Turn: slip 1, knit or purl to 1 st before the gap created by turning on the previous row, ssk or p2tog, k1 or p1, turn. Cont in this pattern until all your Heel sts have been worked, ending on a RS row. You should now have **12 (14) 16 (18, 20, 22)** Heel sts.

## Gusset

With the right side of your work facing, pick up and knit **8 (10) 12 (14, 16, 18)** sts along the left side of your Heel Flap.

Next, knit across the **20 (24) 28 (32, 36, 40)** sts that we've left undisturbed on our needles while working our Heel Flap. Pm, and pick up **8 (10) 12 (14, 16, 18)** sts on the right side of your Heel Flap. Knit across the Heel sts, then knit down the first set of new sts you picked up on the left side. You've reached the end of the rnd, and all your sts have now been picked up. You should now have **48 (58) 68 (78, 88, 98)** sts total on your needles.

## Gusset Decreases

**Rnd 1:** K**20 (24) 28 (32, 36, 40)** sts, sl marker, k1, ssk, knit around to 3 sts before the end of rnd, k2tog, k1.
**Rnd 2:** Work even with no decreases.

Repeat these two rnds until you have **40 (48) 56 (64, 72, 80)** sts on your needles, while at the same time, blending in Color D when you have 3 decrease rnds left.

## Foot

Knit with Color D for **.5 (.5) 1 (1, 1, 1)" [1 (1) 2.5 (2.5, 2.5, 2.5) cm]**, then begin blending in Color E. Since we all have different foot lengths, the amount of colors you use and when to start blending the next will have to be a judgment call. Stop knitting the Foot when your work reaches the tip of your pinky toe.

If you can't easily try your socks on as you knit, or if you are knitting gift socks, the Craft Yarn Council has issued the following length guidelines for the Foot of a sock, measured from the back of the Heel to the end of the Toe.

(All sizes are US.)
**Toddler:** 4½–6" (11–15 cm)
**Kid:** 6–7½" (15–19 cm)
**Women's shoe sizes 4–6.5:** 8–9" (20.5–23 cm)
**Women's shoe sizes 7–9.5:** 9¼–10" (23–25.5 cm)
**Women's shoe sizes 10–12.5:** 10¼–11" (26–28 cm)
**Men's shoe sizes 6–8.5:** 9¼–10" (23.5–25.5 cm)
**Men's shoe sizes 9–11.5:** 10¼–11" (26–28 cm)
**Men's shoe sizes 12–14:** 11¼–12" (28.5–30.5 cm)

When working a Heel Flap and Gusset, you also need to take into account your Toe length:

**Toddler:** 1" (2.5 cm)    **M:** 1½" (4 cm)
**Kid:** 1¼" (3 cm)    **L:** 1½" (4 cm)
**S:** 1½" (4 cm)    **XL:** 1¾" (4 cm)

Now, take your desired Foot length, from back of Heel to end of Toe, and subtract your Toe measurements. For example, my desired Foot length is 9" (23 cm). I subtract my Toe (1½" [4 cm]) and that leaves me with 7½" (19 cm) I need to knit before starting my Toe decreases. Measure starting at the back of the Heel.

I typically start blending in my last color 1" (2.5 cm) before starting the Toe decreases.

## Toe

**Rnd 1**: K1, ssk, k**14 (18) 22 (26, 30, 34)** sts, k2tog, k1, pm, k1, ssk, k**14 (18) 22 (26, 30, 34)** sts, k2tog, k1.

**Rnd 2:** Knit.

**Rnd 3:** K1, ssk, knit to 3 sts before next marker, k2tog, k1, sl m, k1, ssk, knit around to 3 sts before end of rnd, k2tog, k1.

Repeat rnds 2 and 3 until **16 (20) 24 (28, 32, 36)** sts remain.

Use Kitchener Stitch to graft the Toe closed (see page 33).

## Finishing

Weave in all your ends and block your socks (see chapter 4).

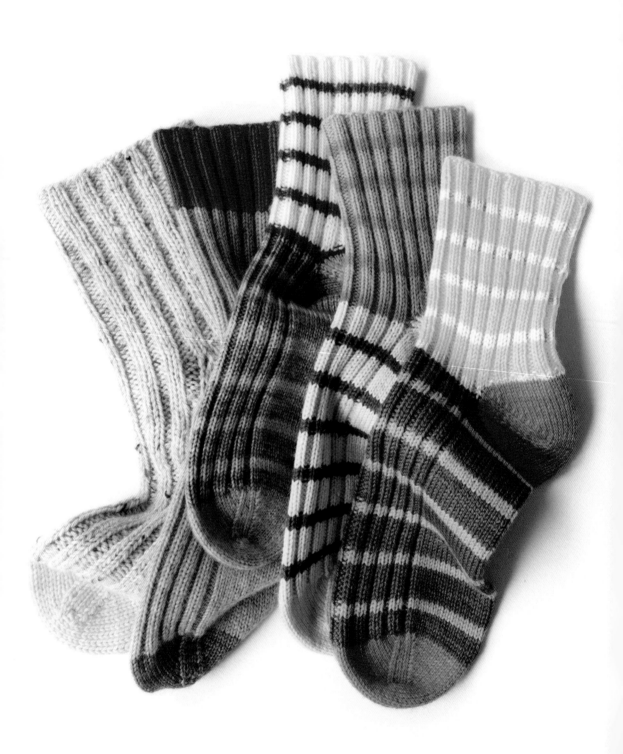

## Chapter 7
# RIBBED SOCKS

I used to dread working ribbing. "Give me Stockinette or give me death!" was my motto. As an English knitter, working purls is a bit slower for me, and I did a fair amount of pouting when it came to knitting the ribbed hems on sweaters, or the cuffs on my socks.

But then I decided I really wanted a pair of classic ribbed socks, and realized I would need to adjust my attitude if I was to undertake an entire project in nothing but 2×2 rib. Rhythm was the key, I discovered—getting into a nice groove with the knit, knit, purl, purl, and choosing to take joy in every stitch while consciously working to relax my hands and slow down. I had to learn to savor my knitting, instead of viewing the ribbing as something I had to suffer through to get to the good stuff. (Putting on some nineties grunge bangers also helps when the "ribbing sucks" attitude tries to creep back in.)

Luckily, ribbed socks are an easy way to incorporate texture into your knitting practice when you've had just about enough of vanilla socks. I've got three recipes for you (including thick ribbed socks), and a great tip for working neat color changes.

# Colorblocked Ribbed Socks

## MATERIALS

Yarn: Knit Picks Stroll [75% fine superwash merino/25% nylon; 231 yards (211 m)/1¾ ounces (50 g)]: 99 (121) 143 (160, 186, 211) yards [91 (111) 131 (146, 170, 193) m] in Dogwood Heather (MC)

Knit Picks Stroll [75% fine superwash merino/25% nylon; 231 yards (211 m)/1¾ ounces (50 g)]: 22 (30) 39 (48, 57, 68) yards [20 (27) 36 (43, 52, 62) m] in Buoy (CC1)

Hedgehog Fibres Sock [90% superwash merino/10% nylon; 437 yards (400 m)/3½ ounces (100 g)]: 10 (12) 14 (16, 18, 20) yards [9 (11) 13 (15, 16, 18) m] in Swamp (CC2)

*Note: As always, any fingering weight sock yarn will do.*

Needles: US size 1 (2.25 mm)

Notions: Tapestry needle, stitch markers, snips, measuring tape

Gauge: 38 sts = 4" (10 cm), knit in 2×2 rib pattern in the rnd and blocked

### Sizes
Toddler (Kid) S (M, L, XL)

### Measurements
The numbers below refer to the circumference of the ball of the foot, not the measurements of the finished sock.

3–4 (5–6) 7 (8, 9, 10)" [8–10 (13–15) 18 (20, 23, 25) cm]

## INSTRUCTIONS

### Cuff

With CC1, CO **40 (48) 56 (64, 72, 80)** sts and join for working in the rnd, being careful not to twist your sts. Est 2×2 rib pattern: [k2, p2] to end.

Cont working rib pattern until Cuff measures 2" (5 cm), or your desired length.

Break CC1 and join in MC.

Now we're going to incorporate an easy trick for making the transition between colors neater. Typically on a ribbed sock, when you change colors, you'll see purl bumps of the old color on the new color.

Notice how you can see the white purl bumps on the red stripes?

On this sock, you can't see any purl bumps. The transition between colors on the ribbing is smooth and neat.

When you are working ribbing and you transition from one color to the next, simply work the first rnd only of your new color in Stockinette, with no ribbing. That's all there is to it. You'll get a neat transition between colors every time.

Now that you have joined the MC into your sock, work 1 rnd in Stockinette (knit every st), then carry on with the 2×2 rib pattern until your Leg (including Cuff) measures 4½" (11 cm), or your desired length. If you would like to knit yours longer or shorter, use the table below to determine a good measurement for various sizes.

**Shorty Socks:** Typically 1–2" (2.5–5 cm)
**Toddler Socks:** 3–4" (8–10 cm)
**Kid Socks:** 4–6" (10–15 cm)
**Adult Mid-calf:** 4–6" (10–15 cm)
**Adult Tall:** 7" (18 cm and up)

Once you are satisfied with the length of your Leg, it's time to move on to the Heel.

## Heel Flap

The Heel Flap is worked in MC. Knit across the first **20 (24) 28 (32, 36, 40)** sts, then begin working your Heel Flap back and forth across the remaining **20 (24) 28 (32, 36, 40)** sts as follows:

**Row 1 (RS):** K2, [slip 1, k1] to end. Turn work.
**Row 2 (WS):** Slip 1 wyif, purl to end. Turn work.
**Row 3:** [Slip, k1] to end. Turn work.

Repeat rows 2 and 3 until Heel Flap measures **1.5 (1.75) 2 (2, 2.25, 2.5)" [4 (4.5) 5 (5, 6, 6.5) cm]**. End after you have worked row 3.

## Heel Turn

**Row 1 (WS):** Slip 1 wyif, p**10 (12) 14 (16, 18, 20)**, p2tog, p1, turn.
**Row 2 (RS):** Slip 1, k3, ssk, k1, turn.
**Row 3:** Slip 1 wyif, p4, p2tog, p1, turn.
**Row 4:** Slip 1, k5, ssk, k1, turn.

You have now established the following pattern for your Heel Turn: slip 1, knit or purl to 1 st before the gap created by turning on the previous row, ssk or p2tog, k1 or p1, turn. Cont in this pattern until all your Heel sts have been worked, ending with a RS row. You should now have **12 (14) 16 (18, 20, 22)** Heel sts.

## Gusset

With the right side of your work facing, pick up and knit **8 (10) 12 (14, 16, 18)** sts along the left side of your Heel Flap.

Next, work in 2×2 ribbing across the **20 (24) 28 (32, 36, 40)** sts that we've left undisturbed on our needles while working our Heel Flap. Pm, and pick up **8 (10) 12 (14, 16, 18)** sts on the right side of your Heel Flap. Knit across the Heel sts, then knit down the first set of new sts you picked up on the left side. You've reached the end of the rnd, and all your sts have now been picked up. You should now have **48 (58) 68 (78, 88, 98)** sts total on your needles.

## Gusset Decreases

**Rnd 1:** Work in 2×2 ribbing across **20 (24) 28 (32, 36, 40)** sts, sl marker, k1, ssk, knit around to 3 sts before the end of rnd, k2tog, k1.
**Rnd 2:** Work even with no decreases.

Repeat these two rnds until you have **40 (48) 56 (64, 72, 80)** sts on your needles.

## Foot

Cont working the 2×2 rib pattern in MC across the first **20 (24) 28 (32, 36, 40)** sts, and working Stockinette across the remaining **20 (24) 28 (32, 36, 40)** sts until your work reaches just to the tip of your pinky toe. If you can't easily try the sock on, or if you are knitting gift socks, the Craft Yarn Council has issued the following length guidelines for the Foot of a sock, measured from the back of the Heel to the end of the Toe.

(All sizes are US.)
**Toddler:** 4½–6" (11–15 cm)
**Kid:** 6–7½" (15–19 cm)
**Women's shoe sizes 4–6.5:** 8–9" (20.5–23 cm)
**Women's shoe sizes 7–9.5**: 9¼–10" (23–25.5 cm)
**Women's shoe sizes 10–12.5:** 10¼–11" (26–28 cm)
**Men's shoe sizes 6–8.5:** 9¼–10" (23.5–25.5 cm)
**Men's shoe sizes 9–11.5:** 10¼–11" (26–28 cm )
**Men's shoe sizes 12–14:** 11¼–12" (28.5–30.5 cm)

When working a Heel Flap and Gusset, you also need to take into account your Toe length:

| | |
|---|---|
| **Toddler:** 1" (2.5 cm) | **M:** 1½" (4 cm) |
| **Kid:** 1¼" (3 cm) | **L:** 1½" (4 cm) |
| **S:** 1½" (4 cm) | **XL:** 1¾" (4 cm) |

Now, take your desired Foot length, from back of Heel to end of Toe, and subtract your Toe measurements. For example, my desired Foot length is 9" (23 cm). I subtract my Toe (1½" [4 cm]) and that leaves me with 7½" (19 cm) I need to knit before starting my Toe decreases. Measure starting at the back of the Heel.

## Toe

Break MC and join in CC2. Knit 1 rnd even, then begin the following decrease pattern:

**Rnd 1:** K1, ssk, k**14 (18) 22 (26, 30, 34)** sts, k2tog, k1, pm, k1, ssk, k**14 (18) 22 (26, 30, 34)** sts, k2tog, k1.
**Rnd 2:** Knit.
**Rnd 3:** K1, ssk, knit to 3 sts before next marker, k2tog, k1, sl m, k1, ssk, knit around to 3 sts before end of rnd, k2tog, k1.

Repeat rnds 2 and 3 until **16 (20) 24 (28, 32, 36)** sts remain.

Use Kitchener Stitch to close the Toe (see page 33).

## Finishing

Weave in all ends and block your socks (see chapter 4).

# DK Ribbed Socks

DK socks are worked exactly like fingering weight socks. We're just using thicker yarn and thicker needles. It can be tricky to find DK yarn with nylon (that wonderful fiber that strengthens our socks and makes them last longer). Most of my thick socks are 100 percent wool, and I typically use them to keep my feet cozy around the house.

## MATERIALS

Hedgehog Fibres Tweedy [50% Falkland merino wool/37.5% recycled wool/12.5% thread waste; 252 yards (230 m)/3½ ounces (100g)]: 86 (103, 128, 145, 169) yards [79 (94, 117, 133, 155) m] in original colorway (MC)

Little Lionhead Knits DK Sock [85% superwash merino/15% nylon; [246 yards (225 m)/3½ ounces (100g)]: 30 (38, 44, 56, 67) yards [27 (35, 40, 51, 61) m] in Sixties Blue (CC)

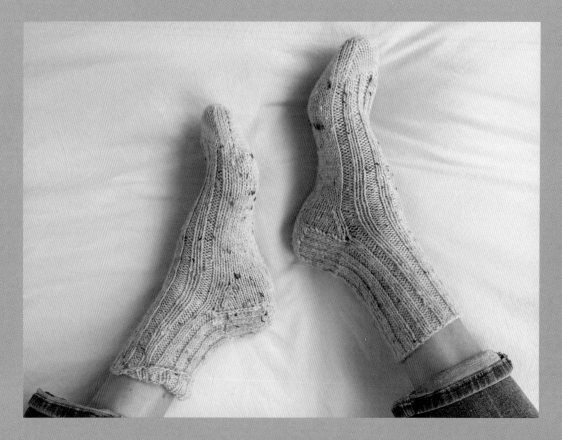

*Note: You can use any DK weight yarn. It can be tough to find DK weight yarn with added nylon, but some independent dyers and yarn companies carry it. I use regular DK weight yarn without nylon frequently, however.*

Needles: US size 3 (3.25 mm)

Notions: Tapestry needle, stitch markers, snips, measuring tape

Gauge: 24 sts = 3" (8 cm), knit in 2×2 rib pattern in the rnd and blocked

## Sizes

Kid (S, M, L, XL)

## Measurements

The numbers below refer to the circumference of the ball of the foot, not the measurements of the finished sock.

5–6 (7, 8, 9, 10)" [13–15 (18, 20, 23, 25) cm]

# INSTRUCTIONS

## Leg

With MC, CO **32 (40, 48, 56, 64)** sts and join for working in the rnd, being careful not to twist your sts. Est 2×2 rib pattern: [k2, p2] to end.

Cont working rib pattern until Leg measures 4" (10 cm), or your desired length. If you would like to knit yours longer or shorter, use the table below to determine a good measurement for various sizes.

**Shorty Socks:** Typically 1–2" (2.5–5 cm)
**Kid Socks:** 4–6" (10–15 cm)
**Adult Mid-calf:** 4–6" (10–15 cm)
**Adult Tall:** 7" (18 cm and up)

Once you are satisfied with the length of your Leg, it's time to move on to the Heel.

## Heel Flap

The Heel Flap is worked in MC. Knit across the first 16 (20, 24, 28, 32) sts, then begin working your Heel Flap back and forth across the remaining 16 (20, 24, 28, 32) sts as follows:

**Row 1 (RS):** K2, [slip 1, k1] to end. Turn work.
**Row 2 (WS):** Slip 1, purl to end. Turn work.
**Row 3:** [Slip 1, k1] to end. Turn work.

Repeat rows 2 and 3 until Heel Flap measures **1.75 (2, 2, 2.25, 2.5)" [4.5 (5, 5, 6, 6.5) cm]**. End after you have worked row 3.

## Heel Turn

**Row 1 (WS):** Slip 1, purl **8 (10, 12, 14, 16)**, p2tog, p1, turn.
**Row 2 (RS):** Slip 1, k3, ssk, k1, turn.
**Row 3:** Slip 1, p4, p2tog, p1, turn.
**Row 4:** Slip 1, k5, ssk, k1, turn.

You have now established the following pattern for your Heel Turn: slip 1, knit or purl to 1 st before the gap created by turning on the previous row, ssk or p2tog, k1 or p1, turn. Cont in this pattern until all your Heel sts have been worked, ending on a RS row. You should now have **10 (12, 14, 16, 18)** Heel sts.

## Gusset

With the right side of your work facing, pick up and knit **6 (8, 8, 8, 10)** sts along the left side of your Heel Flap.

Next, work in 2×2 ribbing across the **16 (20, 24, 28, 32)** sts that we've left undisturbed on our needles while working our Heel Flap.

Pm, and pick up **6 (8, 8, 8, 10)** sts on the right side of your Heel Flap. Knit across the Heel sts, then knit down the first set of new sts you picked up on the left side. You've reached the end of the rnd, and all your sts have now been picked up. You should now have 38 (48, 54, 60, 70) sts total on your needles.

### Gusset Decreases

**Rnd 1:** Work in 2×2 ribbing across **16 (20, 24, 28, 32)** sts, sl marker, k1, ssk, knit around to 3 sts before the end of rnd, k2tog, k1.
**Rnd 2:** Work even with no decreases.

Repeat these two rnds until you have 32 (40, 48, 56, 64) sts on your needles.

### Foot

Cont working the 2×2 rib pattern in MC across the first **16 (20, 24, 28, 32)** sts, while working Stockinette (knit every st) across the remaining **16 (20, 24, 28, 32)** sts until your work reaches just to the tip of your pinky toe. If you can't easily try the sock on, or if you are knitting gift socks, the Craft Yarn Council has issued the following length guidelines for the Foot of a sock, measured from the back of the Heel to the end of the Toe.

(All sizes are US.)
**Kid:** 6–7½" (15–19 cm)
**Women's shoe sizes 4–6.5:** 8–9" (20.5–23 cm)
**Women's shoe sizes 7–9.5:** 9¼–10" (23–25.5 cm)
**Women's shoe sizes 10–12.5:** 10¼–11" (26–28 cm)
**Men's shoe sizes 6–8.5:** 9¼–10" (23.5–25.5 cm)
**Men's shoe sizes 9–11.5:** 10¼–11" (26–28 cm)
**Men's shoe sizes 12–14:** 11¼–12" (28.5–30.5 cm)

When working a Heel Flap and Gusset, you also need to take into account your Toe length:

**Kid:** 1¼" (3 cm)          **L:** 1½" (4 cm)
**S:** 1½" (4 cm)            **XL:** 1¾" (4 cm)
**M:** 1½" (4 cm)

Now, take your desired Foot length, from back of Heel to end of Toe, and subtract your Toe measurements. For example, my desired foot length is 9" (23 cm). I subtract my Toe (1½" [4 cm]) and that leaves me with 7½" (19 cm) I need to knit before starting my Toe decreases. Measure starting at the back of the Heel.

### Toe

Break MC and join in CC1. Knit 1 rnd even, then begin the following decrease pattern:

**Rnd 1:** K1, ssk, k**10 (14, 18, 22, 26)** sts, k2tog, k1, pm, k1, ssk, k**10 (14, 18, 22, 26)** sts, k2tog, k1.
**Rnd 2:** Knit.
**Rnd 3:** K1, ssk, knit to 3 sts before next marker, k2tog, k1, sl m, k1, ssk, knit around to 3 sts before end of rnd, k2tog, k1.

Repeat rnds 2 and 3 until **16 (20, 24, 28, 32)** sts remain.

Use Kitchener Stitch to close the Toe (see page 33).

### Finishing

Weave in all ends and block your socks (see chapter 4).

# Breton Stripe Ribbed Socks

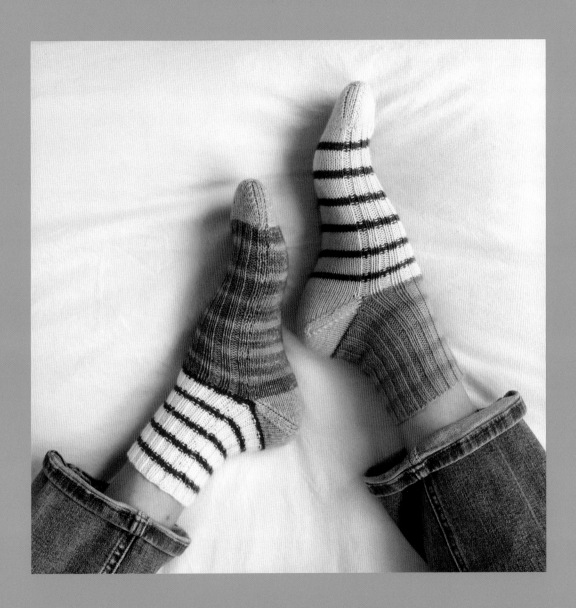

## MATERIALS

**Yarn:** Fingering weight sock yarn in the following approximate amounts (I used leftover scrap yarn from other projects):

CC1: 22 (36) 48 (60, 74, 88) yards [20 (33) 44 (55, 68, 80) m]

CC2: 6 (12) 16 (20, 24, 28) yards [5 (11) 15 (18, 22, 26) m]

CC3: 30 (42) 58 (74, 88, 102) yards [27 (38) 53 (68, 80, 93) m]

CC4: 8 (14) 20 (26, 32, 40) yards [7 (13) 18 (24, 29, 36) m]

CC5: 14 (18) 26 (32, 38, 44) yards [13 (16) 24 (29, 35, 40) m]

**Needles:** US size 1 (2.25 mm)

**Notions:** Tapestry needle, stitch markers (including a clasp marker), snips, measuring tape

**Gauge:** 38 sts = 4" (10 cm), knit in Breton Stripe Pattern in the round and blocked

### Sizes
Toddler (Kid) S (M, L, XL)

### Measurements
The numbers below refer to the circumference of the ball of the foot, not the measurements of the finished sock.

3–4 (5–6) 7 (8, 9, 10)" [8–10 (13–15) 18 (20, 23, 25) cm]

### Breton Stripe Pattern
**Color 1:** 8 rnds
**Color 2:** 3 rnds

## INSTRUCTIONS

### Leg
With CC1, CO **40 (48) 56 (64, 72, 80)** and join for working in the rnd, being careful not to twist your sts.

Est 2×2 rib pattern: [k2, p2] around to end.

Cont working rib pattern, while at the same time working the stripe pattern until you have completed 4 sets of the stripe pattern. Then, work 8 rnds of CC1 and 1 rnd of CC2. On the next 2 rnds of CC2, work in rib pattern across the first **20 (24) 28 (32, 36, 40)** sts, and work in Stockinette (knit every st) across the remaining **20 (24) 28 (32, 36, 40)** sts.

### Afterthought Heel Placement
Break CC1 and CC2. You have finished the Leg, and now it's time to mark where your Heel will go. Place a clasp marker on the following st, according to your size (simply count the sts from the beg of rnd until you reach the correct number):

| | |
|---|---|
| **Toddler:** 30 | **M:** 48 |
| **Kid:** 36 | **L:** 54 |
| **S:** 42 | **XL:** 60 |

### Foot
Join in CC3 and CC4. Establish the following pattern: Work the rib pattern across the first **20 (24) 28 (32, 36, 40)** sts, while working Stockinette across the remaining **20 (24) 28 (32, 36, 40)** sts. Cont in this pattern, while at the same time working the stripe pattern, until your Foot reaches just to the tip of your pinky toe. If you can't easily try the sock on, or if you are knitting gift socks, the Craft Yarn Council

has issued the following length guidelines for the Foot of a sock, measured from the back of the Heel to the end of the Toe.

(All sizes are US.)
**Toddler:** 4½–6" (11–15 cm)
**Kid:** 6–7½" (15–19 cm)
**Women's shoe sizes 4–6.5:** 8–9" (20.5–23 cm)
**Women's shoe sizes 7–9.5:** 9¼–10" (23–25.5 cm)
**Women's shoe sizes 10–12.5:** 10¼–11" (26–28 cm)
**Men's shoe sizes 6–8.5:** 9¼–10" (23.5–25.5 cm)
**Men's shoe sizes 9–11.5:** 10¼–11" (26–28 cm)
**Men's shoe sizes 12–14:** 11¼–12" (28.5–30.5 cm)

When working a Heel Flap and Gusset, you also need to take into account your Toe length:

**Toddler:** 1" (2.5 cm)        **M:** 1½" (4 cm)
**Kid:** 1¼" (3 cm)             **L:** 1½" (4 cm)
**S:** 1½" (4 cm)               **XL:** 1¾" (4 cm)

Now, take your desired Foot length, from back of Heel to end of Toe, and subtract your Toe measurements. For example, my desired Foot length is 9" (23 cm). I subtract my Toe (1½" [4 cm]) and that leaves me with 7½" (19 cm) I need to knit before starting my Toe decreases. Measure starting at the back of the Heel.

## Toe

With CC5, knit 1 rnd even, then begin the following decrease pattern for your Toe:

**Rnd 1:** K1, ssk, k**14 (18) 22 (26, 30, 34)** sts, k2tog, k1, pm, k1, ssk, k**14 (18) 22 (26, 30, 34)** sts, k2tog, k1.
**Rnd 2:** Knit.
**Rnd 3:** K1, ssk, knit to 3 sts before next marker, k2tog, k1, sl m, k1, ssk, knit around to 3 sts before end of rnd, k2tog, k1.

Repeat rnds 2 and 3 until **16 (20) 24 (28, 32, 36)** sts remain.

Graft your Toe closed using Kitchener Stitch (see page 33).

## Heel

Place your Heel sts back on your needles (see page 38). Remove the marker and snip that st! Join in CC5 and work 3 rnds even, then work the following decrease pattern:

**Rnd 1:** K1, ssk, k**14 (18) 22 (26, 30, 34)** sts, k2tog, k1, pm, k1, ssk, k**14 (18) 22 (26, 30, 34)** sts, k2tog, k1.
**Rnd 2:** Knit.
**Rnd 3:** K1, ssk, knit to 3 sts before next marker, k2tog, k1, sl m, k1, ssk, knit around to 3 sts before end of rnd, k2tog, k1.

Repeat rnds 2 and 3 until **16 (20) 24 (28, 32, 36)** sts remain.

## Finishing

Weave in all ends and block your socks (see chapter 4).

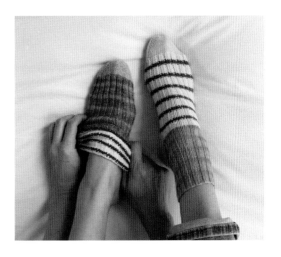

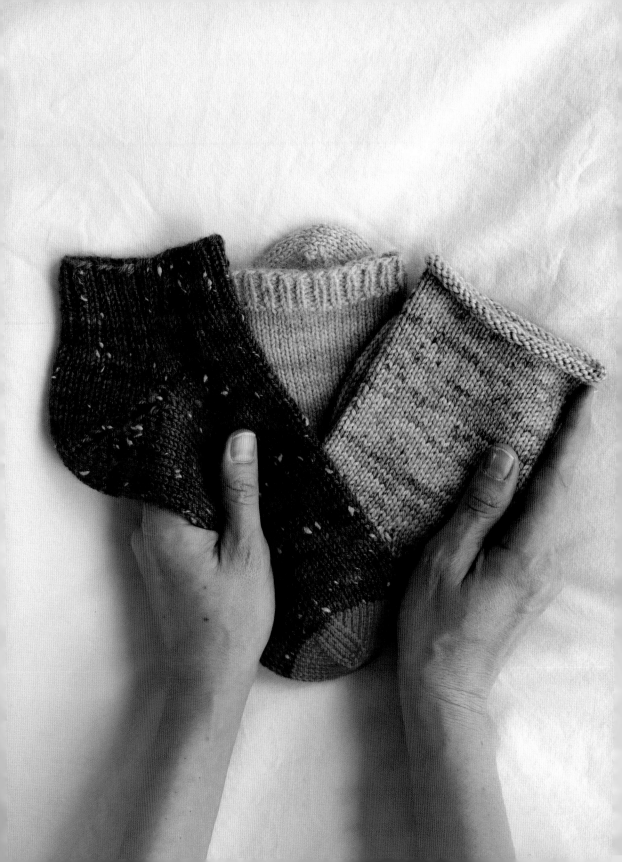

## Chapter 8
# THICK SOCKS

Oklahoma, where I have lived my entire life (except for a disastrous 35-day stint in Maine), is a swampy oven in terms of heat and humidity. Cool temperatures don't arrive until late November, and it's not unusual to wear shorts in February.

Thick socks, then, are not entirely needed in my part of the world. But that doesn't stop me from knitting them because they are 1) insanely quick—gotta love that instant gratification, and 2) inherently gift-worthy (see reason number 1).

But if you live in a frigid climate, or if you are a generous, warm-hearted person (unlike me), you might consider knitting up some thick, chunky socks. They fly off the needles in record time, and before you've managed to finish three episodes of *Gilmore Girls*, you've got a pair of the warmest, coziest socks, ready to cover your own freezing feet, or the feet of someone you've deemed knit-worthy.

No special skills are required. You'll just need to invest in some thick yarn and some bigger needles.

# Classic DK Socks Recipe

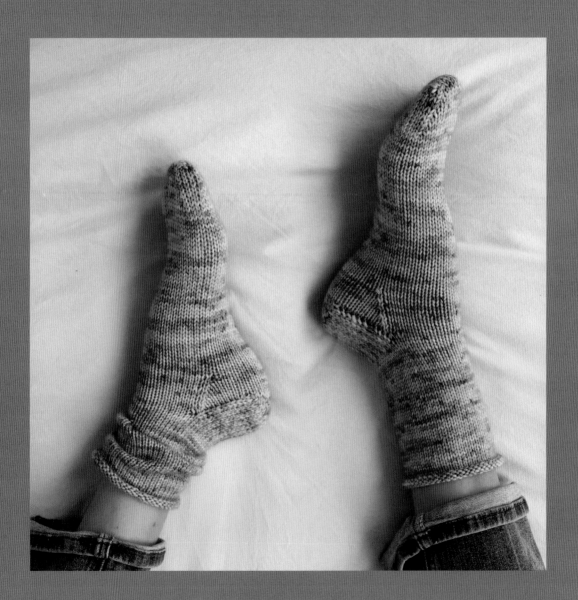

## MATERIALS

**Yarn:** LolaBean Yarn Co. Pinto Bean DK [100% merino wool; 250 yards (229 m)/4 ounces (113 g): 178 (199, 221, 245, 268) yards [163 (181, 202, 224, 245) m] in Georgia Peach

*Note: As always, any DK weight yarn will do.*

**Needles:** US size 3 (3.25 mm)

**Notions:** Tapestry needle, stitch markers, snips, measuring tape

**Gauge:** 24 sts = 3¼" (8 cm), knit in stockinette in the rnd and blocked

### Sizes

Kid (S, M, L, XL)

### Measurements

The numbers below refer to the circumference of the ball of the foot, not the measurements of the finished sock.

5–6 (7, 8, 9, 10)" [13–15 (18, 20, 23, 25) cm]

## INSTRUCTIONS

### Leg

I went with a classic rolled cuff for this sock. All you have to do is cast on and start knitting the Leg, and the Stockinette will naturally curl into a cute little cuff at the top.

With MC, CO **32 (40, 48, 56, 64)** sts and join for working in the rnd, being careful not to twist your sts.

Work in Stockinette (knit every st) until Leg measures 5" (13 cm), or your desired length.

If you would like to knit yours longer or shorter, use the table below to determine a good measurement for various sizes.

**Shorty Socks:** Typically 1–2" (2.5–5 cm)
**Kid Socks:** 4–6" (10–15 cm)
**Adult Mid-calf:** 4–6" (10–15 cm)
**Adult Tall:** 7" (18 cm and up)

Once you are satisfied with the length of your Leg, it's time to move on to the Heel.

### Heel Flap

Knit across the first **16 (20, 24, 28, 32)** sts, then begin working your Heel Flap back and forth across the remaining **16 (20, 24, 28, 32)** sts as follows:

**Row 1 (RS):** K2, [slip 1, k1] to end. Turn work.
**Row 2 (WS):** Slip 1 wyif, purl to end. Turn work.
**Row 3:** [Slip, k1] to end. Turn work.

Repeat rows 2 and 3 until Heel Flap measures **1.75 (2, 2, 2.25, 2.5)" [4.5 (5, 5, 6, 6.5) cm]**. End after you have worked row 3.

### Heel Turn

**Row 1 (WS):** Slip 1 wyif, p**8 (10, 12, 14, 16)**, p2tog, p1, turn.
**Row 2 (RS):** Slip 1, k3, ssk, k1, turn.
**Row 3:** Slip 1 wyif, p4, p2tog, p1, turn.
**Row 4:** Slip 1, k5, ssk, k1, turn.

You have now established the following pattern for your Heel Turn: slip 1, knit or purl to 1 st before the gap created by turning on the previous row, ssk or p2tog, k1 or p1, turn. Cont in this pattern until all your Heel sts have been worked, ending on a RS row. You should now have **10 (12, 14, 16, 18)** Heel sts.

## Gusset

With the right side of your work facing, pick up and k**6 (8, 8, 8, 10)** sts along the left side of your Heel Flap.

Next, knit across the **16 (20, 24, 28, 32)** sts that we've left undisturbed on our needles while working our Heel Flap. Pm, and pick up **6 (8, 8, 8, 10)** sts on the right side of your Heel Flap. Knit across the Heel sts, then knit down the first set of new sts you picked up on the left side. You've reached the end of the rnd, and all your sts have now been picked up. You should now have **38 (48, 54, 60, 70)** sts total on your needles.

## Gusset Decreases

**Rnd 1:** Knit across **16 (20, 24, 28, 32)** sts, sl marker, k1, ssk, knit around to 3 sts before the end of rnd, k2tog, k1.
**Rnd 2:** Work even with no decreases.

Repeat these two rnds until you have **32 (40, 48, 56, 64)** sts on your needles.

## Foot

Cont working in Stockinette until your work reaches just to the tip of your pinky toe. If you can't easily try the sock on, or if you are knitting gift socks, the Craft Yarn Council has issued the following length guidelines for the Foot of a sock, measured from the back of the Heel to the end of the Toe.

(All sizes are US.)
**Kid:** 6–7½" (15–19 cm)
**Women's shoe sizes 4–6.5:** 8–9" (20.5–23 cm)
**Women's shoe sizes 7–9.5:** 9¼–10" (23–25.5 cm)
**Women's shoe sizes 10–12.5:** 10¼–11" (26–28 cm)
**Men's shoe sizes 6–8.5:** 9¼–10" (23.5–25.5 cm)
**Men's shoe sizes 9–11.5:** 10¼–11" (26–28 cm)
**Men's shoe sizes 12–14:** 11¼–12" (28.5–30.5 cm)

When working a Heel Flap and Gusset, you also need to take into account your Toe length:

**Kid:** 1¼" (3 cm)          **L:** 1½" (4 cm)
**S:** 1½" (4 cm)           **XL:** 1¾" (4 cm)
**M:** 1½" (4 cm)

Now, take your desired Foot length, from back of Heel to end of Toe, and subtract your Toe measurements. For example, my desired Foot length is 9" (23 cm). I subtract my Toe (1½" [4 cm]) and that leaves me with 7½" (19 cm) I need to knit before starting my Toe decreases. Measure starting at the back of the Heel.

## Toe

**Rnd 1:** K1, ssk, k**10 (14, 18, 22, 26)** sts, k2tog, k1, pm, k1, ssk, k**10 (14, 18, 22, 26)** sts, k2tog, k1.
**Rnd 2:** Knit.
**Rnd 3:** K1, ssk, knit to 3 sts before next marker, k2tog, k1, sl m, k1, ssk, knit around to 3 sts before end of rnd, k2tog, k1.

Repeat rnds 2 and 3 until **16 (20, 24, 28, 32)** sts remain.

Use Kitchener Stitch to close the Toe (see page 33).

## Finishing

Weave in all ends and block your socks (see chapter 4).

# Shorty DK Socks

## MATERIALS

**Yarn:** Little Lionhead Knits DK Tweed [85% SW Bluefaced Leicester/15% Donegal nep; 246 yards (225 m)/3½ ounces (110g)]: 83 (100, 118, 132, 151) yards [76 (91, 108, 121, 138) m] in Golden Brown (MC)

Knit Picks Stroll, held double: [75% fine superwash merino/25% nylon; 231 yards (211 m)/1¾ ounces (50 g)]: 32 (40, 51, 64, 78) yards [29 (37, 47, 59, 71) m] in Pucker (CC)

*Note: When you knit holding two strands of fingering weight yarn together, you achieve a DK weight. You can use any fingering weight sock yarn held double, or a single strand of any DK yarn.*

**Needles:** US size 3 (3.25 mm)

**Notions:** Tapestry needle, stitch markers, snips, measuring tape

**Gauge:** 24 sts = 3¼" (8 cm), knit in stockinette in the rnd and blocked

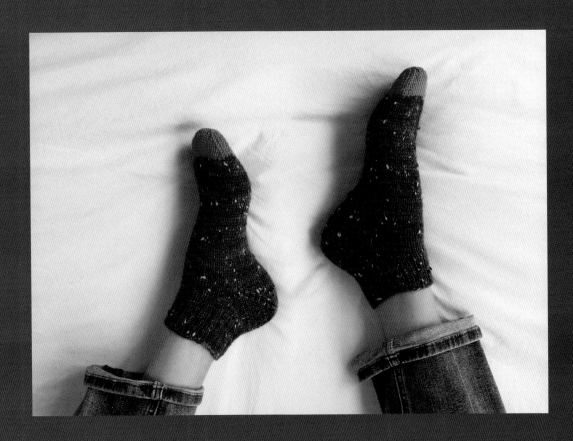

## Sizes
Kid (S, M, L, XL)

## Measurements
The numbers below refer to the circumference of the ball of the foot, not the measurements of the finished sock.

5–6 (7, 8, 9, 10)" [13–15 (18, 20, 23, 25) cm]

# INSTRUCTIONS

## Cuff
With MC, CO **33 (39, 48, 57, 63)** sts and join for working in the rnd, being careful not to twist your sts. Est 2×1 rib pattern: [k2, p1] to end.

Cont working rib pattern until Cuff measures 1½" (4 cm), or your desired length. On the last rnd of the ribbing, we need to get our stitch count back to an even number. If you are working the size M, you already have an even number and can move on to the Leg instructions. Otherwise, make the following increase or decrease according to your size:

**Kid:** Work in rib pattern to the last 3 sts, k2tog, p1. **32** sts.

**S:** Work in rib pattern to the last 3 sts, kfb, k1, p1. **40** sts.

**L:** Work in rib pattern to the last 3 sts, k2tog, p1. **56** sts.

**XL:** Work in rib pattern to the last 3 sts, kfb, k1, p1. **64** sts.

## Leg
Work in Stockinette (knit every st) until Leg (including Cuff) measures 2" (5 cm), or your desired length. If you would like to knit yours longer or shorter, use the table below to determine a good measurement for various sizes.

**Shorty Socks:** Typically 1–2" (2.5–5 cm)
**Kid Socks:** 4–6" (10–15 cm)
**Adult Mid-calf:** 4–6" (10–15 cm)
**Adult Tall:** 7" (18 cm and up)

Once you are satisfied with the length of your Leg, it's time to move on to the Heel.

## German Short-Row Heel
*Note: For a detailed tutorial on the techniques used in this Heel, visit page 49.*

Once you've decided your Leg is long enough, on the next rnd, knit across **16 (20, 24, 28, 32)** sts. Now we need to place markers before beginning our Heel, which will be worked across the remaining **16 (20, 24, 28, 32)** sts. Follow the instructions according to your size below:

**Kid:** K5, pm, k6, pm, k5. Turn work.
**S:** K6, pm, k8, pm, k6. Turn work.
**M:** K8, pm, k8, pm, k8. Turn work.
**L:** K9, pm, k10, pm, k9. Turn work.
**XL:** K10, pm, k12, pm, k10. Turn work.

You should be looking at the wrong side of your work. Wyif (you will always slip wyif), slip the first st and mds (see page 50). Purl to the end, then turn work.

Slip the first st and mds. Knit all the way to where you made the mds on the previous row and turn work. Mds, then purl all the way to where you made the mds on the previous row. Turn work, sl the sts, mds, then knit to the next mds.

Cont repeating these instructions until you have worked all the sts on either side of your markers. When finished, you should have a line of double sts on either side of your markers.

Knit across the Heel sts in between the two markers, then sl m, and knit the first double st together. Cont knitting the double sts together until you have worked all of them.

Knit across the first **16 (20, 24, 28, 32)** sts that make up the front of your sock. You should be at the Heel needle again. Knit each double st together, then work across the remainder of your Heel sts, slipping the markers as you come to them.

Knit across the first **16 (20, 24, 28, 32)** sts again, then knit across the Heel sts to the second marker on the Heel needle. Remove that marker, k1, turn work, mds, then purl to the other m. Remove the m, p1, mds, turn work. Knit to the first mds you made on the previous rnd, knit the double st together, k1, turn work, mds. Purl to the mds you made on the previous rnd, purl the double st together, p1, turn work, mds.

Cont in this pattern until you've used all the sts on either end of the needle. Resume knitting all your sock sts in the rnd, knitting the remaining double st together when you come to it.

## Foot

Cont working in Stockinette until your work reaches just to the tip of your pinky toe. If you can't easily try the sock on, or if you are knitting gift socks, the Craft Yarn Council has issued the following length guidelines for the Foot of a sock, measured from the back of the Heel to the end of the Toe.

(All sizes are US.)
**Kid:** 6–7½" (15–19 cm)
**Women's shoe sizes 4–6.5:** 8–9" (20.5–23 cm)

**Women's shoe sizes 7–9.5:** 9¼–10" (23–25.5 cm)
**Women's shoe sizes 10–12.5:** 10¼–11" (26–28 cm)
**Men's shoe sizes 6–8.5:** 9¼–10" (23.5–25.5 cm)
**Men's shoe sizes 9–11.5:** 10¼–11" (26–28 cm)
**Men's shoe sizes 12–14:** 11¼–12" (28.5–30.5 cm)

When working a German Short-Row Heel, you also need to take into account your toe length:

**Kid:** 1¼" (3 cm)        **L:** 1½" (4 cm)
**S:** 1½" (4 cm)          **XL:** 1¾" (4 cm)
**M:** 1½" (4 cm)

Now, take your desired Foot length, from back of Heel to end of Toe, and subtract your Toe measurements. For example, my desired Foot length is 9" (23 cm). I subtract my Toe (1½" [4 cm]) and that leaves me with 7½" (19 cm) I need to knit before starting my Toe decreases. Measure starting at the back of the Heel.

## Toe

Break MC and join in CC. Knit 1 rnd even, then begin the following decrease pattern:

**Rnd 1:** K1, ssk, k**10 (14, 18, 22, 26)** sts, k2tog, k1, pm, k1, ssk, k**10 (14, 18, 22, 26)** sts, k2tog, k1.
**Rnd 2**: Knit.
**Rnd 3:** K1, ssk, knit to 3 sts before next marker, k2tog, k1, sl m, k1, ssk, knit around to 3 sts before end of rnd, k2tog, k1.

Repeat rnds 2 and 3 until **16 (20, 24, 28, 32)** sts remain.

Use Kitchener Stitch to close the Toe (see page 33).

## Finishing

Weave in all ends and block your sock (see chapter 4).

# Just Add Mohair Socks

While DK weight socks can be achieved with DK yarn (of course), you can also create thick socks by holding two strands of fingering weight yarn together. And to create really luxurious socks, hold a strand of silk mohair, or baby alpaca, together with a strand of fingering weight sock yarn. These are absolutely the softest, coziest, warmest socks I've ever made. I only get to wear them about three days a year because of the aforementioned perpetual heat dome I live under, but those three days are magical.

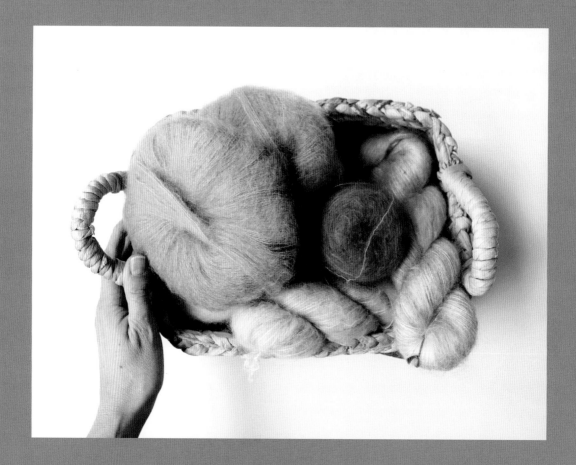

## MATERIALS

Yarn: A Knitter's Homestead Sock [100% organic non-superwash merino; fingering weight] held together with A Knitter's Homestead Silk Mohair [72% kid mohair/28% silk; laceweight] : 148 (161, 180, 202, 224) [135 (147, 165, 185, 205) m] each in Cappuccino (sock) and Potter's Clay (silk) (MC)

A Knitter's Homestead Sock held together with A Knitter's Homestead Silk Mohair: 124 (143, 160, 183, 204) yards [113 (131, 146, 167, 187) m] each in Goldfinch (sock) and Potter's Clay (silk) (CC)

*Note: When you knit holding a strand of fingering weight yarn together with mohair, you achieve a DK weight. You can use any fingering weight yarn, and any mohair yarn you like.*

Needles: US size 3 (3.25 mm)

Notions: Tapestry needle, stitch markers, snips, measuring tape

Gauge: 28 sts = 3¾" (9.5 cm), knit in Stockinette in the rnd and blocked

### Sizes
Kid (S, M, L, XL)

### Measurements
The numbers below refer to the circumference of the ball of the foot, not the measurements of the finished sock.

5–6 (7, 8, 9, 10)" [13–15 (18, 20, 23, 25) cm]

### Stripe Pattern
Knit 5 rnds of each color.

## INSTRUCTIONS

### Cuff
With MC, CO **32 (40, 48, 56, 64)** sts and join for working in the rnd, being careful not to twist your sts. Est 1×1 ribbing: [k1, p1] to end.

Cont working 1×1 ribbing until Cuff measures ½" (1 cm), or your desired length.

Break MC.

### Leg
Join in CC and begin working Stripe Pattern. Work in Stockinette (knit every st) until Leg (including Cuff) measures 6" (15 cm), or your desired length. If you would like to knit yours longer or shorter, use the table below to determine a good measurement for various sizes.

**Shorty Socks:** Typically 1–2" (2.5–5 cm)
**Kid Socks:** 4–6" (10–15 cm)
**Adult Mid-calf:** 4–6" (10–15 cm)
**Adult Tall:** 7" (18 cm and up)

Once you are satisfied with the length of your Leg, it's time to move on to the Heel. I finished my Leg after working a yellow stripe.

### Heel Flap
The Heel Flap is worked in MC. Knit across the first **16 (20, 24, 28, 32)** sts, then begin working your Heel Flap back and forth across the remaining **16 (20, 24, 28, 32)** sts as follows:

**Row 1 (RS):** K2, [slip 1, k1] to end. Turn work.
**Row 2 (WS):** Slip 1 wyif, p to end. Turn work.
**Row 3:** [Slip, k1] to end. Turn work.

Repeat rows 2 and 3 until Heel Flap measures 1.75 (2, 2, 2.25, 2.5)" [4.5 (5, 5, 6, 6.5) cm]. End after you have worked row 3.

## Heel Turn

**Row 1 (WS):** Slip 1 wyif, p8 (10, 12, 14, 16), p2tog, p1, turn.
**Row 2 (RS):** Slip 1, k3, ssk, k1, turn.
**Row 3:** Slip 1 wyif, p4, p2tog, p1, turn.
**Row 4:** Slip 1, k5, ssk, k1, turn.

You have now established the following pattern for your Heel Turn: slip 1, knit or purl to 1 st before the gap created by turning on the previous row, ssk or p2tog, k1 or p1, turn. Cont in this pattern until all your Heel sts have been worked, ending on a RS row. You should now have **10 (12, 14, 16, 18)** Heel sts.

## Gusset

With the right side of your work facing, pick up and knit **6 (8, 8, 8, 10)** sts along the left side of your Heel Flap.

Next, knit across the **16 (20, 24, 28, 32)** sts that we've left undisturbed on our needles while working our Heel Flap. Pm, and pick up **6 (8, 8, 8, 10)** sts on the right side of your Heel Flap. Knit across the Heel sts, then knit down the first set of new sts you picked up on the left side. You've reached the end of the rnd, and all your sts have now been picked up. You should now have **38 (48, 54, 60, 70)** sts total on your needles.

## Gusset Decreases

**Rnd 1:** Knit across **16 (20, 24, 28, 32)** sts, sl marker, k1, ssk, knit around to 3 sts before the end of rnd, k2tog, k1.
**Rnd 2:** Work even with no decreases.

Repeat these two rnds until you have **32 (40, 48, 56, 64)** sts on your needles, while at the same time continuing to work the Stripe Pattern.

## Foot

Cont working the Stripe Pattern in Stockinette until your work reaches just to the tip of your pinky toe.

*Note: Try to end your Foot with a CC stripe, since your Toe will be worked in MC.*

If you can't easily try the sock on, or if you are knitting gift socks, the Craft Yarn Council has issued the following length guidelines for the Foot of a sock, measured from the back of the Heel to the end of the Toe.

(All sizes are US.)
**Kid:** 6–7½" (15–19 cm)
**Women's shoe sizes 4–6.5:** 8–9" (20.5–23 cm)
**Women's shoe sizes 7–9.5:** 9¼–10" (23–25.5 cm)
**Women's shoe sizes 10–12.5:** 10¼–11" (26–28 cm)
**Men's shoe sizes 6–8.5:** 9¼–10" (23.5–25.5 cm)
**Men's shoe sizes 9–11.5:** 10¼–11" (26–28 cm)
**Men's shoe sizes 12–14:** 11¼–12" (28.5–30.5 cm)

When working a Heel Flap and Gusset, you also need to take into account your Toe length:

**Kid:** 1¼" (3 cm)          **L:** 1½" (4 cm)
**S:** 1½" (4 cm)            **XL:** 1¾" (4 cm)
**M:** 1½" (4 cm)

Now, take your desired Foot length, from back of Heel to end of Toe, and subtract your Toe measurements. For example, my desired Foot length is 9" (23 cm). I subtract my Toe (1½" [4 cm]) and that leaves me with 7½" (19 cm) I need to knit before starting my Toe decreases. Measure starting at the back of the Heel.

## Toe

The Toe is worked in MC.

**Rnd 1:** K1, ssk, k**10 (14, 18, 22, 26)** sts, k2tog, k1, pm, k1, ssk, k**10 (14, 18, 22, 26)** sts, k2tog, k1.
**Rnd 2:** Knit.
**Rnd 3:** K1, ssk, knit to 3 sts before next marker, k2tog, k1, sl m, k1, ssk, knit around to 3 sts before end of rnd, k2tog, k1.

Repeat rnds 2 and 3 until **16 (20, 24, 28, 32)** sts remain.

Use Kitchener Stitch to close the Toe (see page 33).

## Finishing

Weave in all ends and block your socks (see chapter 4).

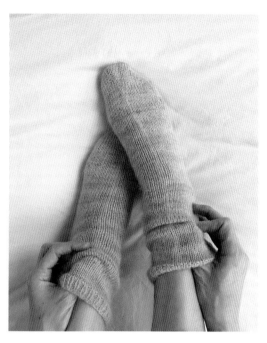

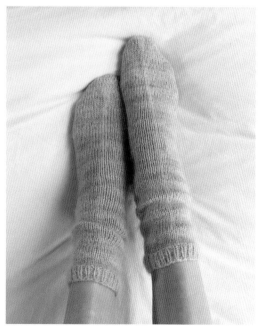

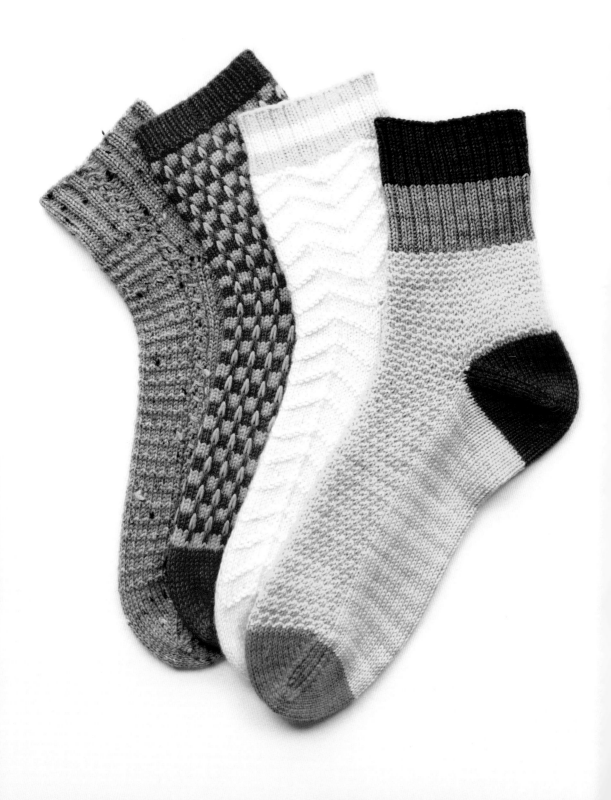

# Chapter 9
# SOCKS WITH KNITS, PURLS & SLIPPED STITCHES

Once you've knit up a pretty pile of basic socks, and you've grown confident in the construction techniques, adding in texture via simple knits, purls, and slipped stitches is the next step in developing your sock-knitting skills. In this chapter, I've included four socks that incorporate interesting stitch patterns that are easy for beginners, and fun for advanced knitters as well. All you need to know is how to knit, purl, slip a stitch, and make a yarn over.

# Surf Wax Socks

Having spent my entire life in a landlocked state with only lake "beaches" to enjoy (and let me tell you, there's not a lot to enjoy about a man-made Oklahoma lake beach, despite what our tourism board will try to sell you on), I've developed a bit of a fascination with surf culture, and people who just live by the sea, like it's totally normal. While I've never done it myself, the *idea* of Rollerblading down a beach boardwalk, listening to Fleetwood Mac, and watching whales breach in the distance sounds like it would probably be the best day ever. These socks are my homage to that perfect day in a little surf town on the Pacific coast (which, again, I've never actually been to!).

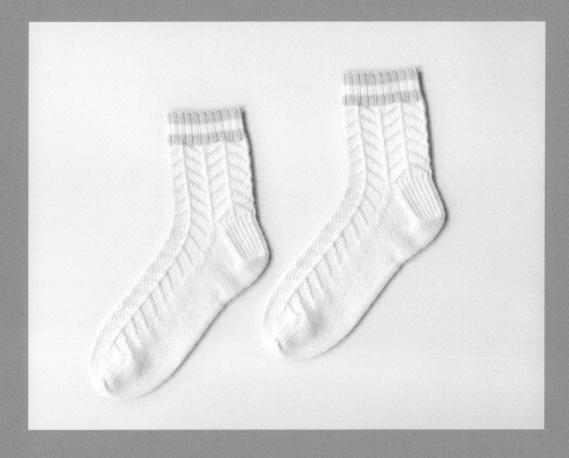

## MATERIALS

**Yarn:** Knit Picks Stroll [75% fine superwash merino/25% nylon; 231 yards (211 m)/1¾ ounces (50 g)]: 219 (248, 276, 302) yards [200 (227, 252, 276) m] in Bare (MC)

Hedgehog Fibres Sock [90% superwash merino/10% nylon; 437 yards (400 m)/3½ ounces (100 g)]: 10 (14, 18, 22) yards [9 (13, 16, 20) m] in UFO (CC)

*Note: As always, any fingering weight sock yarn will do.*

**Needles:** US size 1 (2.25 mm )

**Notions:** Tapestry needle, snips, measuring tape, stitch markers

**Gauge:** 36 sts = 4" (10 cm), knit in Chevron Pattern in the round and blocked

**Sizes**
S (M, L, XL)

**Measurements**
The numbers below refer to the circumference of the ball of the foot, not the measurements of the finished sock.

7 (8, 9, 10)" (18, 20, 23, 25 cm)

## Chevron Pattern
**Size S**
**Rnd 1:** [Slip 1, k5, p1, slip 1, p1, k5] 4 times.
**Rnd 2:** [K5, p2, k1, p2, k4] 4 times.
**Rnd 3:** [Slip 1, k3, p2, k1, slip 1, k1, p2, k3] 4 times.
**Rnd 4:** [K3, p2, k5, p2, k2] 4 times.
**Rnd 5:** [Slip 1, k1, p2, k3, slip 1, k3, p2, k1] 4 times.
**Rnd 6:** [K1, p2, k9, p2] 4 times.
**Rnd 7:** [Slip 1, p1, k5, slip 1, k5, p1] 4 times.

**Size M**
**Rnd 1:** [Slip 1, k6, p1, slip 1, p1, k6] 4 times.
**Rnd 2:** [K6, p2, k1, p2, k5] 4 times.
**Rnd 3:** [Slip 1, k4, p2, k1, slip 1, k1, p2, k4] 4 times.
**Rnd 4:** [K4, p2, k5, p2, k3] 4 times.
**Rnd 5:** [Slip 1, k2, p2, k3, slip 1, k3, p2, k2] 4 times.
**Rnd 6:** [K2, p2, k9, p2, k1] 4 times.
**Rnd 7:** [Slip 1, p2, k5, slip 1, k5, p2] 4 times.
**Rnd 8:** [K1, p1, k13, p1] 4 times.

**Size L**
**Rnd 1:** [Slip 1, k7, p1, slip 1, p1, k7] 4 times.
**Rnd 2:** [K7, p2, k1, p2, k6] 4 times.
**Rnd 3:** [Slip 1, k5, p2, k1, slip 1, k1, p2, k5] 4 times.
**Rnd 4:** [K5, p2, k5, p2, k4] 4 times.
**Rnd 5:** [Slip 1, k3, p2, k3, slip 1, k3, p2, k3] 4 times.
**Rnd 6:** [K3, p2, k9, p2, k2] 4 times.
**Rnd 7:** [Slip 1, k1, p2, k5, slip 1, k5, p2, k1] 4 times.
**Rnd 8:** [K1, p2, k13, p2] 4 times.
**Rnd 9:** [Slip 1, p1, k7, slip 1, k7, p1] 4 times.

**Size XL**
**Rnd 1:** [Slip 1, k8, p1, slip 1, p1, k8] 4 times.
**Rnd 2:** [K8, p2, k1, p2, k7] 4 times.
**Rnd 3:** [Slip 1, k6, p2, k1, slip 1, k1, p2, k6] 4 times.
**Rnd 4:** [K6, p2, k5, p2, k5] 4 times.
**Rnd 5:** [Slip 1, k4, p2, k3, slip 1, k3, p2, k4] 4 times.
**Rnd 6:** [K4, p2, k9, p2, k3] 4 times.
**Rnd 7:** [Slip 1, k2, p2, k5, slip 1, k5, p2, k2] 4 times.
**Rnd 8:** [K2, p2, k13, p2, k1] 4 times.
**Rnd 9:** [Slip 1, p2, k7, slip 1, k7, p2] 4 times.
**Rnd 10:** [K1, p1, k17, p1] 4 times.

# INSTRUCTIONS

## Cuff

With CC, CO **57 (63, 72, 81)** sts and join for working in the rnd, being careful not to twist your sts. Establish 2×1 rib pattern: [k2, p1] to end.

*TIP: Use the trick you learned on page 91 for making neat transitions between colors on ribbing.*

In rib pattern, work 5 more rnds of CC. Join in MC and work 6 rnds. Finish with 6 more rnds of CC. On the last rnd of the ribbing, we need to get our stitch count back to an even number. If you are working size L, you already have an even number and can move on to the Leg instructions. The rest of you, make the following increase or decrease according to your size:

**S:** Work in rib pattern to the last 3 sts, k2tog, p1. **56** sts.

**XL:** Work in rib pattern to last 3 sts, k2tog, p1. **80** sts.

**M:** Work in rib pattern to the last 3 sts, kfb, k1, p1. **64** sts.

Break CC.

## Leg

Begin working the Chevron Pattern that corresponds to your size. Repeat all **7 (8, 9, 10)** rnds of the pattern until your Leg (including Cuff) measures 4½" (11 cm), or your desired length. It does not matter on which rnd of the Chevron Pattern you end, however I think it looks tidier if you end after completing the last rnd of the pattern.

## Heel Flap

Work in established Chevron Pattern across the first **28 (32, 36, 40)** sts. Begin working your Heel Flap back and forth across the remaining **28 (32, 36, 40)** sts as follows:

**Row 1 (RS):** K2, [slip 1, k1] to end. Turn work.
**Row 2 (WS):** Slip 1 wyif, p to end. Turn work.
**Row 3:** [Slip 1, k1] to end. Turn work.

Repeat rows 2 and 3 until Heel Flap measures **2 (2, 2.25, 2.5)" [5 (5, 6, 6.5) cm]**. End after you have worked row 3.

## Heel Turn

**Row 1 (WS):** Slip 1 wyif, p14 (16, 18, 20), p2tog, p1, turn.
**Row 2 (RS):** Slip 1, k3, ssk, k1, turn.
**Row 3:** Slip 1 wyif, p4, p2tog, p1, turn.
**Row 4:** Slip 1, k5, ssk, k1, turn.

You have now established the following pattern for your Heel Turn: slip 1, knit or purl to 1 st before the gap created by turning on the previous row, ssk or p2tog, k1 or p1, turn. Cont in this pattern until all your Heel sts have been worked, ending on a RS row. You should now have **16 (18, 20, 22)** Heel sts.

## Gusset

With the right side of your work facing, pick up and knit **12 (14, 16, 18)** sts along the left side of your Heel Flap.

Next, work **28 (32, 36, 40)** sts across the front of your sock in established Chevron Pattern. Pm, and pick up **12 (14, 16, 18)** sts on the right side of your Heel Flap. Knit across the Heel sts, then knit down the first set of new sts you

picked up on the left side. You've reached the end of the rnd, and all your sts have now been picked up. You should now have **68 (78, 88, 98)** sts total on your needles.

### Gusset Decreases
**Row 1:** Work in established Chevron Pattern across **28 (32, 36, 40)** sts, sl marker, k1, ssk, knit around to 3 sts before the end of rnd, k2tog, k1.
**Row 2:** Work even with no decreases.
Repeat these two rnds until you have **56 (64, 72, 80)** sts on your needles.

### Foot
Cont working in established Chevron Pattern across the first **28 (32, 36, 40)** and working Stockinette (knit every st) across the remaining **28 (32, 36, 40)** sts until your Foot reaches your desired length before beginning your Toe decreases. The Craft Yarn Council has issued the following length guidelines for the Foot of a sock, measured from the back of the Heel to the end of the Toe.

(All sizes are US.)
**Women's shoe sizes 4–6.5:** 8–9" (20.5–23 cm)
**Women's shoe sizes 7–9.5:** 9¼–10" (23–25.5 cm)
**Women's shoe sizes 10–12.5:** 10¼–11" (26–28 cm)
**Men's shoe sizes 6–8.5:** 9¼–10" (23.5–25.5 cm)
**Men's shoe sizes 9–11.5:** 10¼–11" (26–28 cm)
**Men's shoe sizes 12–14:** 11¼–12" (28.5–30.5 cm)

When working a Heel Flap and Gusset, you also need to take into account your toe length:

**S:** 1½" (4 cm)          **L:** 1½" (4 cm)
**M:** 1½" (4 cm)          **XL:** 1¾" (4 cm)

Now, take your desired Foot length, from back of Heel to end of Toe, and subtract your Toe measurements. For example, my desired Foot length is 9" (23 cm). I subtract my Toe (1½" [4 cm]) and that leaves me with 7½" (19 cm) I need to knit before starting my Toe decreases. Measure starting at the back of the Heel.

It does not matter on which rnd of the Chevron Pattern you end.

### Toe
Begin the following decrease pattern for your Toe:

**Rnd 1:** K1, ssk, k**22 (26, 30, 34)** sts, k2tog, k1, pm, k1, ssk, k**22 (26, 30, 34)** sts, k2tog, k1.
**Rnd 2:** Knit.
**Rnd 3:** K1, ssk, knit to 3 sts before next marker, k2tog, k1, sl m, k1, ssk, knit around to 3 sts before end of rnd, k2tog, k1.

Repeat rnds 2 and 3 until **24 (28, 32, 36)** sts remain.

Graft your Toe closed using Kitchener Stitch (see page 33).

### Finishing
Weave in all ends and block your socks (see chapter 4).

# Trompe le Monde Socks

Slipped stitches produce knitting magic when you work with two or more colors. These socks give the illusion of stranded colorwork, but you only ever work with one color at a time. Make sure to check out my tips on page 73 for working jogless two-color stripes with very few ends to weave in.

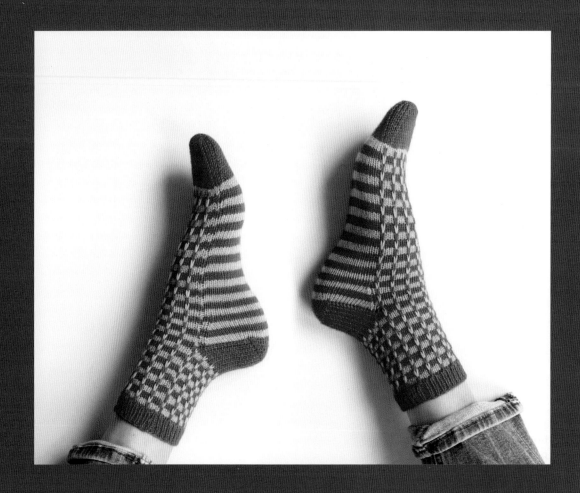

## MATERIALS

**Yarn:** Knit Picks Stroll [75% fine superwash merino/25% nylon; 231 yards (211 m)/1¾ ounces (50 g)]: 91 (105) 128 (140, 166, 189) yards [83 (96) 117 (128, 152, 173) m] in Buoy (MC)

Knit Picks Stroll [75% fine superwash merino/25% nylon; 231 yards (211 m)/1¾ ounces (50 g)]: 72 (83) 97 (112, 129, 142) yards [66 (76) 87 (102, 118, 130) m] in Dogwood Heather (CC)

*Note: As always, any fingering weight sock yarn will do.*

**Needles:** US size 1 (2.25 mm)

**Notions:** Tapestry needle, stitch markers, snips, measuring tape

**Gauge:** 36 sts = 4" (10 cm), knit in Slip Stitch Pattern in the rnd and blocked

### Sizes
Toddler (Kid) S (M, L, XL)

### Measurements
The numbers below refer to the circumference of the ball of the foot, not the measurements of the finished sock.

3–4 (5–6) 7 (8, 9, 10)" [8–10 (13–15) 18 (20, 23, 25) cm]

### Slip Stitch Pattern
**Rnds 1–3:** With CC, [k3, slip 1] to end.
**Rnd 4:** With CC, knit even.
**Rnds 5–7:** With MC, [k3, slip 1] to end.
**Rnd 8:** With MC, knit even.

## INSTRUCTIONS

### Cuff
With MC, CO **39 (48) 57 (63, 72, 81)** sts and join for working in the rnd, being careful not to twist your sts. Est 2×1 ribbing: [k2, p1] around to end.

Cont working rib pattern until Cuff measures 1" (2.5 cm), or your desired length. On the last rnd of the ribbing, we need to get our stitch count back to an even number. If you are working the Kid or L sizes, you already have an even number and can move on to the Leg instructions. The rest of you, make the following increase or decrease according to your size:

**Toddler:** Work in rib pattern to the last 3 sts, kfb, k1, p1. **40** sts.

**M:** Work in rib pattern to the last 3 sts, kfb, k1, p1. **64** sts.

**S:** Work in rib pattern to the last 3 sts, k2tog, p1. **56** sts.

**XL:** Work in rib pattern to the last 3 sts, k2tog, p1. **80** sts.

### Leg
**Setup rnd:** With MC, knit 1 rnd even. Cut MC and join in CC. Begin Slip Stitch Pattern. Repeat all 8 rnds of the pattern until Leg (including Cuff!) measures 4" (10 cm), or your desired length. End after working rnd 6 of the pattern.

**Next rnd:** Work in pattern across first **20 (24) 28 (32, 36, 40)** sts, then knit even in Stockinette (knit every st) across the remaining **20 (24) 28 (32, 36, 40)** sts.

## Heel Flap

*Note: If you are following my sample, you should be knitting the Heel in MC.*

Knit in pattern (you should be on rnd 8) across the first **20 (24) 28 (32, 36, 40)** sts, then begin working your Heel Flap back and forth across the remaining **20 (24) 28 (32, 36, 40)** sts as follows:

**Row 1 (RS):** K2, [slip 1, k1] to end. Turn work.
**Row 2 (WS):** Slip 1 wyif, purl to end. Turn work.
**Row 3:** [Slip 1, k1] to end. Turn work.

Repeat rows 2 and 3 until Heel Flap measures **1.5 (1.75) 2 (2, 2.25, 2.5)" [4 (4.5) 5 (5, 6, 6.5) cm]**. End after you have worked row 3.

## Heel Turn

**Row 1 (WS):** Slip 1 wyif, p10 (12) 14 (16, 18, 20), p2tog, p1, turn.
**Row 2 (RS):** Slip 1, k3, ssk, k1, turn.
**Row 3:** Slip 1 wyif, p4, p2tog, p1, turn.
**Row 4:** Slip 1, k5, ssk, k1, turn.

You have now established the following pattern for your Heel Turn: slip 1, knit or purl to 1 st before the gap created by turning on the previous row, ssk or p2tog, k1 or p1, turn. Cont in this pattern until all your Heel sts have been worked, ending on a RS row. You should now have **12 (14) 16 (18, 20, 22)** Heel sts.

## Gusset

With the right side of your work facing, pick up and knit **8 (10) 12 (14, 16, 18)** sts along the left side of your Heel Flap.

Next, work in pattern (you should be on rnd 1 of the Slip Stitch Pattern) across the **20 (24) 28 (32, 36, 40)** sts that we've left undisturbed on our needles while working our Heel Flap. Pm, and pick up **8 (10) 12 (14, 16, 18)** sts on the right side of your Heel Flap. Knit across the Heel sts, then knit down the first set of new sts you picked up on the left side. You've reached the end of the rnd, and all your sts have now been picked up. You should now have **48 (58) 68 (78, 88, 98)** sts total on your needles.

You will cont working the Slip Stitch Pattern across the first **20 (24) 28 (32, 36, 40)** sts, while working plain Stockinette across the remaining **20 (24) 28 (32, 36, 40)** sts as you work the Gusset Decreases and then the Foot.

## Gusset Decreases

**Rnd 1:** Work in pattern across **20 (24) 28 (32, 36, 40)** sts, sl marker, k1, ssk, knit around to 3 sts before the end of rnd, k2tog, k1.
**Rnd 2:** Work even with no decreases.

Repeat these two rnds until you have **40 (48) 56 (64, 72, 80)** sts on your needles.

## Foot

Cont working the Slip Stitch Pattern across the first **20 (24) 28 (32, 36, 40)** sts, and working Stockinette across the remaining **20 (24) 28 (32, 36, 40)** sts until your work reaches just to the end of your pinky toe. If you can't easily try your socks on, or if you are knitting gift socks, the Craft Yarn Council has issued the following length guidelines for the Foot of a sock, measured from the back of the Heel to the end of the Toe.

(All sizes are US.)
**Toddler:** 4½–6" (11–15 cm)
**Kid:** 6–7½" (15–19 cm)
**Women's shoe sizes 4–6.5:** 8–9" (20.5–23 cm)
**Women's shoe sizes 7–9.5:** 9¼–10" (23–25.5 cm)
**Women's shoe sizes 10–12.5:** 10¼–11" (26–28 cm)
**Men's shoe sizes 6–8.5:** 9¼–10" (23.5–25.5 cm)
**Men's shoe sizes 9–11.5:** 10¼–11" (26–28 cm)
**Men's shoe sizes 12–14:** 11¼–12" (28.5–30.5 cm)

When working a Heel Flap and Gusset, you also need to take into account your Toe length:

**S:** 1½" (4 cm)          **L:** 1½" (4 cm)
**M:** 1½" (4 cm)          **XL:** 1¾" (4 cm)

Now, take your desired Foot length, from back of Heel to end of Toe, and subtract your Toe measurements. For example, my desired Foot length is 9"/ (23 cm). I subtract my Toe (1½" [4 cm]) and that leaves me with 7½" (19 cm) I need to knit before starting my Toe decreases. Measure starting at the back of the Heel.

End on rnd 4 or 8 of the Slip Stitch Pattern before working the Toe.

## Toe

With MC, work 1 rnd even in Stockinette, then begin the following decrease pattern for the Toe:

**Rnd 1:** K1, ssk, k**14 (18) 22 (26, 30, 34)** sts, k2tog, k1, pm, k1, ssk, k**14 (18) 22 (26, 30, 34)** sts, k2tog, k1.
**Rnd 2:** Knit.
**Rnd 3:** K1, ssk, knit to 3 sts before next marker, k2tog, k1, sl m, k1, ssk, knit around to 3 sts before end of rnd, k2tog, k1.

Repeat rnds 2 and 3 until **16 (20) 24 (28, 32, 36)** sts remain.

Close the Toe using Kitchener Stitch (see page 33).

## Finishing

Weave in all ends and block your sock (see chapter 4).

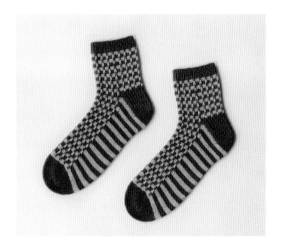

# Soma Socks

The mock cable is such a fantastic stitch to have in your knitting library. You get the sweet look of a tiny cable without having to use an actual cable needle. I've also incorporated the Andalusian stitch in these socks. This simple knit/purl combination creates a beautiful texture that adds such a lovely layer of interest to an otherwise basic sock.

One thing to note about the mock cable that might be useful if you are new to this stitch pattern: You will be decreasing one stitch on the first round of your mock cable, but don't worry. You'll get that stitch back by making a yarn over on the second round of the pattern.

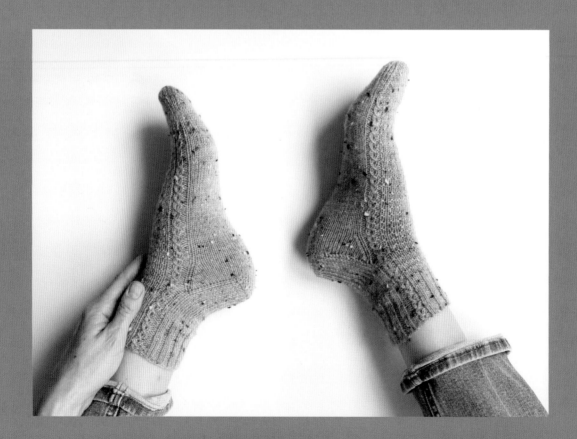

## MATERIALS

**Yarn:** Knit Picks Stroll Tweed [65% fine super-wash merino/25% nylon/10% Donegal tweed; 231 yards (211 m)/1¾ ounces (50 g)]: 149 (166) 180 (192, 212, 234) yards [136 (152) 165 (176, 194, 214) m] in Lavender Field Heather.

*Note: As always, any fingering weight sock yarn will do.*

**Needles:** US size 1 (2.25 mm)

**Notions:** Tapestry needle, stitch markers, snips, measuring tape

**Gauge:** 38 sts = 4" (10 cm), knit in pattern in the rnd and blocked

## Sizes
Toddler (Kid) S (M, L, XL)

## Measurements
The numbers below refer to the circumference of the ball of the foot, not the measurements of the finished sock.

3–4 (5–6) 7 (8, 9, 10)" [8–10 (13–15) 18 (20, 23, 25) cm]

## INSTRUCTIONS

### Cuff
CO **40 (48) 56 (64, 72, 80)** sts and join for working in the rnd, being careful not to twist your sts.

**Setup Rnd:** P1, k3, p1, [k2, p2] **2 (3) 4 (5, 6, 7)** times, k2, p1, k3, p2, [k2, p2] **4 (5) 6 (7, 8, 9)** times, k2, p1.

**Rnd 1:** P1, slip 1, k2, psso, p1, [k2, p2] **2 (3) 4 (5, 6, 7)** times, k2, p1, slip 1, k2, psso, p2, [k2, p2] **4 (5) 6 (7, 8, 9)** times, k2, p1.

**Rnd 2:** P1, k1, yo, k1, p1, [k2, p2] **2 (3) 4 (5, 6, 7)** times, k2, p1, k1, yo, k1, p2, [k2, p2] **4 (5) 6 (7, 8, 9)** times, k2, p1.

**Rnd 3:** P1, k3, p1, [k2, p2] **2 (3) 4 (5, 6, 7)** times, k2, p1, k3, p2, [k2, p2] **4 (5) 6 (7, 8, 9)** times, k2, p1.

**Rnd 4:** P1, k3, p1, [k2, p2] **2 (3) 4 (5, 6, 7)** times, k2, p1, k3, p2, [k2, p2] **4 (5) 6 (7, 8, 9)** times, k2, p1.

The instructions in purple make up your Mock Cable Stitch.

Repeat rnds 1–4 **3 (4) 6 (6, 6, 6)** more times.

### Leg
**Rnd 1:** P1, slip 1, k2, psso, p1, k**10 (14) 18 (22, 26, 30)**, p1, sl 1, k2, psso, p1, k**20 (24) 28 (32, 36, 40)**.

**Rnd 2:** P1, k1, yo, k1, p1, k**10 (14) 18 (22, 26, 30)**, p1, k1, yo, k1, p1, k**20 (24) 28 (32, 36, 40)**.

**Rnd 3:** P1, k3, p1, k**10 (14) 18 (22, 26, 30)**, p1, k3, p1, k**20 (24) 28 (32, 36, 40)**.

**Rnd 4:** P1, k3, p1, [k1, p1] **5 (7) 9 (11, 13, 15)** times, p1, k3, p1, k**20 (24) 28 (32, 36, 40)**.

Repeat rnds 1–4 until your Leg (including Cuff) measures 3" (8 cm), or your desired length. It doesn't matter on which rnd of the pattern you stop for the Heel.

## Heel Flap

Work in pattern across the first **20 (24) 28 (32, 36, 40)** sts, then begin working your Heel Flap back and forth across the remaining **20 (24) 28 (32, 36, 40)** sts as follows:

**Row 1 (RS):** K2, [slip 1, k1] to end. Turn work.
**Row 2 (WS):** Slip 1 wyif, p to end. Turn work.
**Row 3:** [Slip 1, k1] to end. Turn work.

Repeat rows 2 and 3 until Heel Flap measures **1.5 (1.75) 2 (2, 2.25, 2.5)"/4 (4.5) 5 (5, 6, 6.5)** cm. End after you have worked row 3.

## Heel Turn

**Row 1 (WS):** Slip 1 wyif, p10 (12) 14 (16, 18, 20), p2tog, p1, turn.
**Row 2 (RS):** Slip 1, k3, ssk, k1, turn.
**Row 3:** Slip 1 wyif, p4, p2tog, p1, turn.
**Row 4:** Slip 1, k5, ssk, k1, turn.

You have now established the following pattern for your Heel Turn: slip 1, knit or purl to 1 st before the gap created by turning on the previous row, ssk or p2tog, k1 or p1, turn. Cont in this pattern until all your Heel sts have been worked, ending on a RS row. You should now have **12 (14) 16 (18, 20, 22)** Heel sts.

## Gusset

With the right side of your work facing, pick up and knit **8 (10) 12 (14, 16, 18)** sts along the left side of your Heel Flap.

Next, work in pattern across the **20 (24) 28 (32, 36, 40)** sts that we've left undisturbed on our needles while working our Heel Flap. Pm, and pick up **8 (10) 12 (14, 16, 18)** sts on the right side of your Heel Flap. Knit across the Heel sts, then knit down the first set of new sts you picked up on the left side. You've reached the end of the rnd, and all your sts have now been picked up. You should now have **48 (58) 68 (78, 88, 98)** sts total on your needles.

## Gusset Decreases

**Rnd 1:** Work in pattern across **20 (24) 28 (32, 36, 40)** sts, sl marker, k1, ssk, knit around to 3 sts before the end of rnd, k2tog, k1.
**Rnd 2:** Work even with no decreases.

Repeat these two rnds until you have **40 (48) 56 (64, 72, 80)** sts on your needles.

## Foot

Cont working in pattern across the first **20 (24) 28 (32, 36, 40)** sts, and working Stockinette (knit every st) across the remaining **20 (24) 28 (32, 36, 40)** sts until your work reaches just to the tip of your pinky toe. If you can't easily try your socks on as you knit (working on double-pointed needles or tiny circulars can make this challenging), or if you are knitting gift socks for some lucky recipient,

the Craft Yarn Council has issued the following length guidelines for the Foot of a sock, measured from the back of the Heel to the end of the Toe. End after working rnd 3 or 4 of the Mock Cable Stitch pattern.

(All sizes are US.)
**Toddler:** 4½–6 (11–15 cm)
**Kid:** 6–7½" (15–19 cm)
**Women's shoe sizes 4–6.5:** 8–9" (20.5–23 cm)
**Women's shoe sizes 7–9.5:** 9¼–10" (23–25.5 cm)
**Women's shoe sizes 10–12.5:** 10¼–11" (26–28 cm)
**Men's shoe sizes 6–8.5:** 9¼–10"(23.5–25.5 cm)
**Men's shoe sizes 9–11.5:** 10¼–11" (26–28 cm)
**Men's shoe sizes 12–14:** 11¼–12" (28.5–30.5 cm)

When working a Heel Flap and Gusset, you also need to take into account your Toe length:

| | |
|---|---|
| **Toddler:** 1" (2.5 cm) | **M:** 1½" (4 cm) |
| **Kid:** 1¼" (3 cm) | **L:** 1½" (4 cm) |
| **S:** 1½" (4 cm) | **XL:** 1¾" (4 cm) |

Now, take your desired Foot length, from back of Heel to end of Toe, and subtract your Toe measurements. For example, my desired Foot length is 9" (23 cm). I subtract my Toe (1½" [4 cm]) and that leaves me with 7½" (19 cm) I need to knit before starting my Toe decreases. Measure starting at the back of the Heel.

## Toe

**Rnd 1:** K1, ssk, k**14 (18) 22 (26, 30, 34)** sts, k2tog, k1, pm, k1, ssk, k**14 (18) 22 (26, 30, 34)** sts, k2tog, k1.
**Rnd 2:** Knit.
**Rnd 3:** K1, ssk, knit to 3 sts before next marker, k2tog, k1, sl m, k1, ssk, knit around to 3 sts before end of rnd, k2tog, k1.

Repeat rnds 2 and 3 until **16 (20) 24 (28, 32, 36)** sts remain.

Close the Toe sts with Kitchener Stitch (see page 33).

## Finishing

Weave in all ends and block your socks (see chapter 4).

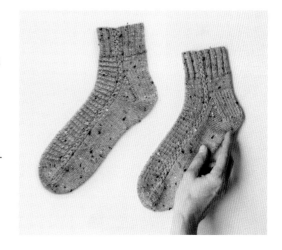

# Luna Socks

This stitch pattern creates the squishiest, softest fabric. I've used it here in a colorful pair of socks, but it would also look lovely dressed down in a neutral tweed, or a tonal yarn. The beauty of sock knitting is that customization requires almost no special skills. Simply changing the yarn choice, or shortening the cuff, can make a dramatic difference. Use my special trick on page 92 to get a neat color transition on your ribbing.

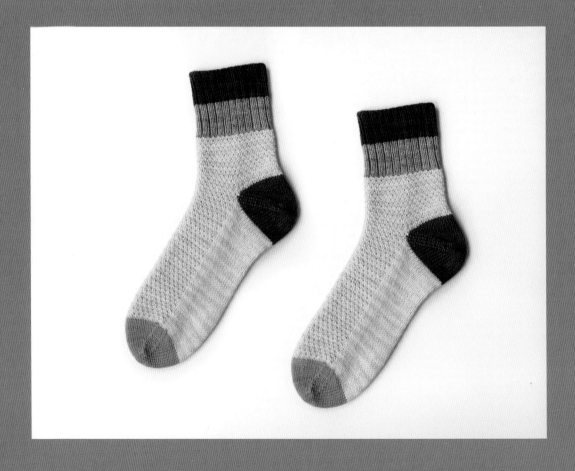

## MATERIALS

**Yarn:** Hedgehog Fibres Sock [90% superwash merino/10% nylon; 437 yards (400 m)/3½ ounces (100 g)]: 83 (102) 121 (144, 168, 189) yards [76 (93) 111 (132, 154, 173) m] in UFO (MC)

Spun Right Round Classic Sock 100% superwash merino; 438 yards (401 m)/3½ ounces (100 g): 16 (21) 27 (36, 42, 51) yards [15 (19) 25 (33, 38, 47) m] in OOAK (CC1)

Twisted Ambitions Yarn Sweet Sock [75% superwash merino/25% nylon; 463 yards (423 m)/3½ ounces (100 g)]: 16 (21) 27 (36, 42, 51) yards [15 (19) 25 (33, 38, 47) m] in Rust (CC2)

Filcolana Arwetta [80% superwash merino/20% nylon; 230 yards (210 m)/1¾ ounces (50 g)]: 10 (12) 14 (16, 18, 20) yards [9 (11) 13 (15, 16, 18) m] in 352 Red Squirrel (CC3)

Knit Picks Stroll [75% fine superwash merino/25% nylon; 231 yards (211 m)/1¾ ounces (50 g)]: 10 (12) 14 (16, 18, 20) yards [9 (11) 13 (15, 16, 18) m] in Pucker (CC4)

*Note: As always, any fingering weight sock yarn will do.*

**Needles:** US size 1 (2.25 mm)

**Notions:** Tapestry needle, stitch markers (including a clasp marker), snips, measuring tape

**Gauge:** 38 sts = 4" (10 cm), knit in primary stitch pattern in the round and blocked

## Sizes

Toddler (Kid) S (M, L, XL)

## Measurements

The numbers below refer to the circumference of the ball of the foot, not the measurements of the finished sock.

3–4 (5–6) 7 (8, 9, 10)" [8–10 (13–15) 18 (20, 23, 25) cm]

## INSTRUCTIONS

### Cuff

With CC1, CO **39 (48) 57 (63, 72, 81)** sts and join for working in the rnd, being careful not to twist your sts. Est 2×1 ribbing: [k2, p1] to end.

Cont working the ribbing until your Cuff measures 1½" (4 cm). Break CC1 and join in CC2. Work 2×1 ribbing an additional 1½" (4 cm). On the last rnd of the ribbing, we need to get our stitch count back to an even number. If you are working the Kid or L sizes, you already have an even number and can move on to the Leg instructions. The rest of you, make the following increase or decrease according to your size:

**Toddler:** Work in rib pattern to the last 3 sts, kfb, k1, p1. **40** sts.

**M:** Work in rib pattern to the last 3 sts, kfb, k1, p1. **64** sts.

**S:** Work in rib pattern to the last 3 sts, k2tog, p1. **56** sts.

**XL:** Work in rib pattern to the last 3 sts, k2tog, p1. **80** sts.

Break CC2.

## Leg

Join in MC and knit 1 rnd even, then begin the following st pattern:

**Rnd 1:** [K1, p1] to end.
**Rnd 2:** Knit.
**Rnd 3:** [P1, k1] to end.
**Rnd 4:** Knit.

Repeat these four rnds until Leg (including Cuff) measures 4½" (11 cm), or your desired length. End after working rnd 2 or 4.

## Placing the Marker for the Afterthought Heel

Once you've decided your Leg is long enough, on the next rnd, work in pattern (you should be on rnd 1 or 3) across **20 (24) 28 (32, 36, 40) sts**, knit in Stockinette (knit every st) across the remaining **20 (24) 28 (32, 36, 40)** sts. Clip a clasp marker on the center st of those last **20 (24) 28 (32, 36, 40)** sts you just knit. You've placed a marker in the center of the last half of your sts, which is where your Afterthought Heel will eventually go. Now move on to the Foot and come back once you've finished the Toe.

## Foot

Cont repeating all 4 rnds of the st pattern across the first **20 (24) 28 (32, 36, 40)** sts, while working Stockinette across the remaining **20 (24) 28 (32, 36, 40)** sts until your work reaches the desired length. The Craft Yarn Council has issued the following length guidelines for the Foot of a sock, measured from the back of the Heel to the end of the Toe.

(All sizes are US.)
**Toddler:** 4½–6" (11–15 cm)
**Kid:** 6–7½" (15–19 cm)
**Women's shoe sizes 4–6.5:** 8–9" (20.5–23 cm)
**Women's shoe sizes 7–9.5:** 9¼–10" (23–25.5 cm)
**Women's shoe sizes 10–12.5:** 10¼–11" (26–28 cm)
**Men's shoe sizes 6–8.5:** 9¼–10" (23.5–25.5 cm)
**Men's shoe sizes 9–11.5:** 10¼–11" (26–28 cm)
**Men's shoe sizes 12–14:** 11¼–12" (28.5–30.5 cm)

When working an Afterthought Heel, you need to take into account both your Heel length and your Toe length (they will be the same).

| | |
|---|---|
| **Toddler:** 1" (2.5 cm) | **M:** 1½" (4 cm) |
| **Kid:** 1¼" (3 cm) | **L:** 1½" (4 cm) |
| **S:** 1½" (4 cm) | **XL:** 1¾" (4 cm) |

Now, take your desired Foot length, from back of Heel to end of Toe, and subtract both your Heel and Toe measurements. For example, my desired Foot length is 9" (23 cm). I subtract my Toe (1½" [4 cm]), and my Heel (1½" [4 cm]) and that leaves me with 6" (15 cm) I need to knit before starting my Toe decreases.

## Toe

Cut MC yarn and join in CC4. Knit 1 rnd even in Stockinette before beginning the following decrease pattern to shape your Toe:

**Rnd 1:** K1, ssk, k14 (18) 22 (26, 30, 34) sts, k2tog, k1, pm, k1, ssk, k14 (18) 22 (26, 30, 34) sts, k2tog, k1.
**Rnd 2:** Knit.
**Rnd 3:** K1, ssk, knit to 3 sts before next marker, k2tog, k1, sl m, k1, ssk, knit around to 3 sts before end of rnd, k2tog, k1.

Repeat rnds 2 and 3 until **16 (20) 24 (28, 32, 36)** sts remain.

Use Kitchener Stitch to close up your Toe (see page 33).

## Knitting the Afterthought Heel

First, place all your Heel sts on your needles (see page 40 for a detailed explanation of this technique). You should have **40 (48) 56 (64, 72, 80)** sts divided evenly on your needles.

Join in CC3 and k 3 rnds even, then begin the following decrease pattern for your Heel:

**Rnd 1:** K1, ssk, k**14 (18) 22 (26, 30, 34)** sts, k2tog, k1, pm, k1, ssk, k**14 (18) 22 (26, 30, 34)** sts, k2tog, k1.
**Rnd 2:** Knit.
**Rnd 3:** K1, ssk, knit to 3 sts before next marker, k2tog, k1, sl m, k1, ssk, knit around to 3 sts before end of rnd, k2tog, k1.

Repeat rnds 2 and 3 until **16 (20) 24 (28, 32, 36)** sts remain.

*Note: You can adjust the depth and fit of your Heel by working more or fewer decrease rnds. Try the sock on occasionally as you work your decreases to see how it's fitting. Stop your decreases when you can easily pinch the fabric closed. If you have to pull the fabric to get it to close over your heel, then you need to work more decrease rnds to give your Heel more depth so it doesn't feel tight across the top of your foot. On your next sock, work more knit rnds before beginning your decreases.*

Use Kitchener Stitch to close your Heel sts (see page 33).

## Finishing

Weave in all ends and block your socks (see chapter 4).

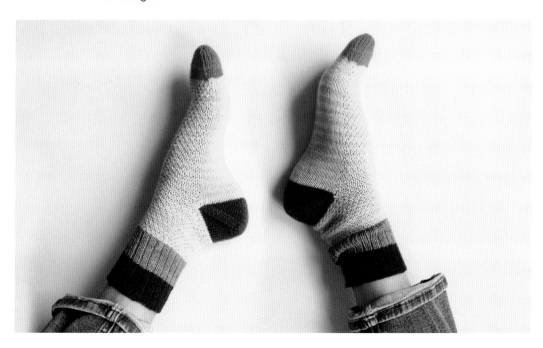

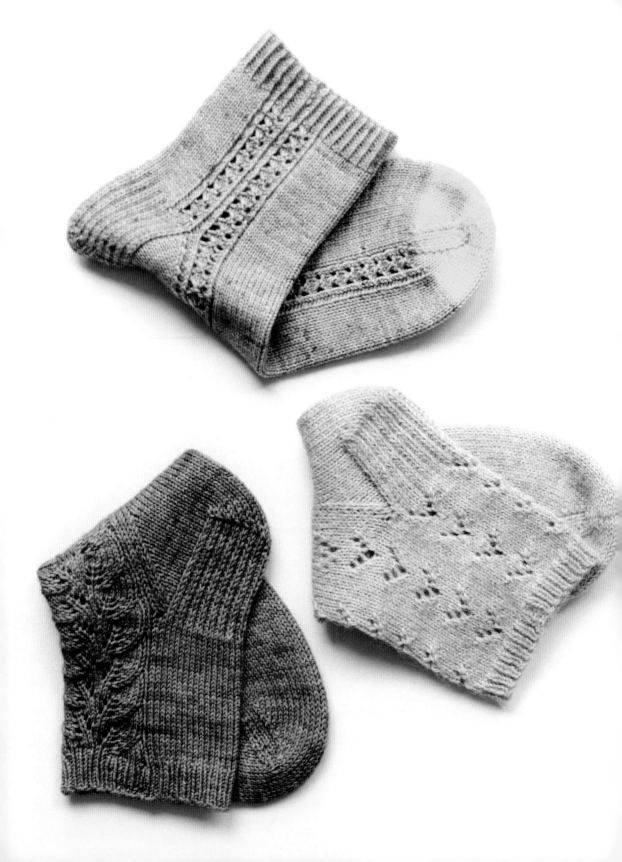

# Chapter 10
# LACE SOCKS

In the early years of my knitting life, I thought lace knitting was some kind of magic employed by only the most wizened, battle-hardened knitters. Surely only ancient beings who had long ago mastered every knitting technique known to humankind could produce such complex, intricate garments. I would look at those designs and despair that my clumsy hands could ever craft something so delicate, so beautiful, so impossible.

But boredom, as it often does, spurred me to try that which looked beyond my reach. (I started playing drums when I went through a dry spell with reading—couldn't find a good book to save my life. So embrace boredom, I say, because you never know what random, thrilling things you'll end up trying or doing.) When I peeked behind the curtain, I discovered that lace was actually quite simple to knit. A decrease here, a yarn over there, and suddenly you've knit yourself a stunning leaf pattern without breaking much of a sweat, proving yet again that knitting really is magic.

# Murmuration Socks

These delicate little socks are one of my favorite patterns. Their
simplicity and timeless style make me feel like the kind of person who has
a clowder of hairless cats, and who sips spiced brandy by a roaring fire
with a book in hand, listening to Nina Simone records in my East Village
pied-á-terre. (Sadly, I don't even have ONE hairless cat, I've never tried
regular brandy—much less the spiced variety, and I'm not entirely sure
I know what a pied-á-terre is. Having spent my entire life in Oklahoma,
however, I have some facts about cross-breeding cows that would blow
your mind.)

 I knit my pair in a lovely soft gray because occasionally I like to
step outside my colorful box and experiment with neutrals. This pattern
would look stunning in an array of yarns, however. Bright jewel tones,
heathered autumnal hues, and even speckled yarns would complement these
sweet little arrows nicely.

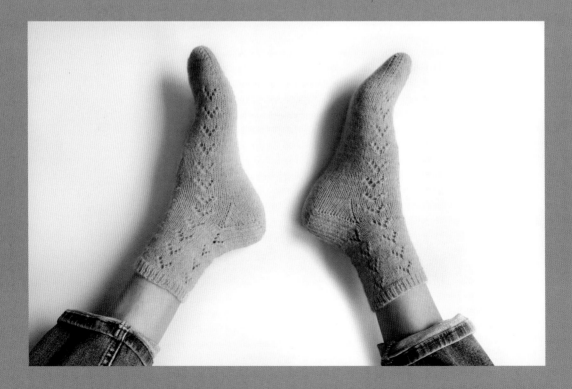

## MATERIALS

**Yarn:** Purl Soho Quartz [65% merino wool/35% suri alpaca; 420 yards (384 m)/3½ ounces (100 g)]: 136 (160, 189, 217) yards [124 (146, 173, 198) m] in Ash Heather.

*Note: As always, any fingering weight sock yarn will do.*

**Needles:** US size 1 (2.25 mm)

**Notions:** Tapestry needle, snips, measuring tape, stitch marker

**Gauge:** 38 sts = 4" (10 cm), knit in lace pattern in the round and blocked

### Sizes
S (M, L, XL)

### Measurements
The numbers below refer to the circumference of the ball of the foot, not the measurements of the finished sock.

7 (8, 9, 10)" [18 (20, 23, 25) cm]

### Lace Arrow Pattern
#### Size S
**Rnd 1:** K4, yo, ssk, [k7, yo, ssk] 5 times, k3.
**Rnds 2 and 4:** Knit.
**Rnd 3:** K2, k2tog, yo, k1, yo, ssk [k4, k2tog, yo, k1, yo, ssk] 4 times, k4, k2tog, yo, k1, yo, ssk, k2.
**Rnd 5:** K1, k2tog, yo, k3, yo, ssk, [k2, k2tog, yo, k3, yo, ssk] 4 times, k2, k2tog, yo, k3, yo, ssk, k1.
**Rnds 6, 7, 8, and 9:** Knit.

#### Size M
**Rnd 1:** K5, yo, ssk, [k9, yo, ssk] 4 times, k9, yo, ssk, k4.
**Rnds 2 and 4:** Knit.
**Rnd 3:** K3, k2tog, yo, k1, yo, ssk [k6, k2tog, yo, k1, yo, ssk] 4 times, k6, k2tog, yo, k1, yo, ssk, k3.
**Rnd 5:** K2, k2tog, yo, k3, yo, ssk, [k4, k2tog, yo, k3, yo, ssk] 4 times, k4, k2tog, yo, k3, yo, ssk, k2.
**Rnds 6, 7, 8, and 9:** Knit.

#### Size L
**Rnd 1:** K4, yo, ssk, [k7, yo, ssk] 6 times, k7, yo, ssk, k3.
**Rnds 2 and 4:** Knit.
**Rnd 3:** K2, k2tog, yo, k1, yo, ssk [k4, k2tog, yo, k1, yo, ssk] 6 times, k4, k2tog, yo, k1, yo, ssk, k2.
**Rnd 5:** K1, k2tog, yo, k3, yo, ssk, [k2, k2tog, yo, k3, yo, ssk] 6 times, k2, k2tog, yo, k3, yo, ssk, k1.
**Rnds 6, 7, 8, and 9:** Knit.

#### Size XL
**Rnd 1:** K4, yo, ssk, [k8, yo, ssk] 6 times, k8, yo, ssk, k4.
**Rnds 2 and 4:** Knit.
**Rnd 3:** K2, k2tog, yo, k1, yo, ssk, [k5, k2tog, k1, yo, ssk] 6 times, k5, k2tog, yo, k1, yo, ssk, k3.
**Rnd 5:** K1, k2tog, yo, k3, yo, ssk, [k3, k2tog, yo, k3, yo, ssk] 6 times, k3, k2tog, yo, k3, ssk, k2.
**Rnds 6, 7, 8, and 9:** Knit.

# INSTRUCTIONS

## Cuff

CO **54 (66, 72, 80)** sts and join for working in the rnd, being careful not to twist your sts. Establish 1×1 rib pattern: [k1, p1] to end.

Cont in 1×1 rib pattern until Cuff measures ¾" (2 cm), or your desired length.

## Leg

Knit 2 rnds in Stockinette (knit every st), then begin working the Lace Arrow Pattern that corresponds to your size. Repeat all 9 rnds of the lace pattern until the Leg (including Cuff) measures 3½" (9 cm), or your desired length. In the sample sock, I worked 4 repeats of the Lace Arrow Pattern before stopping for the Heel. End after completing rnd 7.

**Size S ONLY:** Knit across the first 26 sts (you are on rnd 8 of the lace pattern). M1, k27 sts, m1, k1. **56** sts.

**Size M ONLY:** K across the first 31 sts (you are on rnd 8 of the lace pattern). K2tog, k30, k2tog, k1. **64** sts.

## Heel Flap

Work in Lace Arrow Pattern across the first **28 (32, 36, 40)** sts (Sizes S and M, you should be on Rnd 9, sizes L and XL, you should be on Rnd 8). Begin working your Heel Flap back and forth across the remaining **28 (32, 36, 40)** sts as follows:

**Row 1 (RS):** K2, [slip 1, k1] to end. Turn work.
**Row 2 (WS):** Slip 1 wyif, purl to end. Turn work.
**Row 3:** [Slip 1, k1] to end. Turn work.

Repeat rows 2 and 3 until Heel Flap measures **2 (2, 2.25, 2.5)" [5 (5, 6, 6.5) cm]**. End after you have worked row 3.

## Heel Turn

**Row 1 (WS):** Slip 1 wyif, p**14 (16, 18, 20)**, p2tog, p1, turn.
**Row 2 (RS):** Slip 1, k3, ssk, k1, turn.
**Row 3:** Slip 1 wyif, p4, p2tog, p1, turn.
**Row 4:** Slip 1, k5, ssk, k1, turn.

You have now established the following pattern for your Heel Turn: slip 1, knit or purl to 1 st before the gap created by turning on the previous row, ssk or p2tog, k1 or p1, turn. Cont in this pattern until all your Heel sts have been worked, ending on a RS row. You should now have **16 (18, 20, 22)** Heel sts.

## Gusset

With the right side of your work facing, pick up and knit **12 (14, 16, 18)** sts along the left side of your Heel Flap.

Next, work **28 (32, 36, 40)** sts across the front of your sock in established Lace Arrow Pattern. Pm, and pick up **12 (14, 16, 18)** sts on the right side of your Heel Flap. Knit across the Heel sts, then knit down the first set of new sts you picked up on the left side. You've reached the end of the rnd, and all your sts have now been picked up. You should now have **68 (78, 88, 98)** sts total on your needles.

### Gusset Decreases

**Rnd 1:** Work in established Lace Arrow Pattern across **28 (32, 36, 40)** sts, sl marker, k1, ssk, knit around to 3 sts before the end of rnd, k2tog, k1.
**Rnd 2:** Work even with no decreases.

Repeat these two rnds until you have **56 (64, 72, 80)** sts on your needles.

### Foot

Cont working in established Lace Arrow Pattern across the first **28 (32, 36, 40)** sts, and working Stockinette across the remaining **28 (32, 36, 40)** sts until your Foot reaches your desired length before beginning your Toe decreases. The Craft Yarn Council has issued the following length guidelines for the Foot of a sock, measured from the back of the Heel to the end of the Toe.

(All sizes are US.)
**Women's shoe sizes 4–6.5:** 8–9" (20.5–23 cm)
**Women's shoe sizes 7–9.5:** 9¼–10" (23–25.5 cm)
**Women's shoe sizes 10–12.5:** 10¼–11" (26–28 cm)
**Men's shoe sizes 6–8.5:** 9¼–10" (23.5–25.5 cm)
**Men's shoe sizes 9–11.5:** 10¼–11" (26–28 cm)
**Men's shoe sizes 12–14:** 11¼–12" (28.5–30.5 cm)

When working a Heel Flap and Gusset, you also need to take into account your Toe length:

**S:** 1½" (4 cm)          **L:** 1½" (4 cm)
**M:** 1½" (4 cm)          **XL:** 1¾" (4 cm)

Now, take your desired Foot length, from back of Heel to end of Toe, and subtract your Toe measurements. For example, my desired Foot length is 9" (23 cm). I subtract my Toe (1½" [4 cm]) and that leaves me with 7½" (19 cm) I need to knit before starting my Toe decreases. Measure starting at the back of the Heel.

End after working at least rnd 6 of the pattern.

### Toe

Begin the following decrease pattern for your Toe:

**Rnd 1:** K1, ssk, k**22 (26, 30, 34)** sts, k2tog, k1, pm, k1, ssk, k**22 (26, 30, 34)** sts, k2tog, k1.
**Rnd 2:** Knit.
**Rnd 3:** K1, ssk, k to 3 sts before next marker, k2tog, k1, sl m, k1, ssk, knit around to 3 sts before end of rnd, k2tog, k1.

Repeat rnds 2 and 3 until **24 (28, 32, 36)** sts remain.

Graft your Toe closed using Kitchener Stitch (see page 33).

### Finishing

Weave in all ends and block your socks (see chapter 4).

# Quinata Socks

Speckled or variegated yarns often don't mix well with lace patterns. The intricate designs and stitch patterns tend to get lost when knit up in a busy yarn. I tend to stick with solid or tonal yarns when I'm knitting lace because I want the motif to pop. However, a lightly speckled yarn can turn a feminine, timeless lace pattern into a playful, modern sock. When the lace is limited to a sweet little detail on the sides, both the pattern and the yarn can shine!

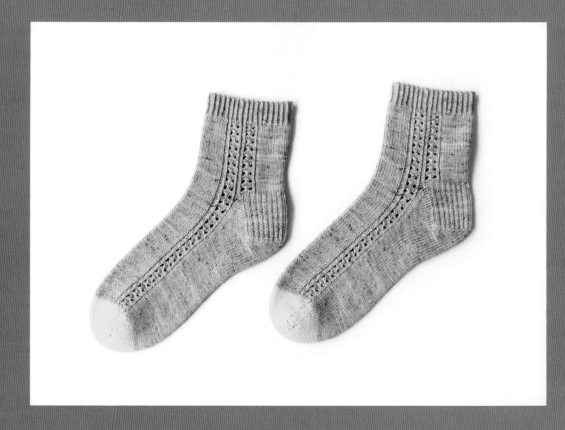

## MATERIALS

**Yarn:** Made By Hailey Bailey Classic Sock [75% superwash merino/25% nylon; 463 yards (423 m)/3½ (100g)]: 212 (240, 269, 292) yards [194 (219, 245, 267) m] in Peony (MC)

Hedgehog Fibres Sock [90% superwash merino/10% nylon; 437 yards (400 m)/3½ ounces (100 g)]: 18 (22, 26, 30) yards [16 (20, 24, 27) m] in UFO (CC)

*Note: As always, any fingering weight sock yarn will do.*

**Needles:** US size 1 (2.25 mm)

**Notions:** Tapestry needle, snips, measuring tape, stitch markers

**Gauge:** 38 sts = 4" (10 cm), knit in pattern in the round and blocked

## Sizes
S (M, L, XL)

## Measurements
The numbers below refer to the circumference of the ball of the foot, not the measurements of the finished sock.

7 (8, 9, 10)" [18 (20, 23, 25) cm]

## Lace Panel
**Rnd 1:** K1tbl, yo, sl 2 sts tog knitwise, k1, p2sso, yo, k1tbl.
**Rnd 2:** K1tbl, p3, k1tbl.
**Rnds 3 and 4:** K1tbl, k3, k1tbl.

## INSTRUCTIONS

### Cuff
With MC, **CO 56 (64, 72, 80)** sts and join for working in the rnd, being careful not to twist your sts. Establish 1×1 twisted rib pattern: [p1tbl, k1tbl] to end.

Cont working 1×1 twisted rib pattern until Cuff measures 1" (2.5 cm), or your desired length.

### Leg
**Setup Rnd:** Next, p1tbl, k1tbl, k3, k1tbl, p1tbl, k**15 (19, 23, 27)**, p1tbl, k1tbl, k3, k1tbl, p1tbl, k1tbl, k3, k1tbl, p1tbl k**15 (19, 23, 27)**, p1tbl, k1tbl, k3, k1tbl.

You have now completed your setup rnd and are ready to incorporate the Lace Panel. You will work the following pattern for the length of the Leg: p1tbl, Lace Panel, p1tbl, k**15 (19, 23, 27)**, p1tbl, Lace Panel, p1tbl, Lace Panel, k**15 (19, 23, 27)**, p1tbl, Lace Panel.

Begin on Rnd 1 of the Lace Panel and repeat those 4 rnds until your Leg measures 3½" (9 cm), or your desired length. End after completing a rnd 3 or 4 of the Lace Panel.

### Heel Flap
Work in established pattern across the first **28 (32, 36, 40)** sts. Begin working your Heel Flap back and forth across the remaining **28 (32, 36, 40)** sts as follows:

**Row 1 (RS):** K2, [slip 1, k1] to end. Turn work.
**Row 2 (WS):** Slip 1 wyif, purl to end. Turn work.
**Row 3:** [Slip 1, k1] to end. Turn work.

Repeat rows 2 and 3 until Heel Flap measures **2 (2, 2.25, 2.5)" [5 (5, 6, 6.5) cm]**. End after you have worked row 3.

## Heel Turn

**Row 1 (WS):** Slip 1 wyif, p**14 (16, 18, 20)**, p2tog, p1, turn.
**Row 2 (RS):** Slip 1, k3, ssk, k1, turn.
**Row 3:** Slip 1 wyif, p4, p2tog, p1, turn.
**Row 4:** Slip 1, k5, ssk, k1, turn.

You have now established the following pattern for your Heel Turn: slip 1, knit or purl to 1 st before the gap created by turning on the previous row, ssk or p2tog, k1 or p1, turn. Cont in this pattern until all your Heel sts have been worked, ending on a RS row. You should now have **16 (18, 20, 22)** Heel sts.

## Gusset

With the right side of your work facing, pick up and knit **12 (14, 16, 18)** sts along the left side of your Heel Flap.

Next, work **28 (32, 36, 40)** sts across the front of your sock in established pattern. Pm, and pick up **12 (14, 16, 18)** sts on the right side of your Heel Flap. Knit across the Heel sts, then knit down the first set of new sts you picked up on the left side. You've reached the end of the rnd, and all your sts have now been picked up. You should now have **68 (78, 88, 98)** sts total on your needles.

## Gusset Decreases

**Rnd 1:** Work in established pattern across **28 (32, 36, 40)** sts, sl marker, k1, ssk, knit around to 3 sts before the end of rnd, k2tog, k1.
**Rnd 2:** Work even with no decreases.
Repeat these two rnds until you have **56 (64, 72, 80)** sts on your needles.

## Foot

Now that you've reached the Foot, you will work the following: p1tbl, Lace Panel, p1tbl, k**15 (19, 23, 27)**, p1tbl, Lace Panel, p1tbl, knit in Stockinette (knit every st) to end of rnd. Cont in this pattern until your Foot reaches your desired length before beginning your Toe decreases. The Craft Yarn Council has issued the following length guidelines for the Foot of a sock, measured from the back of the Heel to the end of the Toe.

(All sizes are US.)
**Women's shoe sizes 4–6.5:** 8–9" (20.5–23 cm)
**Women's shoe sizes 7–9.5:** 9¼–10" (23–25.5 cm)
**Women's shoe sizes 10–12.5:** 10¼–11" (26–28 cm)
**Men's shoe sizes 6–8.5:** 9¼–10" (23.5–25.5 cm)
**Men's shoe sizes 9–11.5:** 10¼–11" (26–28 cm)
**Men's shoe sizes 12–14:** 11¼–12" (28.5–30.5 cm)

When working a Heel Flap and Gusset, you also need to take into account your Toe length:

**S:** 1½" (4 cm)     **L:** 1½" (4 cm)
**M:** 1½" (4 cm)     **XL:** 1¾" (4 cm)

Now, take your desired Foot length, from back of Heel to end of Toe, and subtract your Toe measurements. For example, my desired Foot

length is 9" (23 cm). I subtract my Toe (1½" [4 cm]) and that leaves me with 7½" (19 cm) I need to knit before starting my Toe decreases. Measure starting at the back of the Heel.

Break MC.

## Toe

Switch to CC and knit one rnd even, then begin the following decrease pattern for your Toe:

**Rnd 1:** K1, ssk, k**22 (26, 30, 34)** sts, k2tog, k1, pm, k1, ssk, k**22 (26, 30, 34)** sts, k2tog, k1.

**Rnd 2:** Knit.

**Rnd 3:** K1, ssk, k to 3 sts before next marker, k2tog, k1, sl m, k1, ssk, knit around to 3 sts before end of rnd, k2tog, k1.

Repeat rnds 2 and 3 until **24 (28, 32, 36)** sts remain.

Graft your Toe closed using Kitchener Stitch (see page 33).

## Finishing

Weave in all ends and block your socks (see chapter 4).

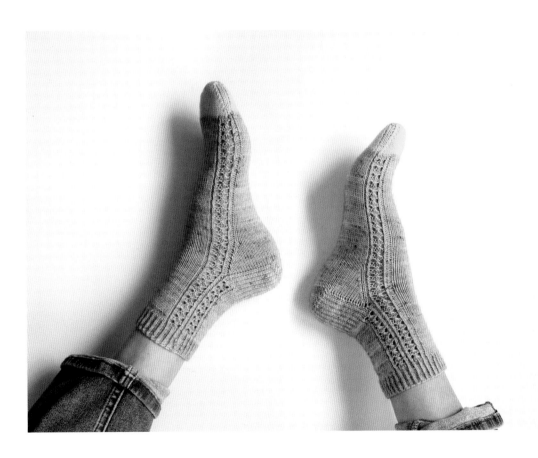

# Camellia Socks

I can't even tell you how many times I've watched Peter Jackson's *Lord of the Rings* trilogy. My desire to live deep in the Shire in a hobbit hole of my very own is matched only by my desire to finally achieve early 1990s Kurt Cobain hair. (A blonde, textured, chin-length bob, if you're curious. But it has to be the right shade of blonde, and that's the tricky part when you have very dark American Indian hair. It's been a twenty-year quest at this point.)

These socks, with their delicate scrolling leaf motif, would most likely be worn by the elves of Middle Earth as they lounged about in chairs made of vines, contemplating the sixth dimension of time, or perfecting their skin care routines. The lace pattern may look daunting to knit, but don't let that deter you. If Théoden King could ride for wrath and ruin, you can knit these socks! The pattern is quite simple to execute and comes with a visual chart as well as written instructions.

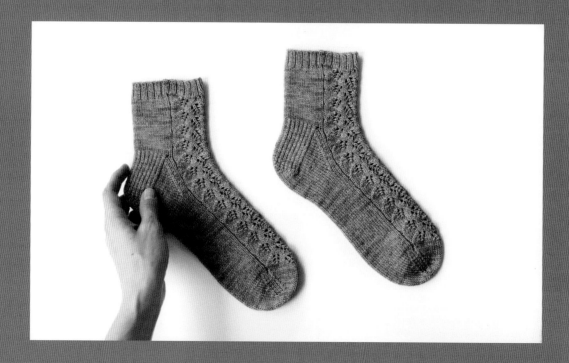

## MATERIALS

Yarn: Twisted Ambitions Yarn Sweet Sock [75% superwash merino/25% nylon; 463 yards (423 m)/3½ ounces (100 g)]: 167 (198, 224, 258, 284) yards [153 (181, 205, 236, 260) m] in Dusk

*Note: As always, any fingering weight sock yarn will do.*

Needles: US size 1 (2.25 mm)

Notions: Tapestry needle, stitch markers, snips, and a measuring tape

Gauge: 38 sts = 4" (10 cm), knit in lace pattern in the rnd and blocked

Sizes
Kid (S, M, L, XL)

Measurements
The numbers below refer to the circumference of the ball of the foot, not the measurements of the finished sock.

5–6 (7, 8, 9, 10)" [13–15 (18, 20, 23, 25) cm]

Not sure how to read a lace chart? It's simple! The numbers on the bottom refer to your sts in a single rnd of knitting. The numbers to the right of the chart refer to the number of rnds over which the chart is worked. The chart is read from bottom to top (in this case, from rnd 1 to rnd 8), and from right to left (in this case, from st 1 to st 21).

This chart is repeated, meaning you will work rnds 1 through 21, then start over at rnd 1 again. The key to the right of the chart gives you the meaning for each of the symbols used, making it easy to visualize the directions.

One thing to note with lace charts: Your stitch counts often fluctuate between rnds. Because you are using yarn overs and decreases to create the lace motifs, you'll notice that you end each rnd with different stitch counts for the motif.

Written Instructions for Chart
**Rnd 1:** P1, k5, k2tog, yo, k1, yo, k3, yo, k1, yo, k2, skp, k1, p1. **21** sts.
**Rnd 2:** P1, k4, k2tog, k11, skp, p1. **19** sts.
**Rnd 3:** P1, k3, k2tog, k1, yo, k1, yo, k10, p1. **20** sts.
**Rnd 4:** P1, k2, k2tog, k14, p1. **19** sts.
**Rnd 5:** P1, k1, k2tog, k2, yo, k1, yo, k3, yo, k1, yo, skp, k5, p1. **21** sts.
**Rnd 6:** P1, k2tog, k11, skp, k4, p1. **19** sts.
**Rnd 7:** P1, k10, yo, k1, yo, k1, skp, k3, p1. **20** sts.
**Rnd 8:** P1, k14, skp, k2, p1. **19** sts.

Lace Leaf Chart

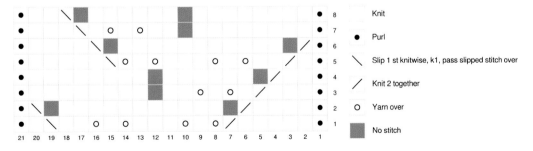

| | Symbol | Meaning |
|---|---|---|
| | | Knit |
| | • | Purl |
| | \ | Slip 1 st knitwise, k1, pass slipped stitch over |
| | / | Knit 2 together |
| | O | Yarn over |
| | ▪ | No stitch |

# INSTRUCTIONS

## Cuff

CO **48 (57, 63, 72, 81)** sts and join for working in the rnd, being careful not to twist your sts. Est 2×1 ribbing: [k2, p1] to end.

Cont working the ribbing until your Cuff measures ¾" (2 cm), or your desired length. On the last rnd of the ribbing, we need to get our stitch count back to an even number. If you are working the Kid or L sizes, you already have an even number and can move on to the Leg instructions. The rest of you, make the following increase or decrease according to your size:

**S:** Work in rib pattern to the last 3 sts, k2tog, p1. **56** sts.

**XL:** Work in rib pattern to last 3 sts, k2tog, p1. **80** sts.

**M:** Work in rib pattern to the last 3 sts, kfb, k1, p1. **64** sts.

## Leg

K1 **(3, 5, 7, 9)** sts, work all 21 sts of rnd 1 of the Lace Leaf Chart, knit to end.

You have now est the pattern for your entire sock (until you get to the Toe decreases): K1 **(3, 5, 7, 9)** sts, work the Lace Leaf Chart over 21 sts, then knit to the end of the rnd. Cont repeating all 8 rnds of the Lace Leaf Chart until your Leg (including Cuff) measures 3½" (9 cm), or your desired length. I did four complete repeats of the chart before stopping for the Heel Flap. Stop for the Heel Flap after working an even-numbered rnd of the chart.

## Heel Flap

Work in pattern across the first **24 (28, 32, 36, 40)** sts, then begin working your Heel Flap back and forth across the remaining **24 (28, 32, 36, 40)** sts as follows:

**Row 1 (RS):** K2, [slip 1, k1] to end. Turn work.
**Row 2 (WS):** Slip 1 wyif, purl to end. Turn work.
**Row 3:** [Slip 1, k1] to end. Turn work.

Repeat rows 2 and 3 until Heel Flap measures **1.75 (2, 2, 2.25, 2.5)" [4.5 (5, 5, 6, 6.5) cm]**. End after you have worked row 3.

## Heel Turn

**Row 1 (WS):** Slip 1 wyif, p12 **(14, 16, 18, 20)**, p2tog, p1, turn.
**Row 2 (RS):** Slip1, k3, ssk, k1, turn.
**Row 3:** Slip 1 wyif, p4, p2tog, p1, turn.
**Row 4:** Slip 1, k5, ssk, k1, turn.

You have now established the following pattern for your Heel Turn: slip 1, knit or purl to 1 st before the gap created by turning on the previous row, ssk or p2tog, k1 or p1, turn. Cont in this pattern until all your Heel sts have been worked, ending on a RS row. You should now have **14 (16, 18, 20, 22)** Heel sts.

## Gusset

With the right side of your work facing, pick up and knit **10 (12, 14, 16, 18)** sts along the left side of your Heel Flap.

Next, work in pattern across the **24 (28, 32, 36, 40)** sts that we've left undisturbed on our needles while working our Heel Flap. Pm, and pick up **10 (12, 14, 16, 18)** sts on the right side of your Heel Flap. Knit across the Heel

sts, then knit down the first set of new sts you picked up on the left side. You've reached the end of the rnd, and all your sts have now been picked up. You should now have **58 (68, 78, 88, 98)** sts total on your needles.

## Gusset Decreases

**Rnd 1:** Work in pattern across **24 (28, 32, 36, 40)** sts, sl marker, k1, ssk, knit around to 3 sts before the end of rnd, k2tog, k1.
**Rnd 2:** Work even with no decreases.
Repeat these two rnds until you have **48 (56, 64, 72, 80)** sts on your needles.

## Foot

Cont working in the same pattern you established on the Leg until your work reaches just to the tip of your pinky toe. If you can't easily try your socks on as you knit, or if you are knitting gift socks, the Craft Yarn Council has issued the following length guidelines for the Foot of a sock, measured from the back of the Heel to the end of the Toe.

(All sizes are US.)
**Kid:** 6–7½" (15–19 cm)
**Women's shoe sizes 4–6.5:** 8–9" (20.5–23 cm)
**Women's shoe sizes 7–9.5:** 9¼–10" (23–25.5 cm)
**Women's shoe sizes 10–12.5:** 10¼–11" (26–28 cm)
**Men's shoe sizes 6–8.5:** 9¼–10" (23.5–25.5 cm)
**Men's shoe sizes 9–11.5:** 10¼–11" (26–28 cm)
**Men's shoe sizes 12–14:** 11¼–12" (28.5–30.5 cm)

When working a Heel Flap and Gusset, you also need to take into account your Toe length:

**Kid:** 1¼" (3 cm)          **L:** 1½" (4 cm)
**S:** 1½" (4 cm)          **XL:** 1¾" (4 cm)
**M:** 1½" (4 cm)

Now, take your desired Foot length, from back of Heel to end of Toe, and subtract your Toe measurements. For example, my desired Foot length is 9"(23 cm). I subtract my Toe (1½" [4 cm]) and that leaves me with 7½" (19 cm) I need to knit before starting my Toe decreases. Measure starting at the back of the Heel.

Make sure you end on an even-numbered rnd of the chart before working the Toe decreases.

## Toe

Knit one rnd even in Stockinette (knit every st), then begin the following decrease pattern for your Toe:

**Rnd 1:** K1, ssk, k**18 (22, 26, 30, 34)** sts, k2tog, k1, pm, k1, ssk, k**18 (22, 26, 30, 34)** sts, k2tog, k1.
**Rnd 2:** Knit.
**Rnd 3:** K1, ssk, knit to 3 sts before next marker, k2tog, k1, sl m, k1, ssk, knit around to 3 sts before end of rnd, k2tog, k1.

Repeat rnds 2 and 3 until **20 (24, 28, 32, 36)** sts remain.

Use Kitchener Stitch to close up the Toe of your sock (see page 33).

## Finishing

Weave in all ends and block your sock (see chapter 4).

# Chapter 11
# COLORWORK SOCKS

**A**t one time, colorwork socks were my Everest. (Actually, as a person weirdly obsessed with mountain climbing, I can tell you that the second highest mountain in the world, K2, is much harder to climb. So colorwork socks were my K2.)

I couldn't get my tension right, so the fabric was puckered, and frankly quite ugly. Worse, the socks had no stretch or give. No amount of pulling, sweating, or grunting could get those socks over my heel. I collapsed on my sofa, exhausted from the effort, wondering where I had gone wrong.

Luckily, colorwork socks aren't that difficult, and I only had to adjust a few small things to craft a beautiful sock that fit well!

## Tension, Tension, Tension

This is where most of us flounder a bit in the beginning. We tend to knit the stitches in our

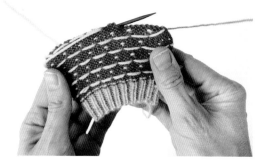

All those strands of yarn on the wrong side of the sock are called "floats."

main color just fine, but when we go to knit a stitch in a contrasting color, we pull too tightly, resulting in tight floats that pucker the fabric and reduce the stretch of the sock. The solution is easy—simply keep your tension relaxed as you knit. Make sure you don't pull too tightly as you switch back and forth between yarns.

You may find on your first couple of socks that you have to pay close attention to your tension as you work. Take heart! You'll find your groove soon enough and will be able to knit colorwork socks while binge-watching *Bachelor in Paradise* (not that I have EVER seen that show, or watched every season, or know anything about the hopeful contestants who show up to tropical locales in search of love or viral fame).

## No Scrunching!

You might have noticed that when you knit, the stitches on your right needle have a habit of scrunching up. Normally this isn't much of an issue, but when you knit colorwork socks, those bunched-up, scrunched-up stitches can create tight floats. Your contrasting-color yarn strand doesn't have as far to travel if the stitches are too close together, resulting in a tight float. The solution? Simply keep your stitches spread out nicely on your right needle as you work.

Again, this will be something you have to pay close attention to at first, but with a little bit of time, your fingers will learn what to do, and you'll automatically keep those stitches spaced out as you work without even having to think about it.

Our goal is to create loose floats that rest neatly on the back of the work. I can easily slide this knitting needle underneath.

## Bigger Needles or More Stitches

As mentioned earlier, the floats on the wrong side of your work reduce the stretch of the knitted fabric. One of two things must happen to ensure a well-fitting sock: Either you knit the sock with bigger needles, or you cast on more stitches. Most patterns will instruct you to do one or the other. I typically like to knit my colorwork socks on bigger needles. I know my stitch counts and I like to keep them the same. Occasionally I'll design a pattern that requires more stitches to create the motif I'm after, however. In that case, I'll stick with my smaller needles because those extra stitches give me the extra fabric I need.

And that's it! Those few little changes will make all the difference in your colorwork sock technique. Once you feel confident in your ability to manage your tension, a whole new world of knitting will be available to you. And it's the BEST world! Colorwork socks are my favorite—it's like painting with yarn.

*Bonus Tip: I've found that working colorwork socks on short circular needles is the best way to manage my tension and, most importantly, ensure I actually have fun while knitting.*

Magic Loop and DPNs can make colorwork a bit fiddly and frustrating. (This is a very personal opinion. You may love working colorwork with either of those techniques, and that's great.) Have you ever been in charge of two or more toddlers? Knitting colorwork socks on DPNs is a bit like that, in my experience. Trying to manage multiple strings on multiple little sticks is like trying to run after a toddler who is determined to cross a busy street, while the other toddler is trying to launch himself head-first into a duck pond. You can't win.

I like the ChiaoGoo Twist Shorties. I keep a few pairs of the US size 2 (2.75 mm) on hand just for colorwork. The right needle is longer than the left needle, and this prevents hand-cramping. So if you find working colorwork a bit difficult with your usual method, give short circulars a try. I knit the cuff, heel, and toe on US size 1 (2.25 mm) needles using magic loop. I knit the body of the sock on US size 2 (2.75 mm), using the ChiaoGoo Twist Shorties.

# Classic Flea Stitch Socks

These socks are absolutely adorable, but admittedly, this stitch pattern
has a pretty disgusting name. (It's also known as the Lice Stitch, which is
even worse.)

Whether you think of the teeny dots on these socks as lice or fleas,
there's no denying the whimsical appeal and cheery attitude they exude.
The color possibilities are endless, and best of all, it's an easy yet fun
way to ease yourself into colorwork knitting. The repetitive pattern is
quickly memorized, leaving your brain free to focus on your tension.

If you are an experienced colorwork knitter, this pattern is just
plain fun to knit. I have several pairs of Flea Stitch socks. It's a go-to
pattern for me when I'm feeling blue or out of sorts. I simply put on my
favorite movie (*Overboard*, starring Goldie Hawn and Kurt Russell) and go to
town making happy socks filled with teeny dots.

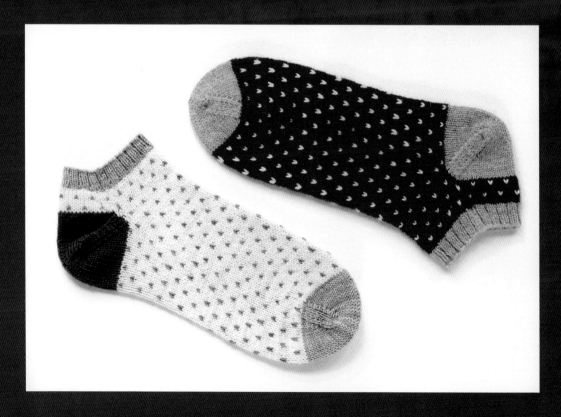

## MATERIALS

### Yarn

**Red Pair**

Knit Picks Stroll [75% fine superwash merino/ 25% nylon; 231 yards (211 m)/1¾ ounces (50 g)]: 47 (63) 86 (104, 128, 147) yards [43 (58) 79 (95, 117, 134) m] in Buoy (MC)

Knit Picks Stroll [75% fine superwash merino/ 25% nylon; 231 yards (211 m)/1¾ ounces (50 g)]: 20 (24) 28 (32, 36, 40) yards [18 (22) 26 (29, 33, 37) m] in Dogwood Heather (CC1)

Knit Picks Stroll [75% fine superwash merino/ 25% nylon; 231 yards (211 m)/1¾ ounces (50 g): 20 (24) 28 (32, 36, 40) yards [18 (22) 26 (29, 33, 37) m] in Dandelion (CC2)

**Blue Pair**

Little Lionhead Knits Fingering Weight Sock Yarn [85% superwash merino/15 % nylon; 437 yards (400 m)/3½ ounces (100 g)]: 47 (63) 86 (104, 128, 147) yards [43 (58) 79 (95, 117, 134) m] in Under the Stars (MC)

Madelinetosh Tosh Sock [100% superwash merino; 395 yards (361 m)/3½ (100 g)]: 14 (19) 23 (27, 31, 35) yards [13 (17) 21 (25, 28, 32) m] in Candlewick (CC1)

Filcolana Arwetta [80% superwash merino/ 20% nylon; 230 yards (210 m)/1¾ ounces (50 g)]: 26 (32) 38 (44, 48, 52) yards [24 (29) 35 (40, 44, 48) m] in 202 Teal (CC2)

*Note: As always, any fingering weight sock yarn will do.*

**Needles:** US size 1 (2.25 mm), US size 2 (2.75 mm)

**Notions:** Tapestry needle, stitch markers (including a clasp marker), snips, and a measuring tape

**Gauge:** 36 sts = 4" (10 cm), knit in colorwork pattern in the rnd on US size 2 (2.75 mm) needles and blocked

### Sizes

Toddler (Kid) S (M, L, XL)

### Measurements

The numbers below refer to the circumference of the ball of the foot, not the measurements of the finished sock.

3–4 (5–6) 7 (8, 9, 10)" [8–10 (13–15) 18 (20, 23, 25) cm]

### Chart

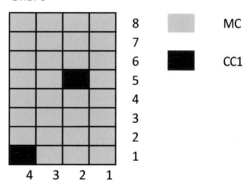

Not sure how to read a colorwork chart? It's simple! The numbers on the bottom refer to your stitches in a single round of knitting. The numbers to the right of the chart refer to the number of rounds over which the chart is worked. The chart is read from bottom to top (in this case, from rnd 1 to rnd 8), and from right to left (in this case, from st 1 to st 4).

Charts are usually repeated, meaning in a given round, you will work sts 1 through 4, then start back at the beginning with st 1 again. You'll keep working sts 1 through 4 until you reach the end of the round. Then you'll move up to the second round, and repeat those sts. Once you have completed all 8 rounds of the chart, you'll start over again at st 1, rnd 1.

## INSTRUCTIONS

### Cuff

With US size 1 (2.25 mm) needles, and CC1, CO **39 (48) 57 (63, 72, 81)** sts and join for working in the rnd, being careful not to twist your sts. Est 2×1 ribbing: [k2, p1] to end.

Cont working the ribbing until your Cuff measures ¾" (2 cm), or your desired length. On the last rnd of the ribbing, we need to get our stitch count back to an even number. If you are working the Kid or L sizes, you already have an even number and can move on to the Leg instructions. The rest of you, make the following increase or decrease according to your size:

**Toddler:** Work in rib pattern to the last 3 sts, kfb, k1, p1. **40** sts.

**S:** Work in rib pattern to the last 3 sts, k2tog, p1. **56** sts.

**M:** Work in rib pattern to the last 3 sts, kfb, k1, p1. **64** sts.

**XL:** Work in rib pattern to the last 3 sts, k2tog, p1. **80** sts.

### Leg

Break CC1 and switch to US size 2 (2.75 mm) needles. Join in MC. Knit 3 rnds in Stockinette (knit every st), then join in CC2 and begin working colorwork chart. Work rnds 1–6 of the chart, then proceed to the instructions for placing the Afterthought Heel marker.

*Note: This length will create shorty socks, as shown in the pictures. If you would prefer calf-length socks, use the chart below to determine your Leg measurements, and keep repeating all 8 rnds of the chart until your Leg reaches your desired length. Once you are satisfied, move on to the instructions for placing the Afterthought Heel marker.*

**Toddler Socks:** 3–4" (8–10 cm)

**Kid Socks:** 4–6" (10–15 cm)

**Adult Mid-calf:** 4–6" (10–15 cm)

**Adult Tall:** 7" (18 cm and up)

### Placing the Marker for the Afterthought Heel

Once you've decided your Leg is long enough, on the next rnd (make sure it's a rnd 3 or 7 in the chart—if you are following my instructions for shorty socks, you should be on rnd 7) simply knit **30 (36) 42 (48, 54, 60)** sts, and clip a clasp marker onto that last st you just knit. Then just keep knitting to the end of the rnd. You have now marked where your Afterthought Heel will eventually go, and you should now be on either rnd 4 or 8 of the chart.

## Knitting the Foot

Cont repeating all 8 rnds of the Flea Stitch Chart until your Foot reaches your desired length. The Craft Yarn Council has issued the following length guidelines for the Foot of a sock, measured from the back of the Heel to the end of the Toe.

(All sizes are US.)
**Toddler:** 4½–6" (11–15 cm)
**Kid:** 6–7½" (15–19 cm)
**Women's shoe sizes 4–6.5:** 8–9" (20.5–23 cm)
**Women's shoe sizes 7–9.5:** 9¼–10" (23–25.5 cm)
**Women's shoe sizes 10–12.5:** 10¼–11" (26–28 cm)
**Men's shoe sizes 6–8.5:** 9¼–10" (23.5–25.5 cm)
**Men's shoe sizes 9–11.5:** 10¼–11" (26–28 cm)
**Men's shoe sizes 12–14:** 11¼–12" (28.5–30.5 cm)

When working an Afterthought Heel, you need to take into account both your Heel length and your Toe length (they will be the same).

**Toddler:** 1" (2.5 cm)      **M:** 1½" (4 cm)
**Kid:** 1¼" (3 cm)      **L:** 1½" (4 cm)
**S:** 1½" (4 cm)      **XL:** 1¾" (4 cm)

Now, take your desired Foot length, from back of Heel to end of Toe, and subtract both your Heel and Toe measurements. For example, my desired Foot length is 9" (23 cm). I subtract my Toe (1½" [4 cm]), and my Heel (1½" [4 cm]) and that leaves me with 6" (15 cm) I need to knit before starting my Toe decreases.

## Toe

Break MC and CC2 and switch back to US size 1 (2.25 mm) needles. Join in CC1. Knit 1 rnd even in Stockinette, then begin the following decrease pattern to shape your Toe:

**Rnd 1:** K1, ssk, k**14 (18) 22 (26, 30, 34)** sts, k2tog, k1, pm, k1, ssk, k**14 (18) 22 (26, 30, 34)** sts, k2tog, k1.
**Rnd 2:** Knit.
**Rnd 3:** K1, ssk, knit to 3 sts before next marker, k2tog, k1, sl m, k1, ssk, knit around to 3 sts before end of rnd, k2tog, k1.

Repeat rnds 2 and 3 until **16 (20) 24 (28, 32, 36)** sts remain.

Use Kitchener Stitch to close up your Toe (see page 33).

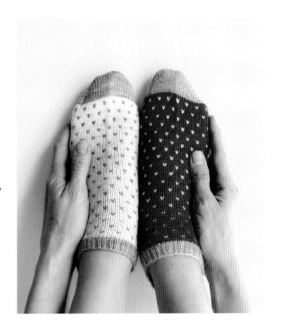

## Knitting the Afterthought Heel

First, get your US size 1 (2.25 mm) needles on the rows of sts on either side of your clipped-on st marker (see page 37 for a detailed tutorial on working an Afterthought Heel).

You will work your Afterthought Heel the same as you did your Toe. Join in CC1 and knit 3 rnds even. Then begin the following decrease pattern:

**Rnd 1:** K1, ssk, k14 (18) 22 (26, 30, 34) sts, k2tog, k1, pm, k1, ssk, k14 (18) 22 (26, 30, 34) sts, k2tog, k1.
**Rnd 2:** Knit.
**Rnd 3:** K1, ssk, knit to 3 sts before next marker, k2tog, k1, sl m, k1, ssk, knit around to 3 sts before end of rnd, k2tog, k1.

Repeat rnds 2 and 3 until **16 (20) 24 (28, 32, 36)** sts remain. Use Kitchener Stitch to close that Heel up (see page 33).

*Note: You can adjust the depth and fit of your Heel by working more or fewer decrease rnds. Try the sock on occasionally as you work your decreases to see how it's fitting. Stop your decreases when you can easily pinch the fabric closed.*

## Finishing

Weave in your ends and block your socks (see chapter 4).

There! That wasn't so bad, was it? Hopefully you've got a lovely sock with smooth fabric that glides easily onto your foot. Is your fabric puckered? Is it too tight? No worries. Some skills take a bit of practice to get right. Just keep focusing on your tension as you work the next sock. I knit at least three pairs of wonky, ill-fitting colorwork socks before I finally found my groove and got my tension worked out. You might get it right on the first try, or it might take you a few pairs, but you'll get there in the end.

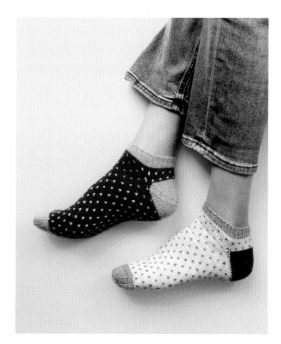

# Linea Socks

These socks have a more modern motif, and once again, the chart is easy to memorize and work, leaving you with plenty of brain power to focus on any tension issues you might be having. I feel like this pattern would make for a lovely pair of trouser socks. Not that I personally own trousers, or would have anywhere fancy to wear them if I did. But if you are a person who visits art museums, or has a career that requires an office, or enjoys long, lazy lunches at Parisian bistros with friends, then these socks would look quite lovely peeking out from the hem of your perfectly tailored pants. They also look cool when paired with jeans and classic white Converse Chuck Taylor's (which is about as fancy as my wardrobe gets).

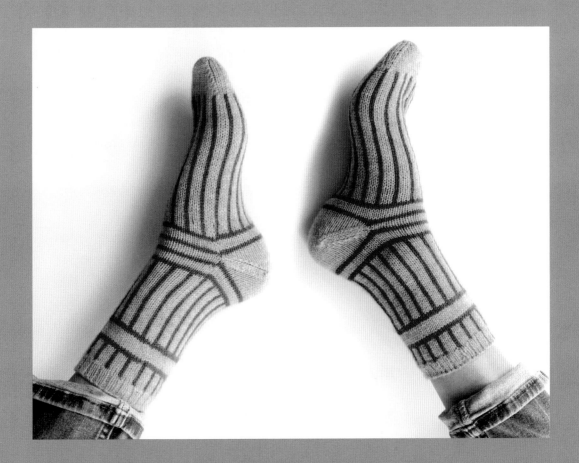

## MATERIALS

**Yarn:** Knit Picks Stroll [75% fine superwash merino/25% nylon; 231 yards (211 m)/1¾ ounces (50 g)]: 126 (148, 172, 200, 236) yards [115 (135, 157, 183, 215) m] in Dogwood Heather (MC)

Knit Picks Stroll [75% fine superwash merino/25% nylon; 231 yards (211 m)/1¾ ounces (50 g)]: 68 (89, 110, 132, 158) yards [62 (81, 101, 121, 144) m] in Buoy (CC)

*Note: As always, any fingering weight sock yarn will do.*

Needles: US size 1 (2.25 mm), US size 2 (2.75 mm)

Notions: Tapestry needle, stitch markers (including a clasp marker), snips, measuring tape,

Gauge: 38 sts = 4" (10 cm) knit in colorwork pattern in the round on US size 2 (2.75 mm) needles and blocked

Sizes
Kid (S, M, L, XL)

Measurements
The numbers below refer to the circumference of the ball of the foot, not the measurements of the finished sock.

5–6 (7, 8, 9, 10)" [13–15 (18, 20, 23, 25) cm]

Chart

| | | | | 1 | | MC |
| 4 | 3 | 2 | 1 | | | |

| | | | | | | CC1 |

## INSTRUCTIONS

Cuff
With US size 1 (2.25 mm) needles and MC, CO **48 (57, 63, 72, 81)** sts. Join for working in the rnd, being careful not to twist your sts. Est 2×1 rib pattern: [k2, p1] to end.

Cont working in rib pattern until Cuff measures ¾" (2 cm), or your desired length. On the last rnd of the ribbing, we need to get our stitch count back to an even number. If you are working the Kid or L sizes, you already have an even number and can move on to the Leg instructions. The rest of you, make the following increase or decrease according to your size:

S: Work in rib pattern to the last 3 sts, k2tog, p1. **56** sts.

M: Work in rib pattern to the last 3 sts, kfb, k1, p1. **64** sts.

XL: Work in rib pattern to last 3 sts, k2tog, p1. **80** sts.

Leg
Switch to larger needles. Join in CC and work 8 repeats of the chart. Next, knit even in Stockinette (knit every st) for 2 rnds with CC, then work 6 rnds of Stockinette in MC, followed by 2 more rnds of Stockinette in CC.

Work the chart for 29 rnds, then work the following stripe pattern in Stockinette:

**CC:** 2 rnds
**MC:** 3 rnds
**CC:** 2 rnds
**MC:** 3 rnds

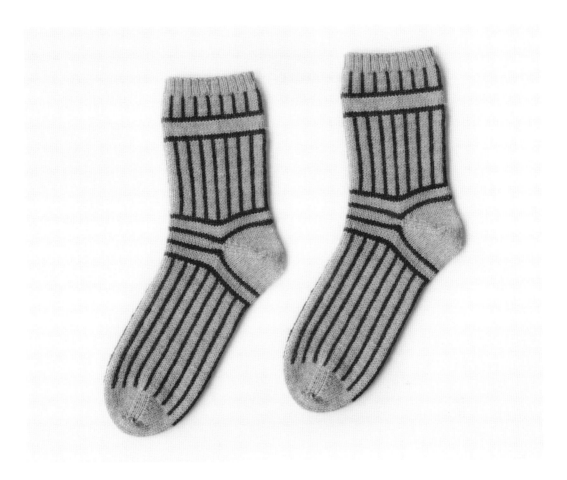

## Placing the Marker for the Afterthought Heel

Once you've decided your Leg is long enough, on the next rnd simply knit **36 (42, 48, 54, 60)** sts, and clip a clasp marker onto that last st you just knit. Then just keep knitting to the end of the rnd. You have now marked where your Heel will eventually go, and you should now be ready to work rnd 8 of the chart.

## Foot

Work the following stripe pattern in Stockinette:

**CC:** 2 rnds
**MC:** 3 rnds
**CC:** 2 rnds

Begin working the chart again, repeating it until your Foot reaches the desired length. The Craft Yarn Council has issued the following length guidelines for the Foot of a sock, measured from the back of the Heel to the end of the Toe.

(All sizes are US.)

**Kid:** 6–7½" (15–19 cm)
**Women's shoe sizes 4–6.5:** 8–9" (20.5–23 cm)
**Women's shoe sizes 7–9.5:** 9¼–10" (23–25.5 cm)
**Women's shoe sizes 10–12.5:** 10¼–11" (26–28 cm)
**Men's shoe sizes 6–8.5:** 9¼–10" (23.5–25.5 cm)
**Men's shoe sizes 9–11.5:** 10¼–11" (26–28 cm)
**Men's shoe sizes 12–14:** 11¼–12" (28.5–30.5 cm)

When working an Afterthought Heel, you need to take into account both your Heel length and your Toe length (they will be the same).

**Kid:** 1¼" (3 cm)      **L:** 1½" (4 cm)
**S:** 1½" (4 cm)        **XL:** 1¾" (4 cm)
**M:** 1½" (4 cm)

Now, take your desired Foot length, from back of Heel to end of Toe, and subtract both your Heel and Toe measurements. For example, my desired Foot length is 9" (23 cm). I subtract my Toe (1½" [4 cm]), and my Heel (1½" [4 cm]) and that leaves me with 6" (15 cm) I need to knit before starting my Toe decreases.

## Toe

Switch to US size 1 (2.25 mm) needles and break CC. With MC, knit 1 rnd even, then begin working the following decrease pattern to shape your Toe.

**Rnd 1:** K1, ssk, k**18 (22, 26, 30, 34)** sts, k2tog, k1, pm, k1, ssk, k**18 (22, 26, 30, 34)** sts, k2tog, k1.
**Rnd 2:** Knit.
**Rnd 3:** K1, ssk, k to 3 sts before next marker, k2tog, k1, sl m, k1, ssk, knit around to 3 sts before end of rnd, k2tog, k1.

Repeat rnds 2 and 3 until **20 (24, 28, 32, 36)** sts remain.

Graft your Toe closed using Kitchener Stitch (see page 33).

## Knitting the Afterthought Heel

First, get your US size 1 (2.25 mm) needles on the rows of sts on either side of your clipped-on stitch marker (see page 37 for a detailed tutorial on working an Afterthought Heel).

You will work your Afterthought Heel the same as you did your Toe. Join in MC and knit 3 rnds even. Then begin the following decrease pattern:

**Rnd 1:** K1, ssk, k**18 (22, 26, 30, 34)** sts, k2tog, k1, pm, k1, ssk, k**18 (22, 26, 30, 34)** sts, k2tog, k1.
**Rnd 2:** Knit.
**Rnd 3:** K1, ssk, knit to 3 sts before next marker, k2tog, k1, sl m, k1, ssk, knit around to 3 sts before end of rnd, k2tog, k1.

Repeat rnds 2 and 3 until **20 (24, 28, 32, 36)** sts remain. Use Kitchener Stitch to close that Heel up (see page 33).

*Note: You can adjust the depth and fit of your Heel by working more or fewer decrease rnds. Try the sock on occasionally as you work your decreases to see how it's fitting. Stop your decreases when you can easily pinch the fabric closed.*

## Finishing

Weave in all ends and block your socks (see chapter 4).

# Sunny Side Up Socks

Now that we've had a bit of practice with simpler motifs, it's time to increase the difficulty level. (But don't worry, I didn't crank it up by much. This pair of socks is still very easy for beginner colorwork enthusiasts.)

This motif features a modified polka dot that, while easy to memorize, might require a bit more concentration at first than the simple Flea Stitch. But the result is so worth it. This sock just makes me happy, and it's a fantastic staple pattern that can be knit up in any arrangement of colors. (I chose yellow and white at random and was pleased to discover that my sample ended up looking like happy rows of sunny-side-up eggs.)

Make sure you take special care with your tension on these socks. Big blocks of contrasting colors can pucker up if you don't stay relaxed.

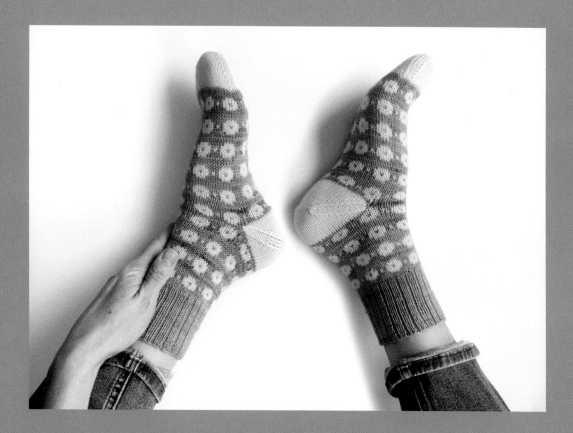

## MATERIALS

**Yarn:** La Bien Aimee Merino Super Sock [75% merino/25% nylon; 467 yards (425 m)/3½ ounces (100g)]: 102 (131, 158, 174, 199) yards [93 (120, 144, 159, 182) m] in Yellow Brick Road (MC)

Knit Picks Stroll [75% fine superwash merino/25% nylon; 231 yards (211 m)/1¾ ounces (50 g)]: 68 (89, 110, 132, 158) yards [62 (81, 101, 121, 144) m] in Bare (CC1)

Goosey Fibers Sock [75% superwash merino/25% nylon; 462 yards (422 m)/3½ ounces (100 g)]: 16 (20, 24, 28, 32) yards [15 (18, 22, 26, 29) m] in Zissou (CC2)

*Note: As always, any fingering weight sock yarn will do.*

**Needles:** US size 1 (2.25 mm), US size 2 (2.75 mm)

**Notions:** Tapestry needle, stitch markers (including a clasp marker), snips, measuring tape

**Gauge:** 36 sts = 4" (10 cm), knit in colorwork pattern in the round on US size 2 (2.75 mm) needles and blocked

### Sizes
Kid (S, M, L, XL)

### Measurements
The numbers below refer to the circumference of the ball of the foot, not the measurements of the finished sock.

5–6 (7, 8, 9, 10)" [13–15 (18, 20, 23, 25) cm]

## Scandi Circle Chart

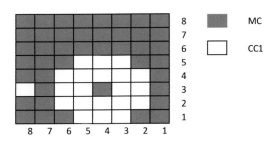

## INSTRUCTIONS
### Cuff
With US size 1 (2.25 mm) needles and CC2, CO **48 (57, 63, 72, 81)** sts and join for working in the rnd, being careful not to twist your sts. Est 2×1 ribbing: [k2, p1] to end.

Cont working the ribbing until your Cuff measures 2½" (6 cm), or your desired length. On the last rnd of the ribbing, we need to get our stitch count back to an even number. If you are working the Kid or L sizes, you already have an even number and can move on to the Leg instructions. The rest of you, make the following increase or decrease according to your size:

**S:** Work in rib pattern to the last 3 sts, k2tog, p1. **56** sts.

**M:** Work in rib pattern to the last 3 sts, kfb, k1, p1. **64** sts.

**XL:** Work in rib pattern to the last 3 sts, k2tog, p1. **80** sts.

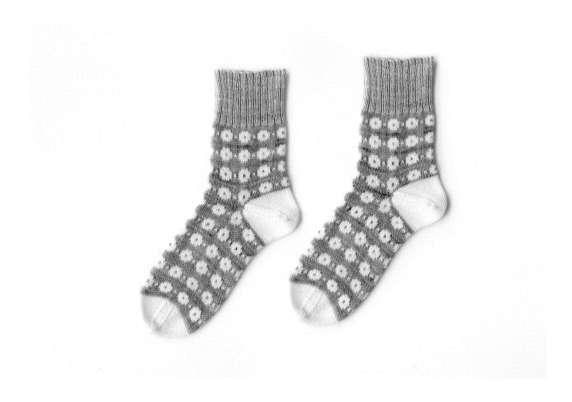

## Leg

Break CC2 and switch to US size 2 (2.75 mm) needles. Join in MC and knit 2 rnds even in Stockinette (knit every st). Join in CC 1 and begin working the Scandi Circle Chart. Repeat all 8 rnds of the chart until the Leg (including Cuff) measures 5½" (14 cm), or your desired length. Make sure to end after working rnd 6 of the chart.

## Placing the Marker for the Afterthought Heel

Once you've decided your Leg is long enough, on the next rnd (you should be on rnd 7 of the chart) simply knit **36 (42, 48, 54, 60)** sts, and clip a clasp marker onto that last st you just knit. Then just keep knitting to the end of the rnd. You have now marked where your Afterthought Heel will eventually go, and you should now be ready to work rnd 8 of the chart.

## Foot

Cont repeating all 8 rnds of the chart until your Foot reaches the desired length. The Craft Yarn Council has issued the following length guidelines for the Foot of a sock, measured from the back of the Heel to the end of the Toe.

(All sizes are US.)

**Kid:** 6–7½" (15–19 cm)
**Women's shoe sizes 4–6.5:** 8–9" (20.5–23 cm)
**Women's shoe sizes 7–9.5:** 9¼–10" (23–25.5 cm)
**Women's shoe sizes 10–12.5:** 10¼–11" (26–28 cm)
**Men's shoe sizes 6–8.5:** 9¼–10" (23.5–25.5 cm)
**Men's shoe sizes 9–11.5:** 10¼–11" (26–28 cm)
**Men's shoe sizes 12–14:** 11¼–12" (28.5–30.5 cm)

When working an Afterthought Heel, you need to take into account both your Heel length and your Toe length (they will be the same).

**Kid:** 1¼" (3 cm)  **L:** 1½" (4 cm)
**S:** 1½" (4 cm)  **XL:** 1¾" (4 cm)
**M:** 1½" (4 cm)

Now, take your desired Foot length, from back of Heel to end of Toe, and subtract both your Heel and Toe measurements. For example, my desired Foot length is 9" (23 cm). I subtract my Toe (1½" [4 cm]), and my Heel (1½" [4 cm]) and that leaves me with 6" (15 cm) I need to knit before starting my Toe decreases.

## Toe

Break MC and switch back to US size 1 (2.25 mm) needles. Using CC1, knit 1 rnd even in Stockinette, then begin the following decrease pattern to shape your Toe:

**Rnd 1:** K1, ssk, k**18 (22, 26, 30, 34)** sts, k2tog, k1, pm, k1, ssk, k**18 (22, 26, 30, 34)** sts, k2tog, k1.
**Rnd 2:** Knit.
**Rnd 3:** K1, ssk, knit to 3 sts before next marker, k2tog, k1, sl m, k1, ssk, knit around to 3 sts before end of rnd, k2tog, k1.

Repeat rnds 2 and 3 until **20 (24, 28, 32, 36)** sts remain.

Use Kitchener Stitch to close up your Toe (see page 33).

## Knitting the Afterthought Heel

First, get your US size 1 (2.25 mm) needles on the rows of sts on either side of your clipped-on stitch marker. (See page 33 for a detailed tutorial on working an Afterthought Heel.)

You will work your Afterthought Heel the same as you did your Toe. Join in CC1 and knit 3 rnds even. Then begin the following decrease pattern:

**Rnd 1:** K1, ssk, k**18 (22, 26, 30, 34)** sts, k2tog, k1, pm, k1, ssk, k**18 (22, 26, 30, 34)** sts, k2tog, k1.
**Rnd 2:** Knit.
**Rnd 3:** K1, ssk, knit to 3 sts before next marker, k2tog, k1, sl m, k1, ssk, knit around to 3 sts before end of rnd, k2tog, k1.

Repeat rnds 2 and 3 until **20 (24, 28, 32, 36)** sts remain. Use Kitchener Stitch to close that Heel up (see page 33).

*Note: You can adjust the depth and fit of your Heel by working more or fewer decrease rnds. Try the sock on occasionally as you work your decreases to see how it's fitting. Stop your decreases when you can easily pinch the fabric closed.*

## Finishing

Weave in your ends and block your socks (see chapter 4).

# Scrimshaw Socks

Although colorwork is one of my favorite techniques to employ, it does occasionally get exhausting. Sometimes you want the look of colorwork without all the bother. Popping in a band on the leg and foot, with miles of simple one-color Stockinette in between, is the perfect way to get striking stranded socks with only half the fuss and trouble.

I highly recommend visiting your local bookseller or library. You'll often find books containing traditional Scandinavian colorwork charts that you can pop into any old basic sock. Look for charts where the motif can be replicated in four stitches or eight stitches. Those counts will be the easiest to incorporate into my basic sock recipes.

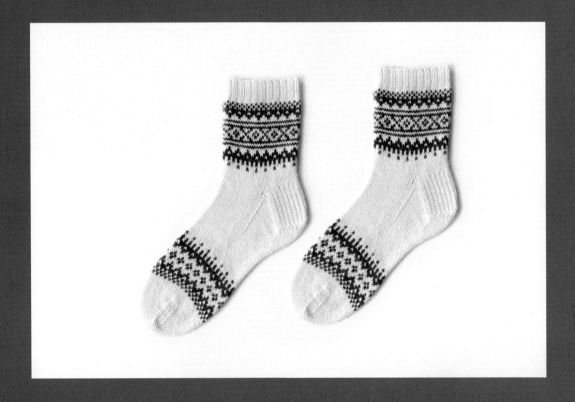

## MATERIALS

**Yarn:** Purl Soho Quartz [65% merino wool/35% suri alpaca; 420 yards (384 m)/3½ ounces (100 g)]: 102 (131, 158, 174, 199) yards [93 (120, 144, 159, 182) m] in Heirloom White (MC)

Purl Soho Quartz [65% merino wool/35% suri alpaca; 420 yards (384 m)/3½ ounces (100 g)]: 29 (42, 61, 78, 92) yards [27 (38, 56, 71, 84) m] in Aquamarine Blue (CC)

*Note: As always, any fingering weight sock yarn will do.*

**Needles:** US size 1 (2.25 mm), US size 2 (2.75 mm)

**Notions:** Tapestry needle, stitch markers (including a clasp marker), snips, measuring tape

**Gauge:** 38 sts = 4" (10 cm), knit in colorwork pattern in the round on US size 2 (2.75 mm) needles and blocked

### Sizes
K, (S, M, L, XL)

### Finished Measurements
The numbers below refer to the circumference of the ball of the foot, not the measurements of the finished sock.

5–6 (7, 8, 9, 10)" [13–15 (18, 20, 23, 25) cm]

## Charts

### Chart A

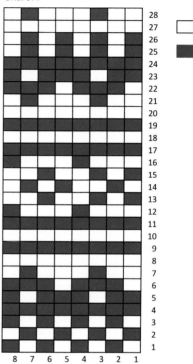

### Chart B

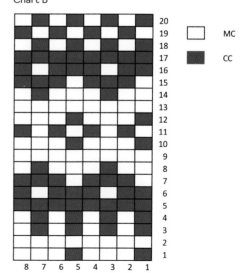

# INSTRUCTIONS

## Cuff

With US size 1 (2.25 mm) needles and MC, CO **48 (57, 63, 72, 81)** sts and join for working in the rnd, being careful not to twist your sts. Est 2×1 ribbing: [k2, p1] to end.

Cont working the ribbing until your Cuff measures ¾" (2 cm), or your desired length. On the last rnd of the ribbing, we need to get our stitch count back to an even number. If you are working the Kid or L sizes, you already have an even number and can move on to the Leg instructions. The rest of you, make the following increase or decrease according to your size:

**S:** Work in rib pattern to the last 3 sts, k2tog, p1. **56** sts.

**XL:** Work in rib pattern to last 3 sts, k2tog, p1. **80** sts.

**M:** Work in rib pattern to the last 3 sts, kfb, k1, p1. **64** sts.

## Leg

Switch to US size 2 (2.75 mm) needles and knit 2 rnds even in Stockinette (knit every st). Join in CC, then work all 28 rnds of Chart A once. Break CC.

Switch back to US size 1 (2.25 mm) needles. Work even in Stockinette using MC until work (including Cuff) measures 5" (13 cm).

## Heel Flap

Knit across the first **24 (28, 32, 36, 40)** sts, then begin working your Heel Flap back and forth across the remaining **24 (28, 32, 36, 40)** sts as follows:

**Row 1 (RS):** K2, [slip 1, k1] to end. Turn work.
**Row 2 (WS):** Slip 1 wyif, purl to end. Turn work.
**Row 3:** [Slip 1, k1] to end. Turn work.

Repeat rows 2 and 3 until Heel Flap measures **1¾ (2, 2, 2¼, 2½)"** [**4.5 (5, 5, 6, 6.5) cm**. End after you have worked row 3.

## Heel Turn

**Row 1 (WS):** Slip 1 wyif, p**12 (14, 16, 18, 20)**, p2tog, p1, turn.
**Row 2 (RS):** Slip 1, k3, ssk, k1, turn.
**Row 3:** Slip 1 wyif, p4, p2tog, p1, turn.
**Row 4:** Slip 1, k5, ssk, k1, turn.

You have now established the following pattern for your Heel Turn: slip 1, knit or purl to one st before the gap created by turning on the previous row, ssk or p2tog, k1 or p1, turn. Cont in this pattern until all your Heel sts have been worked, ending on a RS row. You should now have **14 (16, 18, 20, 22)** Heel sts.

## Gusset

With the right side of your work facing, pick up and knit **10 (12, 14, 16, 18)** sts along the left side of your Heel Flap.

Next, knit across the **24 (28, 32, 36, 40)** sts that we've left undisturbed on our needles while working our Heel Flap. Pm, and pick up **10 (12, 14, 16, 18)** sts on the right side of your Heel Flap. Knit across the Heel sts, then knit down the first set of new sts you picked up on the left side. You've reached the end of the rnd, and all your sts have now been picked up. You should now have **58 (68, 78, 88, 98)** sts total on your needles.

## Gusset Decreases

**Rnd 1:** K**24 (28, 32, 36, 40)** sts, sl marker, k1, ssk, knit around to 3 sts before the end of rnd, k2tog, k1.

**Rnd 2:** Work even with no decreases.

Repeat these two rnds until you have **48 (56, 64, 72, 80)** sts on your needles.

## Foot

Cont working even in Stockinette until it's time to work the next colorwork motif. How will you know when to stop? Well friends, we're going to have to do some simple math (just addition and subtraction, not quantum physics, so don't worry).

The second colorwork motif measures approximately 2" (5 cm) in length. So first, let's figure out the total length of our Foot. The Craft Yarn Council has issued the following length guidelines for the Foot of a sock, measured from the back of the Heel to the end of the Toe.

(All sizes are US.)

**Kid:** 6–7½" (15–19 cm)
**Women's shoe sizes 4–6.5:** 8–9" (20.5–23 cm)
**Women's shoe sizes 7–9.5:** 9¼–10" (23–25.5 cm)
**Women's shoe sizes 10–12.5:** 10¼–11" (26–28 cm)
**Men's shoe sizes 6–8.5:** 9¼–10" (23.5–25.5 cm)
**Men's shoe sizes 9–11.5:** 10¼–11" (26–28 cm)
**Men's shoe sizes 12–14:** 11¼–12" (28.5–30.5 cm)

When working a Heel Flap and Gusset, you also need to take into account your Toe length:

**Kid:** 1¼" (3 cm)
**S:** 1½" (4 cm)
**M:** 1½" (4 cm)
**L:** 1½" (4 cm)
**XL:** 1¾" (4 cm)

Now, take your desired Foot length, from back of Heel to end of Toe, and subtract your Toe measurements. For example, my desired Foot length is 9" (23 cm). I subtract my Toe (1½" [4 cm]) and that leaves me with 7½" (19 cm) I need to knit before starting my Toe decreases. Measure starting at the back of the Heel.

Now that we've subtracted our Toe, we also need to subtract the length of the second colorwork motif (2" [5 cm]). Additionally, we want 1" (2.5 cm) between the end of the colorwork band and the start of the Toe decreases. For my sock, that means I need to knit until my Foot measures 4½" (14 cm), measured from the back of the Heel, before stopping to do more colorwork.

Once you've knit the Foot the appropriate length before the colorwork, switch back to US size 2 (2.75 mm) needles and join in CC. Work all 20 rnds of Chart B once. Break CC and switch back to US size 1 (2.25 mm) needles.

Cont working Stockinette in MC for 1" (3 cm), then move on to the Toe shaping.

## Toe

**Rnd 1:** K1, ssk, k**18 (22, 26, 30, 34)** sts, k2tog, k1, pm, k1, ssk, k**18 (22, 26, 30, 34)** sts, k2tog, k1.

**Rnd 2:** Knit.

**Rnd 3:** K1, ssk, knit to 3 sts before next marker, k2tog, k1, sl m, k1, ssk, knit around to 3 sts before end of rnd, k2tog, k1.

Repeat rnds 2 and 3 until **20 (24, 28, 32, 36)** sts remain.

Use Kitchener Stitch to close up your Toe (see page 33).

## Finishing

Weave in all ends and block your socks (see chapter 4).

*Bonus Tip: Sometimes yarn colors bleed. It's truly horrifying to pull your sock out of the blocking bath only to discover that the inky purple yarn you loved so much leached purple dye over the light gray yarn you paired it with. Super-dark, saturated yarns are most prone to bleeding, but truthfully it can happen on any color if the yarn wasn't rinsed well during the manufacturing process. I suggest throwing a color catcher in with your sock bath if you've used dark, saturated colors on a light background, as I did in my sample sock. You can buy them at big box retailers and online.*

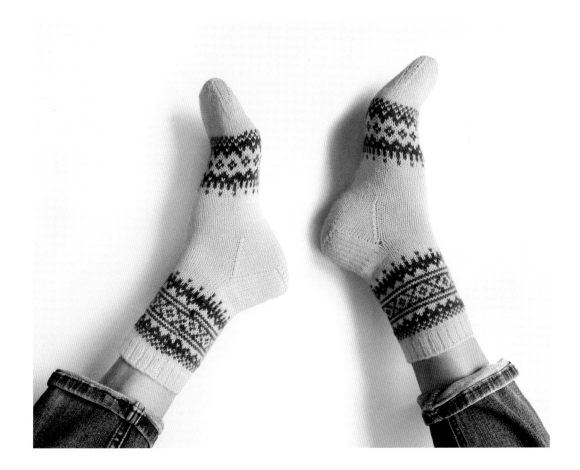

# Scandiland Socks

Friends, this is the sock we've been training to knit! Is it hard? Not at all. Are there many ends to weave in? A few. (Okay, I lied. There's a lot more than a few. The inside of my sock looked like a giant yarn barf. So. Many. Ends. But I just put an old Pixies album on and let Kim Deal's sweet bass riffs get me through it.)

Up to this point, I've been very careful to minimize the number of ends you have to weave in. I know you don't like to do it. And I know that you know that I don't like to do it. But there are some patterns where it just can't be helped. There will be ends, and you will have to tackle them. But you won't mind because you'll look at your finished sock with tears of pride in your eyes, and you'll whisper, "It was all worth it."

This is one of those socks. So keep your snips and your tapestry needle handy (so you'll be more inclined to stop and weave in those ends as you work on the sock), and let's knit!

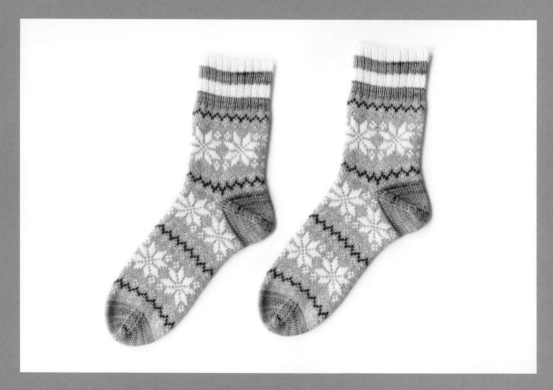

See? It's a nightmare! But I timed myself: It took twenty-two minutes to weave in all those ends. You can do just about any awful task for only twenty-two minutes.

## MATERIALS

**Yarn:** Knit Picks Stroll [75% fine superwash merino/25% nylon; 231 yards (211 m)/1¾ ounces (50 g)]: 133–161 (176–203) yards [122–147 (161–186) m] in Dogwood Heather (MC)

Knit Picks Stroll [75% fine superwash merino/25% nylon; 231 yards (211 m)/1¾ ounces (50 g)]: 42–61 (78–92) yards [38–56 (71–84) m] in Bare (CC1)

La Bien Aimee Super Sock [75% merino/25% nylon; 467 yards (425 m)/3½ ounces (100g)]: 37–54 (68–83) yards [34–49 (62–76) m] in Yellow Brick Road (CC2)

Knit Picks Stroll [75% fine superwash merino/25% nylon; 231 yards (211 m)/1¾ ounces (50 g)]: 18–24 (29–33) yards [16–22 (27–30) m] in Buoy (CC3)

Knit Picks Stroll [75% fine superwash merino/25% nylon; 231 yards (211 m)/1¾ ounces (50 g)]: 22–31 (39–46) yards [20–28 (36–42) m] in Wonderland Heather (CC4)

*Note: As always, any fingering weight sock yarn will do.*

**Needles:** US size 1 (2.25 mm), US size 2 (2.75 mm)

**Notions:** Tapestry needle, stitch markers (including a clasp marker), snips, measuring tape

**Gauge:** 38 sts = 4" (10 cm), knit in colorwork pattern in the round on US size 2 (2.75 mm) needles and blocked

**Sizes**
S/M (L/XL)

## Measurements

The numbers below refer to the circumference of the ball of the foot, not the measurements of the finished sock.

7–8 (9–10)" [18–20 (23–25) cm]

## Chart

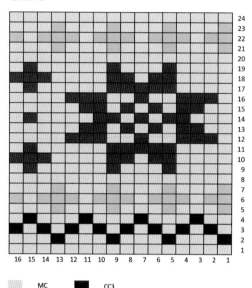

|  | MC |  | CC3 |
| --- | --- | --- | --- |
|  | CC1 |  | CC4 |

You might notice that the Norwegian stars in my sample sock are knit in white yarn, while the Norwegian stars in the chart are represented by hot pink. I did this solely for ease of viewing the chart. Maybe it's just because I'm in my forties now, or maybe it's that my vision has always been bad. Who can say? I just know that when I originally charted those stars in white, I couldn't see the dang things, so I switched them to pink.

## A Note on Sizing (Don't skip this part!)

Math dictates so much of what we do in knitting. (Had I known this, would I have ever picked up the needles eighteen years ago? Probably not.) This particular motif is worked over a repeat of 16 stitches. To make this motif work over multiple sizes, I would have had to increase the spacing between stars, and frankly, I didn't want to do that! Like Bridget Jones, those stars are perfect, just as they are.

So here is where the magic of needle sizing will come into play. If you are knitting the size S or size L, you will work the entire sock on US size 1 (2.25 mm) needles (yes, even the color-work). You will be working with extra stitches, so you won't need bigger needles to accommodate the reduced stretch you get from the floats. If you are working the size M or XL, you will switch needle sizes when directed in the pattern.

## INSTRUCTIONS

### Cuff

*Tip: This Cuff has stripes. Check out page 92 for a great trick that makes striped ribbing look extra neat and tidy.*

With US size 1 (2.25 mm) needles, and CC1, CO **63 (81)** sts and join for working in the rnd, being careful not to twist your sts. Est 2×1 ribbing: [k2, p1] to end. Work 7 more rnds in ribbing in CC1, then join in CC2. Work 8 rnds of ribbing in CC2, then 8 rnds in CC1, then finally 8 rnds in CC2. On the last rnd of the ribbing, we need to get our stitch count back to an even number.

**S/M:** Work in rib pattern to the last 3 sts, kfb, k1, p1. **64** sts.

**L/XL:** Work in rib pattern to the last 3 sts, k2tog, p1. **80** sts.

## Leg

Break CC1 and CC2. Join in MC and switch to US size 2 (2.75 mm) needles. (Remember, only sizes M and XL switch needle sizes.) Work 2 rnds even in Stockinette (knit every st), then work rnds 1–24 of the chart once, joining in CC colors as you need them, and breaking them when you no longer need them. You will be working **4 (5)** repeats of the 16-st repeat each rnd.

Next, work rnds 1–7 of the chart.

## Placing the Marker for the Afterthought Heel

On the next rnd (you should be on rnd 8 of the chart) knit **48 (60)** sts, and clip a clasp marker onto that last st you just knit. Then just keep knitting to the end of the rnd. You have now marked where your Afterthought Heel will eventually go, and you should now be ready to work rnd 9 of the chart.

## Foot

Cont working the chart, repeating all 24 rnds, until your Foot reaches the desired length. The Craft Yarn Council has issued the following length guidelines for the Foot of a sock, measured from the back of the Heel to the end of the Toe.

(All sizes are US.)

**Women's shoe sizes 4–6.5:** 8–9" (20.5–23 cm)
**Women's shoe sizes 7–9.5:** 9¼–10" (23–25.5 cm)
**Women's shoe sizes 10–12.5:** 10¼–11" (26–28 cm)

**Men's shoe sizes 6–8.5:** 9¼–10" (23.5–25.5 cm)
**Men's shoe sizes 9–11.5:** 10¼–11" (26–28 cm)
**Men's shoe sizes 12–14:** 11¼–12" (28.5–30.5 cm)

When working an Afterthought Heel, you need to take into account both your Heel length and your Toe length (they will be the same):

**S:** 1½" (4 cm)          **L:** 1½" (4 cm)
**M:** 1½" (4 cm)          **XL:** 1¾" (4 cm)

Now, take your desired Foot length, from back of Heel to end of Toe, and subtract both your Heel and Toe measurements. For example, my desired Foot length is 9" (23 cm). I subtract my Toe (1½"[4 cm]), and my Heel (1½" [4 cm]) and that leaves me with 6" (15 cm) I need to knit before starting my Toe decreases. You can stop at any point in the chart.

## Toe

Break MC and any CC colors you might be using. Switch back to US size 1 (2.25 mm) needles. Using CC2, knt 1 rnd even in Stockinette, then begin the following decrease pattern to shape your Toe:

**Rnd 1:** K1, ssk, k**26 (34)** sts, k2tog, k1, pm, k1, ssk, k**26 (34)** sts, k2tog, k1.
**Rnd 2:** Knit.
**Rnd 3:** K1, ssk, knit to 3 sts before next marker, k2tog, k1, sl m, k1, ssk, knit around to 3 sts before end of rnd, k2tog, k1.

Repeat rnds 2 and 3 until **28 (36)** sts remain.

Use Kitchener Stitch to close up your Toe (see page 33).

## Knitting the Afterthought Heel

First, get your US size 1 (2.25 mm) needles on the rows of sts on either side of your clipped-on stitch marker. (See page 37 for a detailed tutorial on working an Afterthought Heel.)

You will work your Afterthought Heel the same as you did your Toe. Join in CC2 and knit 3 rnds even. Then begin the following decrease pattern:

**Rnd 1:** K1, ssk, k**26 (34)** sts, k2tog, k1, pm, k1, ssk, k **26 (34)** sts, k2tog, k1.
**Rnd 2**: Knit.

**Rnd 3:** K1, ssk, knit to 3 sts before next marker, k2tog, k1, sl m, k1, ssk, knit around to 3 sts before end of rnd, k2tog, k1.
Repeat rnds 2 and 3 until **28 (36)** sts remain. Use Kitchener Stitch to close that Heel up (see page 33).

*Note: You can adjust the depth and fit of your Heel by working more or fewer decrease rnds. Try the sock on occasionally as you work your decreases to see how it's fitting. Stop your decreases when you can easily pinch the fabric closed.*

## Finishing

Weave in your ends and block your socks (see chapter 4).

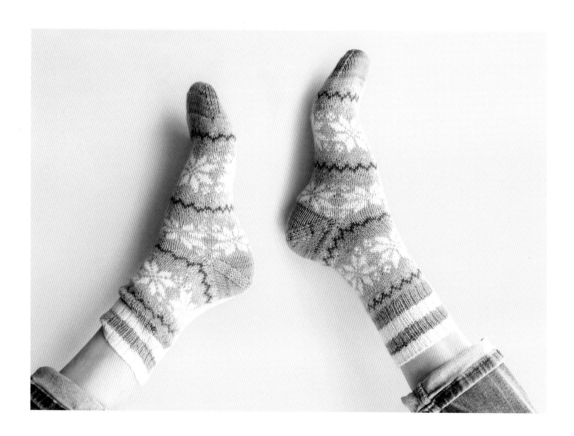

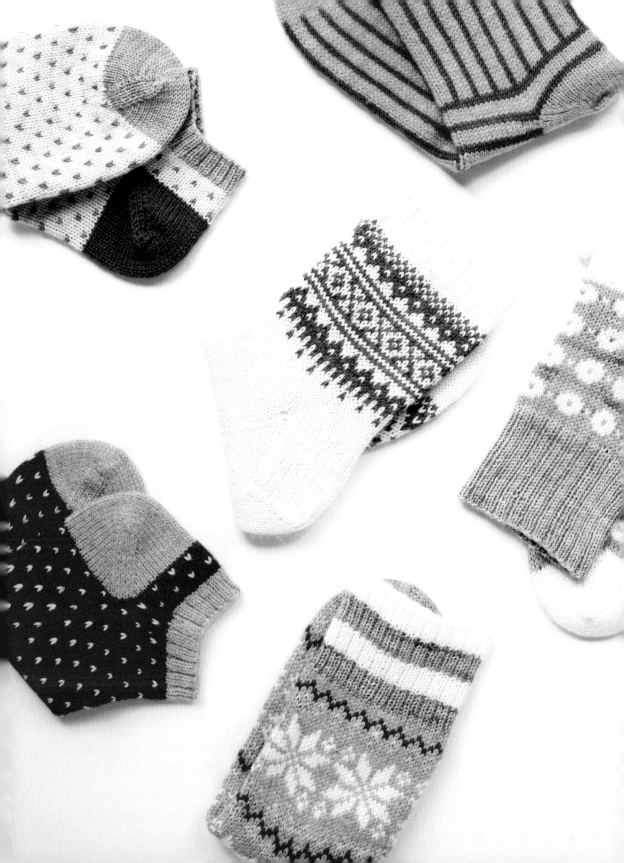

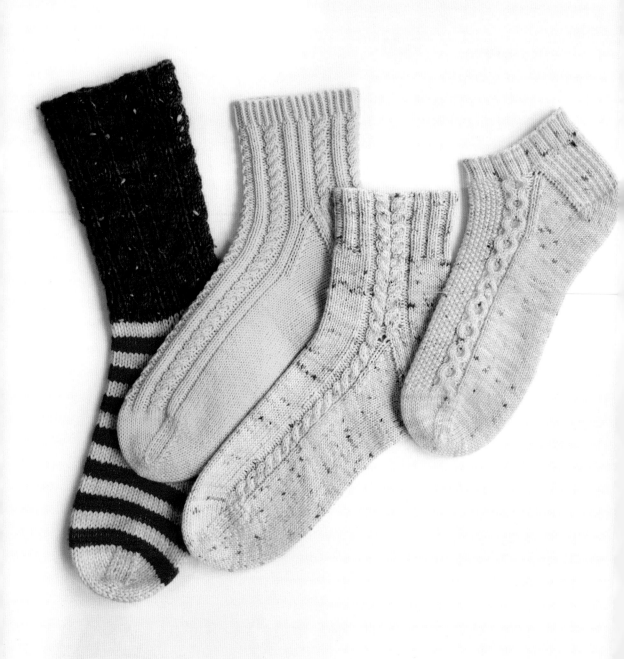

# Chapter 12
# CABLED SOCKS

Years ago, I saw a pattern for a giant, allover cabled cardigan that was the very definition of cool and cozy. Wearing that cardigan, I could imagine myself as a character in *Twin Peaks*, or as that cool girl who shows up late to the house party on a snowy night with a bottle of good wine in her hand and thrilling tales from her recent trekking adventure in Tibet, ready to dazzle everyone.

In reality, I am nowhere close to that ideal. I'm the girl who can't eat dairy, but does it anyway, so she beaches herself on the couch in moderate cheese-induced discomfort, knitting two inches of intricate cables before getting bored and tossing the knitting aside with a melancholic sigh.

It took me a year to finish that stupid cardigan, and I was miserable the entire time. "I HATE cables," I declared (to my dogs, who were the only ones present at the time), "and I'm never knitting them again."

Except I adore the look of cables, so I was really hacked off about how wretched they were to knit. Enter socks, ready to save the day as always! I could handle cables on socks, and actually found them quite entertaining when limited to a very small project that required very little time to knit.

So whether you love to knit them (I envy you), or are considering skipping this chapter altogether (I get it, I really do, but give at least one pair a try), I designed these cabled patterns with JOY in mind. Boredom and excess fiddly-ness were my chief concerns, and I'm proud to say that these patterns are neither boring nor fiddly!

## A Few Notes on Cable Terminology

### C4B/C4R = Cable 4 Back/Cable 4 Right

To work this cable stitch, you place two stitches on your cable needle and hold it to the back of your work. You knit the next two stitches on your left needle, then you knit the stitches from your cable needle. It's called "C4B" to indicate where you hold the cable needle, but sometimes you'll see it written as "C4R" because that indicates the direction the cable twists (to the right).

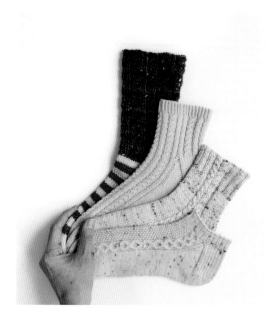

### C4F/C4L = Cable 4 Front/Cable 4 Left

To work this cable stitch, you place two stitches on your cable needle and hold it to the front of your work. You knit the next two stitches on your left needle, then you knit the stitches from your cable needle. It's called "C4F" to indicate where you hold the cable needle, but sometimes you'll see it written as "C4L" because that indicates the direction the cable twists (to the left).

The number refers to how many stitches the cable is worked over. For example, "C6B" would mean you hold three stitches on the cable needle and knit three stitches from the left needle.

Cable motifs are often charted; however, the patterns in this chapter are relatively simple. I wanted you to have a nice library of classic patterns to choose from. I chose to write out the cable instructions rather than chart them.

# Harriet Socks

Let's start out slowly, shall we? Just a few little cables, limited to the sides of the socks, with a lot of Stockinette in between. I love this pattern because it can be modified so easily. You can stick just about any cable pattern on the sides of your socks. Once again, making a trip to the library or bookstore can be so beneficial on your sock journey. Knitting stitch dictionaries can show you how to make all kinds of fancy or simple cable stitches that you can plug right into a basic sock.

Just like with lace, heavily speckled or variegated yarns can muddy the motif, making it hard to see. I tend to stick with solids, tonals, and lightly speckled yarns when I knit cables. (But, as always, you do YOU!)

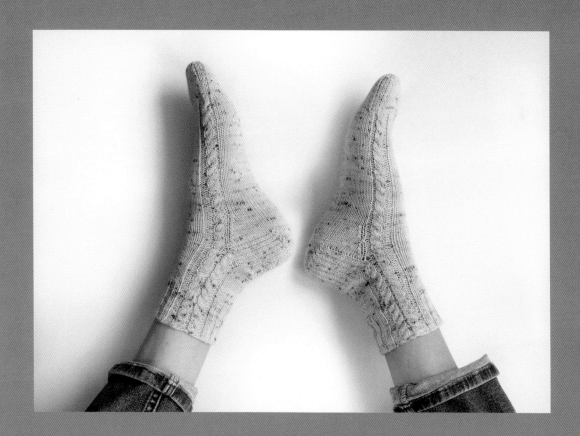

## MATERIALS

Yarn: Madelinetosh Tosh Twist Light [75% superwash merino/25% nylon; 420 yards (384 m)/3½ (100 g)]: 182 (209, 232, 261, 294) yards [166 (191, 212, 239, 269) m] in Anime Dreams

*Note: As always, you can use any fingering weight sock yarn.*

Needles: US size 1 (2.25 mm)

Notions: Tapestry needle, stitch markers, cable needle, snips, measuring tape

Gauge: 38 sts = 4" (6 cm), knit in pattern in the round and blocked

### Sizes
Kid (S, M, L, XL)

### Measurements
The numbers below refer to the circumference of the ball of the foot, not the measurements of the finished sock.

5–6 (7, 8, 9, 10)" [13–15 (18, 20, 23, 25) cm]

## INSTRUCTIONS

### Cuff
CO **46 (54, 62, 70, 78)** sts and join for working in the rnd, being careful not to twist your sts. Est the following cable and 2×2 rib pattern:

**Rnds 1–3:** K4, [p2, k2] **3 (4, 5, 6, 7)** times, p2, k4, p1, k4, [p2, k2] **3 (4, 5, 6, 7)** times, p2, k4, p1.
**Rnd 4:** C4B, [p2, k2] **3 (4, 5, 6, 7)** times, p2, C4F, p1, C4B, [p2, k2] **3 (4, 5, 6, 7)** times, p2, C4F, p1.

Cont repeating all 4 rnds of the cable and 2×2 rib pattern until your Cuff measures 2" (5 cm), or your desired length. End after working rnd 4.

### Leg
The Leg is worked almost the same as the Cuff. We're going to keep the cables, but get rid of the ribbing. We also need to adjust our stitch count, so work the following setup rnd once:

**Setup Rnd:** K4, p2, k**9 (13, 17, 21, 25)**, m1, k1, p2, k4, p1, k4, p2, k**9 (13, 17, 21, 25)**, m1, k1, p2, k4, p1. **48 (56, 64, 72, 80)** sts.

Next, repeat all 4 rnds of the cable pattern below until your work (including Cuff) measures 4" (10 cm), or your desired length. Since you worked the setup rnd, you'll be starting on rnd 2. It doesn't matter on which rnd you stop for the heel.

**Rnds 1–3:** K4, p2, k**10 (14, 18, 22, 26)**, p2, k4, p1, k4, p2, k**10 (14, 18, 22, 26)**, p2, k4, p1.
**Rnd 4:** C4B, p2, k**10 (14, 18, 22, 26)**, p2, C4F, p1, C4B, p2, k**10 (14, 18, 22, 26)**, p2, C4F, p1.

### Heel Flap
Work in cable pattern across the first **24 (28, 32, 36, 40)** sts, then begin working your Heel Flap back and forth across the remaining **24 (28, 32, 36, 40)** sts as follows:

**Row 1 (RS):** K2, [slip 1, k1] to end. Turn work.
**Row 2 (WS):** Slip 1 wyif, purl to end. Turn work.
**Row 3:** [Slip 1, k1] to end. Turn work.

Repeat rows 2 and 3 until Heel Flap measures **1.75 (2, 2, 2.25, 2.5)"** [4.5 (5, 5, 6, 6.5) cm]. End after you have worked row 3.

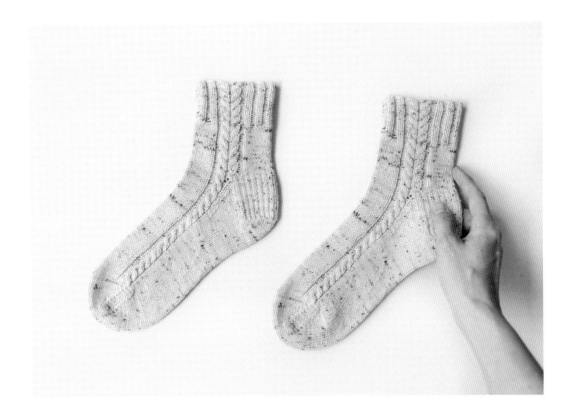

## Heel Turn

**Row 1 (WS):** Slip 1 wyif, p12 **(14, 16, 18, 20)**, p2tog, p1, turn.

**Row 2 (RS):** Slip 1, k3, ssk, k1, turn.

**Row 3:** Slip 1 wyif, p4, p2tog, p1, turn.

**Row 4:** Slip 1, k5, ssk, k1, turn.

You have now established the following pattern for your Heel Turn: slip 1, knit or purl to one st before the gap created by turning on the previous row, ssk or p2tog, k1 or p1, turn. Cont in this pattern until all your Heel sts have been worked, ending with a RS row. You should now have **14 (16, 18, 20, 22)** Heel sts.

## Gusset

With the right side of your work facing, pick up and knit **10 (12, 14, 16, 18)** sts along the left side of your Heel Flap.

Next, work in cable pattern across the **24 (28, 32, 36, 40)** sts that we've left undisturbed on our needles while working our Heel Flap. Pm, and pick up **10 (12, 14, 16, 18)** sts on the right side of your Heel Flap. Knit across the Heel sts, then knit down the first set of new sts you picked up on the left side. You've reached the end of the rnd, and all your sts have now been picked up. You should now have **58 (68, 78, 88, 98)** sts total on your needles.

*Note: From this point forward, you will only be working the cable pattern across the top of your sock [the first 24 (28, 32, 36, 40) sts]. You will be working Stockinette (knit every st) across the remaining 24 (28, 32, 36, 40) sts, which make up the bottom, or sole, of your sock. This means that instead of working four cables, we're down to just two. You will work a C4B, then knit to your next cable and work a C4F, and then work in Stockinette until the last st in the rnd, which you will purl.*

## Gusset Decreases

**Rnd 1:** Work in cable pattern across **24 (28, 32, 36, 40)** sts, sl marker, k1, ssk, knit around to 3 sts before the end of rnd, k2tog, p1.

**Rnd 2:** Work even with no decreases.

Repeat these two rnds until you have **48 (56, 64, 72, 80)** sts on your needles.

## Foot

Cont working cable pattern across the first **24 (28, 32, 36, 40)** sts, and then knitting around to the last st, then p1. Once your work reaches just to the tip of your pinky toe, it's time to work the Toe decreases. If you can't easily try your socks on as you knit, or if you are knitting gift socks, the Craft Yarn Council has issued the following length guidelines for the Foot of a sock, measured from the back of the Heel to the end of the Toe.

(All sizes are US.)

**Kid:** 6–7½" (15–19 cm)
**Women's shoe sizes 4–6.5:** 8–9" (20.5–23 cm)
**Women's shoe sizes 7–9.5:** 9¼–10" (23–25.5 cm)
**Women's shoe sizes 10–12.5:** 10¼–11" (26–28 cm)
**Men's shoe sizes 6–8.5:** 9¼–10" (23.5–25.5 cm)
**Men's shoe sizes 9–11.5:** 10¼–11" (26–28 cm)
**Men's shoe sizes 12–14:** 11¼–12" (28.5–30.5 cm)

When working a Heel Flap and Gusset, you also need to take into account your Toe length:

**Kid:** 1¼" (3 cm)
**S:** 1½" (4 cm)
**M:** 1½" (4 cm)
**L:** 1½" (4 cm)
**XL:** 1¾" (4 cm)

Now, take your desired Foot length, from back of Heel to end of Toe, and subtract your Toe measurements. For example, my desired Foot length is 9" (23 cm). I subtract my Toe (1½" [4 cm]) and that leaves me with 7½" (19 cm) I need to knit before starting my Toe decreases. Measure starting at the back of the Heel.

It doesn't matter on which rnd you end before stopping for the Toe decreases.

## Toe

**Rnd 1:** K1, ssk, k18 (22, 26, 30, 34) sts, k2tog, k1, pm, k1, ssk, k18 (22, 26, 30, 34) sts, k2tog, k1.

**Rnd 2:** Knit.

**Rnd 3:** K1, ssk, knit to 3 sts before next marker, k2tog, k1, sl m, k1, ssk, knit around to 3 sts before end of rnd, k2tog, k1.

Repeat rnds 2 and 3 until **20 (24, 28, 32, 36)** sts remain.

Graft the Toe sts together using Kitchener Stitch (see page 33).

## Finishing

Weave in all ends and block your socks.

# Seafarer Socks

I promise these socks won't be anything like my disastrous allover cabled cardigan. I wouldn't do that to you. Do they take a bit more time to knit than the previous pattern? Yes, but the pattern is easy to memorize and intuitive to knit. You can still listen intently to the audiobook version of Dolly Parton's biography while you knit (a yearly occurrence for me). I'm a firm believer that everyone needs a glorious pair of allover cabled socks at their disposal. Knit them in neon as I did, or opt for a more neutral color—either way they'll be socks you want to wear all winter long!

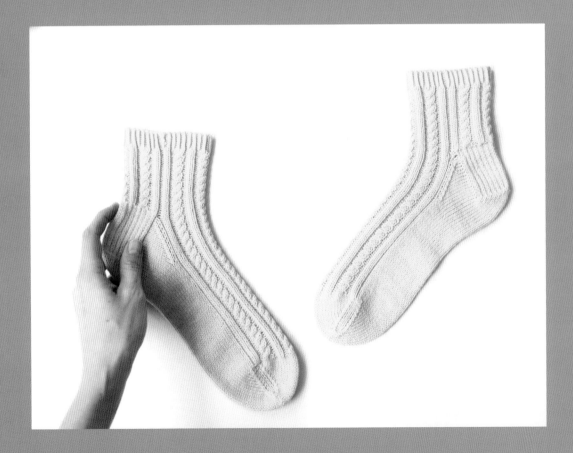

## MATERIALS

**Yarn:** Hedgehog Fibres Sock [90% superwash merino/10% nylon; 437 yards (400 m)/3½ ounces (100 g)]: 180 (208, 234, 271) yards [165 (190, 214, 248) m] in UFO

*Note: As always, you can use any fingering weight sock yarn.*

**Needles:** **Sizes M and L:** US size 1 (2.25 mm) **Sizes S and XL:** US size 2 (2.75 mm)

**Notions:** Tapestry needle, stitch markers, cable needle, snips, measuring tape

**Gauge:** 38 sts = 4" (10 cm), knit in pattern in the rnd and blocked

*Note: You'll notice that sizes M and L use different cast-on numbers than what you are used to. Sizes S and XL call for a different needle size. When working a pattern with multiple, tightly twisted cables, the sock fabric is not as stretchy. To ensure we get a good fit, we either need to increase our stitch count or work with bigger needles. And on top of all that, the cables need to be symmetrically placed on the sock for each size. So some sizes get more stitches, and some sizes have the standard stitch count but use bigger needles. This is good information to know, should you come across weird stitch counts in the future or see a bigger recommended needle size on a pattern and aren't sure why.*

**Sizes**
S (M, L, XL)

**Measurements**
7 (8, 9, 10)" [18 (20, 23, 25) cm]

## INSTRUCTIONS

### Cuff

CO **56 (68, 76, 80)** sts and join for working in the rnd, being careful not to twist your sts. Est Half Twisted Rib 1×1 twisted rib pattern: [k1tbl, p1] to end.

*Here's a fun secret: You and I both know that true 1×1 twisted rib is a bit of a nightmare to knit. It's slow and fiddly and it makes your hands cramp up. It looks so beautiful, though, that it's hard to resist incorporating it into my socks. Cheating is the only recourse, then, to get that neat little cuff without all the pain. It's called "Half Twisted Rib" and here is how you do it: Work the knit sts through the back loop, but just purl the purls like normal. It goes much faster, doesn't hurt nearly as bad, and is ten times less fiddly. And you can't really tell the difference from true 1×1 twisted rib.*

Cont working rib pattern until Cuff measures 1" (2.5 cm), or your desired length.

### Leg

We need to work a setup rnd to get ready for our cable pattern. Once you've worked this rnd, you'll be able to "see" the pattern in knits and purls. Work the following setup rnd according to your size:

**S:** [P1, k2, p1, k4, p1, k2, p1, k4, p1, k2, p1, k4, p1, k2, p1] twice.
**M:** [P1, k2, p2, k4, p2, k2, p2, k4, p2, k2, p2, k4, p2, k2, p1] twice.
**L:** [K1, p2, k4, p2, k2, p2, k2, p2, k4, p2, k2, p2, k2, p2, k4, p2, k1] twice.
**XL:** [K1, p2, k4, p2, k2, p2, k4, p2, k2, p2, k4, p2, k2, p2, k4, p2, k1] twice.

Now you can begin repeating the rib and cable pattern. Repeat the following 4 rnds, according to your size:

## S

**Rnds 1, 2, and 4:** [P1, k2, p1, k4, p1, k2, p1, k4, p1, k2, p1, k4, p1, k2, p1] twice.
**Rnd 3:** [P1, k2, p1, C4B, p1, k2, p1, C4B, p1, k2, p1, C4B, p1, k2, p1] twice.

## M

**Rnds 1, 2, and 4:** [P1, k2, p2, k4, p2, k2, p2, k4, p2, k2, p2, k4, p2, k2, p1] twice.
**Rnd 3:** [P1, k2, p2, C4B, p2, k2, p2, C4B, p2, k2, p2, C4B, p2, k2, p1] twice.

## L

**Rnds 1, 2, and 4:** [K1, p2, k4, p2, k2, p2, k2, p2, k4, p2, k2, p2, k2, p2, k4, p2, k1] twice.
**Rnd 3:** [K1, p2, C4B, p2, k2, p2, k2, p2, C4B, p2, k2, p2, k2, p2, C4B, p2, k1] twice.

## XL

**Rnds 1, 2, and 4:** [K1, p2, k4, p2, k2, p2, k4, p2, k2, p2, k4, p2, k2, p2, k4, p2, k1] twice.
**Rnd 3:** [K1, p2, C4B, p2, k2, p2, C4B, p2, k2, p2, C4B, p2, k2, p2, C4B, p2, k1] twice.

Repeat those 4 rnds until your Leg (including Cuff) measures 3" (8 cm), or your desired length.

### Heel Flap

**Sizes M and L ONLY:** Work across the first **34 (38)** sts in established cable and rib pattern. Then k1, ssk, knit to last 3 sts, k2tog, k1. **66 (74)** sts. Proceed to Heel Flap instructions.

Work in est pattern across the first **28 (34, 38, 40)** sts, then begin working your Heel Flap back and forth across the remaining **28 (32, 36, 40)** sts as follows:

**Row 1 (RS):** K2, [slip 1, k1] to end. Turn work.
**Row 2 (WS):** Slip 1 wyif, purl to end. Turn work.
**Row 3:** [Slip 1, k1] to end. Turn work.

Repeat rows 2 and 3 until Heel Flap measures **2 (2, 2.25, 2.5)" [5 (5, 6, 6.5) cm]**. End after you have worked row 3.

### Heel Turn

**Row 1 (WS):** Slip 1 wyif, p**14 (16, 18, 20)**, p2tog, p1, turn.
**Row 2 (RS):** Slip 1, k3, ssk, k1, turn.
**Row 3:** Sl1 wyif, p4, p2tog, p1, turn.
**Row 4:** Sl1, k5, ssk, k1, turn.

You have now established the following pattern for your Heel turn: slip 1, knit or purl to 1 st before the gap created by turning on the previous row, ssk or p2tog, k1 or p1, turn. Cont in this pattern until all your Heel sts have been worked, ending on a RS row. You should now have **16 (18, 20, 22)** Heel sts.

### Gusset

With the right side of your work facing, pick up and knit **12 (14, 16, 18)** sts along the left side of your Heel Flap.

Next, work in est cable and rib pattern across the **28 (34, 38, 40)** sts that we've left undisturbed on our needles while working our Heel Flap. Pm, and pick up **12 (14, 16, 18)** sts on the right side of your Heel Flap. Knit across the Heel sts, then knit down the first set of new sts you picked up on the left side. You've reached the end of the rnd, and all your sts have now been picked up. You should now have **68 (80, 90, 98)** sts total on your needles.

## Gusset Decreases

**Rnd 1:** Work in est cable and rib pattern across **28 (34, 38, 40)** sts, sl marker, k1, ssk, knit around to 3 sts before the end of rnd, k2tog, k1.
**Rnd 2:** Work even with no decreases. Repeat these two rnds until you have **56 (66, 74, 80)** sts on your needles.

**Sizes M and L ONLY**: When knitting the Foot, you will work the est cable and rib pattern across the first **34 (38)** sts (which make up the top of your sock), and you will work Stockinette (knit every st) across the remaining **32 (36)** sts (which make up the sole of your sock).

## Foot

Cont working in est cable and rib pattern across the first **28 (34, 38, 40)** sts, and working Stockinette across the remaining **28 (32, 36, 40)** sts until your Foot reaches just to the end of your pinky toe. If you can't easily try your socks on as you knit (working on double-pointed needles or tiny circulars can make this challenging), or if you are knitting gift socks for some lucky recipient, the Craft Yarn Council has issued the following length guidelines for the Foot of a sock, measured from the back of the Heel to the end of the Toe.

(All sizes are US.)
**Women's shoe sizes 4–6.5:** 8–9" (20.5–23 cm)
**Women's shoe sizes 7–9.5:** 9¼–10" (23–25.5 cm)
**Women's shoe sizes 10–12.5:** 10¼–11" (26–28 cm)
**Men's shoe sizes 6–8.5:** 9¼–10" (23.5–25.5 cm)
**Men's shoe sizes 9–11.5:** 10¼–11" (26–28 cm)
**Men's shoe sizes 12–14:** 11¼–12" (28.5–30.5 cm)

When working a Heel Flap and Gusset, you also need to take into account your Toe length:
**S:** 1½" (4 cm)          **L:** 1½" (4 cm)
**M:** 1½" (4 cm)          **XL:** 1¾" (4 cm)

Now, take your desired Foot length, from back of Heel to end of Toe, and subtract your Toe measurements. For example, my desired foot length is 9" (23 cm). I subtract my toe (1½" [4 cm]) and that leaves me with 7½" (19 cm) I need to knit before starting my Toe decreases. Measure starting at the back of the Heel.

You can stop for the Toe on any rnd of the cable and rib pattern.

## Toe

**Sizes M and L ONLY:** We need to work a decrease rnd to get our stitch count back on track for the Toe. K1, ssk, k28 (32), k2tog, knit around to end. **64 (72)** sts. Proceed to the Toe instructions.

Knit 1 rnd even, then begin following decrease pattern for the Toe:

**Rnd 1:** K1, ssk, k22 (26, 30, 34) sts, k2tog, k1, pm, k1, ssk, k22 (26, 30, 34) sts, k2tog, k1.
**Rnd 2:** Knit.
**Rnd 3:** K1, ssk, knit to 3 sts before next marker, k2tog, k1, sl m, k1, ssk, knit around to 3 sts before end of rnd, k2tog, k1.

Repeat rnds 2 and 3 until **24 (28, 32, 36)** sts remain.

Use Kitchener Stitch to close up the Toe (see page 33).

## Finishing

Weave in your ends and block your socks (see chapter 4).

# Cozy Cabled Socks

Thick cabled socks are as necessary during the long, dark nights of winter as soup and quality reading material. Whether you are burrowed into your favorite chair by the fire, standing on the cold tile of your laundry room, or trudging about in the snow while you run errands, these socks will see you through frigid temps and mild seasonal depression.

Because I live for surprises, I designed the foot to be knit up in colorful stripes. Who doesn't love to take off their winter boots and see unexpected pops of color?

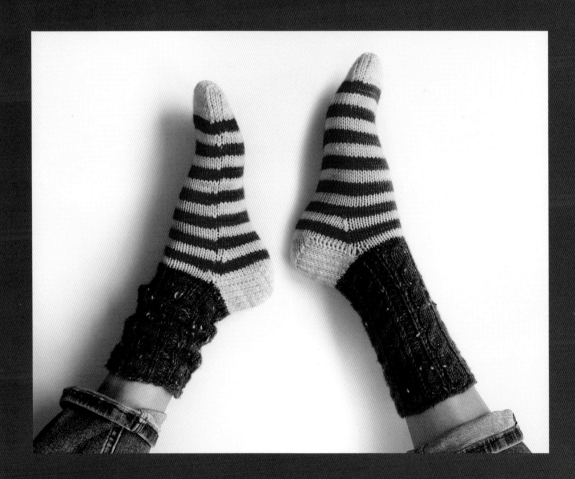

## MATERIALS

**Yarn:** Little Lionhead Knits DK Merino Tweed [85% SW Bluefaced Leicester/15% Donegal nep; 246 yards (225 m)/3½ ounces (110g)]: 96 (118, 132, 156) yards [88 (108, 121, 143) m] in Golden Brown (MC)

Little Lionhead Knits Soft Sock DK [85% superwash merino/15% nylon; [246 yards (225 m)/3½ ounces (100g)]: 60 (72, 89, 103) yards [55 (66, 81, 94) m] in Depression Glass (CC1)

Little Lionhead Knits Soft Sock DK [85% superwash merino/15% nylon, [246 yards (225 m)/3½ ounces (100g)]: 46 (58, 69, 87) yards [42 (53, 63, 80) m] in Let's Picnic (CC2)

*Note: As always, use any DK weight yarn you prefer.*

**Needles:** US size 3 (3.25 mm)

**Notions:** Tapestry needle, stitch markers, cable needle, snips, measuring tape

**Gauge:** 22 sts = 3" (8 cm), knit in cable pattern in the rnd and blocked

24 sts = 3¼" (8 cm), knit in Stockinette (knit every st) in the rnd and blocked

**Sizes**
S (M, L, XL)

**Measurements**
The numbers below refer to the circumference of the ball of the foot, not the measurements of the finished sock.

7 (8, 9, 10)" [18 (20, 23, 25) cm]

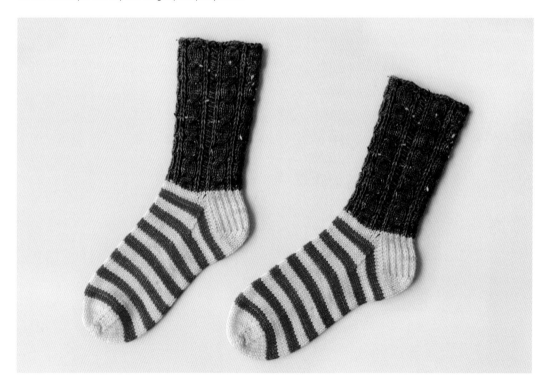

# INSTRUCTIONS

## Leg

With MC, CO **40 (48, 56, 64)** sts and join for working in the rnd, being careful not to twist your sts.

Est the following cable pattern according to your size:

### S

**Rnds 1, 2, 4, 5, and 6:** [P1, slip 1, p2, k4, p2, slip 1, p2, k4, p2, slip 1] twice.

**Rnd 3:** [P1, slip 1, p2, C4B, p2, slip 1, p2, C4B, p2, slip 1] twice.

### M

**Rnds 1, 2, 4, 5, and 6:** [P1, slip 1, p1, k4, p1, slip 1, p1, k4, p1, slip 1, p1, k4, p1, slip 1, p1] twice.

**Rnd 3:** [P1, slip 1, p1, C4B, p1, slip 1, p1, C4B, p1, slip 1, p1, C4B, p1, slip 1, p1] twice.

### L

**Rnds 1, 2, 4, 5, and 6:** [P1, slip 1, p1, k4, p1, slip 1, p1, k4, p1, slip 1, p1, k4, p1, slip 1, p1, k4] twice.

**Rnd 3:** [P1, slip 1, p1, C4B, p1, slip 1 p1, C4B, p1, slip 1, p1, C4B, p1, slip 1, p1, C4B] twice.

### XL

**Rnds 1, 2, 4, 5, and 6:** [P1, k4, p2, slip 1, p2, k4, p2, slip 1, p2, k4, p2, slip 1, p2, k4] twice.

**Rnd 3:** [P1, C4B, p2, slip 1, p2, C4B, p2, slip 1, p2, C4B, p2, slip 1, p2, C4B] twice.

Cont repeating all 6 rnds of cable pattern until Leg measures 6½" (17 cm), or desired length. Break MC. We are now done with cables and will be working in stripey Stockinette the rest of the sock.

## Heel Flap

Join in CC1 and knit in Stockinette st across the first **20 (24, 28, 32)** sts, then begin working your Heel Flap back and forth across the remaining **20 (24, 28, 32)** sts as follows:

**Row 1 (RS):** K2, [slip 1, k1] to end. Turn work.
**Row 2 (WS):** Slip 1 wyif, purl to end. Turn work.
**Row 3:** [Slip 1, k1] to end. Turn work.

Repeat rows 2 and 3 until Heel Flap measures **2 (2, 2.25, 2.5)" [5 (5, 6, 6.5) cm]**. End after you have worked row 3.

## Heel Turn

**Row 1 (WS):** Slip 1 wyif, p10 (12, 14, 16), p2tog, p1, turn.
**Row 2 (RS):** Slip 1, k3, ssk, k1, turn.
**Row 3:** Slip 1 wyif, p4, p2tog, p1, turn.
**Row 4:** Slip 1, k5, ssk, k1, turn.

You have now established the following pattern for your Heel turn: slip 1, knit or purl to 1 st before the gap created by turning on the previous row, ssk or p2tog, k1 or p1, turn. Cont in this pattern until all your Heel sts have been worked, ending on a RS row. You should now have **12 (14, 16, 18)** Heel sts.

## Gusset

With the right side of your work facing, pick up and knit **8 (8, 8, 10)** sts along the left side of your Heel Flap.

Next, across the **20 (24, 28, 32)** sts that we've left undisturbed on our needles while working our Heel Flap. Pm, and pick up **8 (8, 8, 10)** sts on the right side of your Heel Flap. Knit across the Heel sts, then knit down the first set of

new sts you picked up on the left side. You've reached the end of the rnd, and all your sts have now been picked up. You should now have **48 (54, 60, 70)** sts total on your needles.

## Gusset Decreases

**Rnd 1:** Knit across **20 (24, 28, 32)** sts, sl marker, k1, ssk, knit around to 3 sts before the end of rnd, k2tog, k1.

**Rnd 2:** Work even with no decreases.

Repeat these two rnds until you have **40 (48, 56, 64)** sts on your needles, while at the same time working the following stripe pattern:

**CC1:** 4 rows
**CC2:** 4 rows

*Tip: Check out page 72 for helpful tips on working two-color stripes.*

## Foot

Cont working stripe pattern in Stockinette until your work reaches just to the tip of your pinky toe. If you can't easily try the sock on, or if you are knitting gift socks, the Craft Yarn Council has issued the following length guidelines for the Foot of a sock, measured from the back of the Heel to the end of the Toe.

(All sizes are US.)
**Women's shoe sizes 4–6.5:** 8–9" (20.5–23 cm)
**Women's shoe sizes 7–9.5:** 9¼–10" (23–25.5 cm)
**Women's shoe sizes 10–12.5:** 10¼–11" (26–28 cm)
**Men's shoe sizes 6–8.5:** 9¼–10" (23.5–25.5 cm)
**Men's shoe sizes 9–11.5:** 10¼–11" (26–28 cm)
**Men's shoe sizes 12–14:** 11¼–12" (28.5–30.5 cm)

When working a Heel Flap and Gusset, you also need to take into account your Toe length:

**S:** 1½" (4 cm)          **L:** 1½" (4 cm)
**M:** 1½" (4 cm)          **XL:** 1¾" (4 cm)

Now, take your desired Foot length, from back of Heel to end of Toe, and subtract your Toe measurements. For example, my desired Foot length is 9" (23 cm). I subtract my Toe (1½" [4 cm]) and that leaves me with 7½" (19 cm) I need to knit before starting my Toe decreases. Measure starting at the back of the Heel.

## Toe

Break CC2 and knit 1 rnd even before starting Toe decreases:

**Rnd 1:** K1, ssk, k**14 (18, 22, 26)** sts, k2tog, k1, pm, k1, ssk, k**14 (18, 22, 26)** sts, k2tog, k1.
**Rnd 2:** Knit.
**Rnd 3:** K1, ssk, knit to 3 sts before next marker, k2tog, k1, sl m, k1, ssk, knit around to 3 sts before end of rnd, k2tog, k1.

Repeat rnds 2 and 3 until **20 (24, 28, 32)** sts remain.

Use Kitchener Stitch to close the Toe (see page 33).

## Finishing

Weave in all ends and block your socks (see chapter 4).

# Honeycomb and Moss Socks

One of my favorite things about traditional stitch patterns is how they so closely resemble the natural world. Our knitting ancestors (may they ever watch over us and guide our needles to gentle victories) managed to figure out how to use strings and sticks to mimic things they saw in their daily lives.

Honeycomb cables, when knit in a row on an Aran sweater, are the perfect approximation of bee dwellings. And the moss stitch—such a simple combination of knits and purls—perfectly mirrors the texture of a forest floor. The romantic in me swoons over the simple beauty of these stitch motifs, combined here to make the sweetest of little shorty socks.

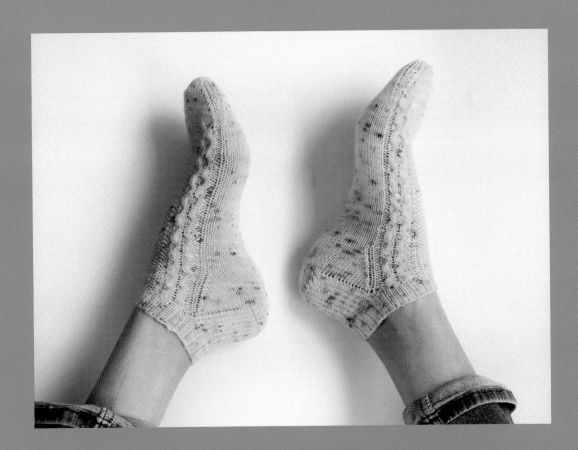

## MATERIALS

**Yarn:** Little Lionhead Knits Soft Sock Fingering [85% superwash merino/15% nylon; 437 yards (400 m)/3½ ounces (100 g)]: 134 (151, 176, 201, 229) yards [123 (138, 161, 184, 209) m] in Midcentury

*Note: As always, any fingering weight sock yarn will do.*

**Needles:** US size 1/2.25 mm

**Notions:** Tapestry needle, stitch markers, cable needle, snips, measuring tape

**Gauge:** 38 sts = 4" (10 cm), knit in pattern in the round and blocked

### Sizes
Kid (S, M, L, XL)

### Measurements
The numbers below refer to the circumference of the ball of the foot, not the measurements of the finished sock.

5–6 (7, 8, 9, 10)" [13–15 (18, 20, 23, 25) cm]

### Honeycomb and Moss Pattern
**Rnds 1 and 5:** P1, k8, p1, [k1, p1] **2 (4, 6, 8, 10)** times, p1, k8, p1, knit around to end.

**Rnds 2, 4, 6, and 8:** P1, k8, p1, [p1, k1] **2 (4, 6, 8, 10)** times, p1, k8, p1, knit around to end.

**Rnd 3:** P1, C4B, C4F, p1, [k1, p1] **2 (4, 6, 8, 10)** times, p1, C4B, C4F, p1, knit around to end.

**Rnd 7:** P1, C4F, C4B, p1, [k1, p1] **2 (4, 6, 8, 10)** times, p1, C4F, C4B, p1, knit around to end.

## INSTRUCTIONS

### Cuff
CO **48 (57, 63, 72, 81)** sts and join for working in the rnd, being careful not to twist your sts. Est 2×1 ribbing: [k2, p1] to end.

Cont working the ribbing until your Cuff measures ¾" (2 cm), or your desired length. On the last rnd of the ribbing, we need to get our stitch count back to an even number. If you are working the Kid or L sizes, you already have an even number and can move on to the Pattern Setup instructions. The rest of you, make the following increase or decrease according to your size:

**S:** Work in rib pattern to the last 3 sts, k2tog, p1. **56** sts.

**XL:** Work in rib pattern to the last 3 sts, k2tog, p1. **80** sts.

**M:** Work in rib pattern to the last 3 sts, kfb, k1, p1. **64** sts.

### Pattern Setup
Next, we need to establish our Honeycomb and Moss Pattern. Work rnd 1 of the Honeycomb and Moss Pattern:

P1, k8, p1, [k1, p1] **4 (6, 8, 10)** times, p1, k8, p1, knit around to end.

### Heel Flap
Work rnd 2 of the Honeycomb and Moss Pattern across the first **24 (28, 32, 36, 40)** sts, then begin working your Heel Flap back and forth across the remaining **24 (28, 32, 36, 40)** sts as follows:

**Row 1 (RS):** K2, [slip 1, k1] to end. Turn work.
**Row 2 (WS):** Slip 1 wyif, purl to end. Turn work.
**Row 3:** [Slip 1, k1] to end. Turn work.

Repeat rows 2 and 3 until Heel Flap measures 1.75 (2, 2, 2.25, 2.5)" [(4.5) 5 (5, 6, 6.5) cm]. End after you have worked row 3.

## Heel Turn

**Row 1 (WS):** Slip 1 wyif, p**12 (14, 16, 18, 20)**, p2tog, p1, turn.
**Row 2 (RS):** Slip 1, k3, ssk, k1, turn.
**Row 3:** Slip 1 wyif, p4, p2tog, p1, turn.
**Row 4:** Slip 1, k5, ssk, k1, turn.

You have now established the following pattern for your Heel Turn: slip 1, knit or purl to 1 st before the gap created by turning on the previous row, ssk or p2tog, k1 or p1, turn. Cont in this pattern until all your Heel sts have been worked, ending on a RS row. You should now have **14 (16, 18, 20, 22)** Heel sts.

## Gusset

With the right side of your work facing, pick up and knit **10 (12, 14, 16, 18)** sts along the left side of your Heel Flap.

Next, work in Honeycomb and Moss Pattern (you should be on Rnd 3) across the **24 (28, 32, 36, 40)** sts that we've left undisturbed on our needles while working our Heel Flap. Pm, and pick up **10 (12, 14, 16, 18)** sts on the right side of your Heel Flap. Knit across the Heel sts, then knit down the first set of new sts you picked up on the left side. You've reached the end of the rnd, and all your sts have now been picked up. You should now have **58 (68, 78, 88, 98)** sts total on your needles.

You will now be working your Gusset decreases and should be on rnd 4 of the Honeycomb and Moss Pattern. Cont repeating all 8 rnds of the pattern as you work your Gusset Decreases and Foot.

## Gusset Decreases

**Rnd 1:** Work in Honeycomb and Moss Pattern across **24 (28, 32, 36, 40)** sts, sl marker, k1, ssk, knit around to 3 sts before the end of rnd, k2tog, k1.
**Rnd 2:** Work even with no decreases.

Repeat these two rnds until you have **48 (56, 64, 72, 80)** sts on your needles.

## Foot

Cont working the Honeycomb and Moss Pattern across the first **24 (28, 32, 36, 40)** sts, and working Stockinette (knit every st) across the remaining **24 (28, 32, 36, 40)** sts until your work reaches just the tip of your pinky toe. If you can't easily try your sock on, or if you are knitting gift socks, the Craft Yarn Council has issued the following length guidelines for the Foot of a sock, measured from the back of the Heel to the end of the Toe.

(All sizes are US.)
**Kid:** 6–7½" (15–19 cm)
**Women's shoe sizes 4–6.5:** 8–9" (20.5–23 cm)
**Women's shoe sizes 7–9.5:** 9¼–10" (23–25.5 cm)
**Women's shoe sizes 10–12.5:** 10¼–11" (26–28 cm)
**Men's shoe sizes 6–8.5:** 9¼–10" (23.5–25.5 cm)
**Men's shoe sizes 9–11.5:** 10¼–11" (26–28 cm)
**Men's shoe sizes 12–14:** 11¼–12" (28.5–30.5 cm)

When working a Heel Flap and Gusset, you also need to take into account your Toe length:

**Kid:** 1¼" (3 cm)  **L:** 1½" (4 cm)
**S:** 1½" (4 cm)  **XL:** 1¾" (4 cm)
**M:** 1½" (4 cm)

Now, take your desired Foot length, from back of Heel to end of Toe, and subtract your Toe measurements. For example, my desired Foot length is 9" (23 cm). I subtract my Toe (1½" [4 cm]) and that leaves me with 7½" (19 cm) I need to knit before starting my Toe decreases. Measure starting at the back of the Heel.

It doesn't matter on which rnd of the Honeycomb and Moss Pattern you stop before shaping the Toe.

## Toe

Knit 1 rnd even in Stockinette, then begin the following decrease pattern for the Toe:

**Rnd 1:** K1, ssk, k**18 (22, 26, 30, 34)** sts, k2tog, k1, pm, k1, ssk, k**18 (22, 26, 30, 34)** sts, k2tog, k1.
**Rnd 2:** Knit.
**Rnd 3:** K1, ssk, knit to 3 sts before next marker, k2tog, k1, sl m, k1, ssk, knit around to 3 sts before end of rnd, k2tog, k1.

Repeat rnds 2 and 3 until **20 (24, 28, 32, 36)** sts remain.

Graft the Toe closed using Kitchener Stitch (see page 33).

## Finishing

Weave in all ends and block your socks (see chapter 4).

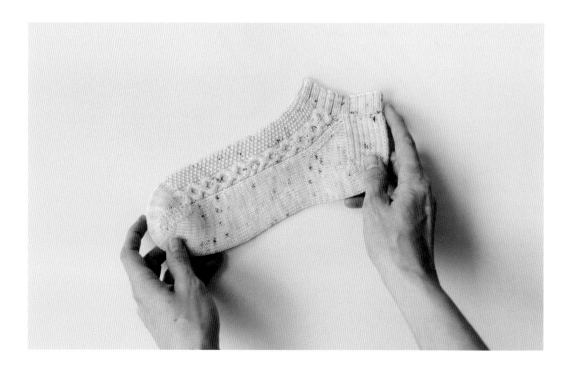

# ACKNOWLEDGMENTS

I was an awkward, gangly kid growing up in rural Oklahoma when I first started dreaming about being a published author. Many thanks to Meredith Clark for making that dream come true by reaching out and asking if I'd like to work with Abrams. What a thrilling email that was!

To Shawna Mullen, who scared me a little because she's an actual Book Editor at an actual New York City publishing house, thank you for taking on a first-time author (and being the opposite of scary!). I imagine that experience is always either amazing or horrifying, and never something in between. You patiently guided me through this process, providing encouragement, most magically, when I needed it the most.

A huge thank-you to managing editor Lisa Silverman, designer Jenice Kim, and the team at Abrams, for somehow deciphering the bizarre notes I sent you about my vision for this book. Even I didn't understand them, and I was the one who wrote them. How you translated that nonsense into a beautiful book that perfectly captures who I am is beyond me.

Many thanks to Jessica Schwab for her technical editing expertise! And for being so patient as I frequently unloaded heaps of patterns on her all at once.

My family is deserving of an extra-special thank-you. To my husband, Dave, thank you for doing literally everything for the six months I spent working on this book. (And I mean everything—he cooked, cleaned, did our taxes, cleaned up after sick dogs, ferried our kids to school, cued up all the best movies, played all the best playlists, took me to the bookstore when I was down, bought me coffee when I was really down, and listened excitedly while I read aloud portions of the book that made absolutely no sense to him because he's not a knitter.) Most of all, thank you for believing I could write this book, and thank you for your really awesome health insurance.

To my kids, Memphis and Sailor, thank you for being so understanding when I couldn't do stuff because I needed to work on my book. I hope the fact that I finally unlocked all the restrictions on your phones makes up for that! Please don't go wild and start communicating with weird strangers online—I don't want to have to go rescue you from some cult in Florida.

Finally, thank you to every reader who has picked up this book, to every knitter who learned to knit socks with me, and to every member of my online community. I would never be here without your support.

# ABOUT THE AUTHOR

Before sock knitting took over her life, Summer Lee worked as a political reporter and commercial photographer. An Oklahoma native and proud member of the Muscogee-Creek Nation, Summer is inspired by color, and the wild, unpredictable lands of her home state. She lives in Tulsa, Oklahoma, with her husband, two teenagers, a dog who adores her, and another dog who hates her for no good reason.